PETER LANYON *At the edge of landscape*

PETER LANYON

At the edge of landscape

Chris Stephens

First published 2000
Published worldwide by 21 Publishing
3–4 Bartholomew Place
London EC1A 7NJ
www.21publishing.com

Designed by The Letter g, London
Production co-ordinated by Uwe Kraus GmbH
Printed in Italy

A catalogue record for this book is available from the British Library
ISBN 1-901785-04-1

Measurements are given in inches, height before width,
followed by depth where appropriate.

Front cover: *Silent Coast*, 1957

Acknowledgements

This book draws upon over twelve years of research into Peter Lanyon and other artists of St Ives, during which time I have incurred considerable debts of gratitude. First and foremost, the book would not have been possible without the help, encouragement and endless patience of Sheila Lanyon. Along with her insight into Peter and his work, her hospitality and wise reticence have been two of the great pleasures of my task. I hope I have responded appropriately to her comments on the text. I am grateful to the Lanyon family, most particularly his sister Mary Schofield for sharing both her memories and her brother's wartime letters, and his sons Andrew, who generously provided me with a large collection of illustrations of his work, and Martin, who has commented on my text and shared the fruits of his own research. When I first showed an interest in Lanyon, I was greatly encouraged by David Goodman, who also shared his recollections of Lanyon. I am immensely grateful to other friends of Lanyon's who spoke with me about him and, in some cases, made available written material: Kenneth Armitage, Wilhelmina Barns-Graham, Anthony Benjamin, Alan Bowness, James Brown, the late Michael Canney and his wife Madeleine, Alan Davie, Paul Feiler, Terry Frost, the late Patrick Heron, Linden Holman, Jeremy Le Grice, David Lewis, Tony Matthews, Margaret Mellis, Tony O'Malley, Charles Thomas, John Wells, Karl Weschke, Nancy Wynne-Jones, Monica Wynter. I thank others who made available material in their possession: most particularly Rene Gimpel and all at Gimpel Fils, who yet again have provided invaluable assistance; Eric Quayle; Robert Scott; David and Tina Wilkinson. I am also grateful to the curators of public collections and the private collectors who afforded access to the works in their care and, in many cases, helped with photographs. As well as Gimpels, several dealers have helped to trace works and I must thank John Austin of Austin/Desmond Fine Art, Jonathan Clark, Robert Delaney at Bernard Jacobson and Madeleine Ponsonby at the New Art Centre. Over the years I have incurred a considerable debt to the staff of the Tate Gallery Archive, in particular Sarah Fox-Pitt, Jennifer Booth and Adrian Glew. For information, I must thank my colleagues Judith Severne, Jo Crook, Roy Perry and Jeremy Lewison; in New York, the staff of the Archives of American Art and the library at the Museum of Modern Art; Fabio Benzi and Derek Hill on Anticoli Corrado; John Eaves on Corsham in the 1950s. My debt to the earlier work on Lanyon by Andrew Causey and Margaret Garlake will be apparent, but I am especially grateful to Margaret for her comments on my text. Sections of the book derive from my D.Phil. on 'St Ives Artists and Landscape' and I am conscious that my approach to the artist's work has been greatly influenced by my supervisor David Mellor to whom I am greatly indebted. I would like to thank the directors of 21 Publishing for inviting me to write this book, Linda Saunders for her sensitive, subtle, but far-reaching improvement of my prose, and Georgia Mazower for gently managing all other aspects of the book's production. Finally, as always, I am inexpressibly grateful for Jo Willer's patience and support.

Contents

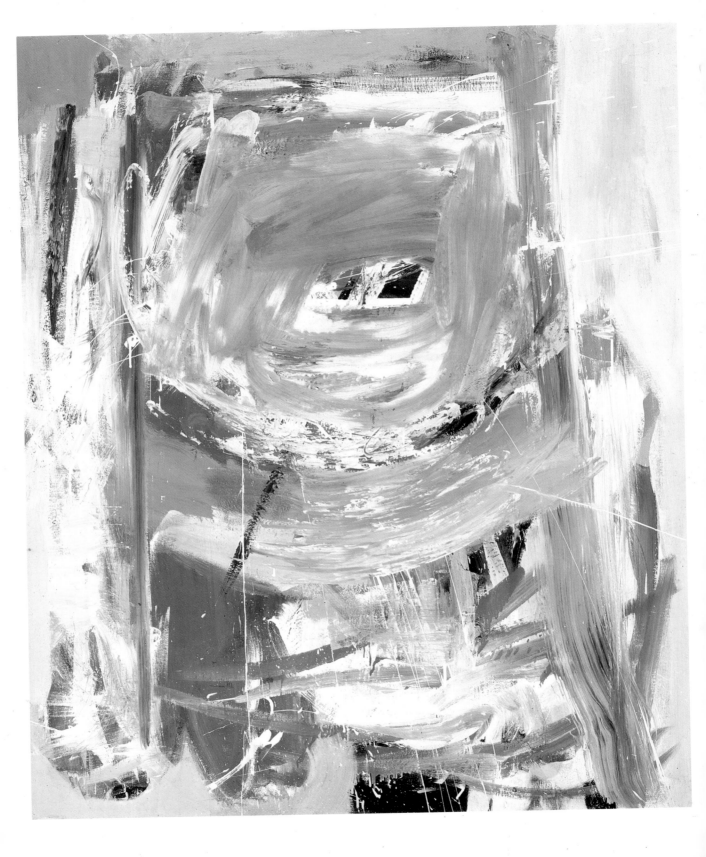

Introduction

'I think of myself as a landscape painter
in the tradition of Constable and Turner.'

Peter Lanyon's perception of himself as an artist belonging to a landscape tradition was reinforced by the verbal explanations he offered of his paintings as portraits of places.[1] Successive commentators have taken the artist at his word and described his works purely in terms of specific places. The catalogue of the Tate Gallery's 'St Ives' exhibition, for example, described the painting *Rosewall* (1960) (1) as 'an aerial view of Rosewall hill outside St Ives, on the road to Zennor and Land's End'.[2] While the work's title may encourage such an interpretation, a reader of that text may be surprised when confronted with the pattern of flesh-coloured paint swirling over thick ochres and splashed whites in the painting itself. Such a topographical explanation in defiance of the visual evidence is typical of writing on the work of artists associated with St Ives, and most particularly of Lanyon. This is not surprising given the artist's own preference for this kind of interpretation, but the approach fails to address the major questions raised by such a painting.

If this is a picture of a specific place, how do we understand the fact that it does not look like that place in the manner with which we are familiar? The painting is vertical in format; it has no perspectival recession; a horizon is neither evident nor implied; though greys, greens and the blues of sea and sky often feature in Lanyon's work, there are frequent intrusions of less 'natural' colours. In essence, the issue of what a Lanyon painting is *of* is far more fraught than would appear from his apparently straightforward commentaries. In part, this is because the artist sought to develop a more complex idea of 'landscape' than the established visual paradigm allowed. This question also exposes broader problems in pictorial interpretation. That is to say, the understanding of Lanyon's work simply in terms of the landscape reflects the failure of audiences, historians and critics to engage with the problems of representation that the paintings suggest. This point was touched upon by Charles Harrison in his critique of 'St Ives', which challenged the insistence on landscape as the principal determinant of the works of art emanating from the area.[3] 'That a particular painting depicts features of St Ives,' he wrote,

is no proof that the Cornish village is or was a necessary condition of its quality ... St Ives may only accidentally have been the site of the artistic developments we associate with it ... Lanyon's paintings, for instance, may be more

1
Rosewall, 1960
Oil on canvas
72 × 60
Ulster Museum, Belfast
Courtesy Trustees of the National Museums
and Galleries of Northern Ireland

significantly like Estève's or Bazaine's or Constant's or
de Kooning's, insofar as they share certain determining
technical conditions with them, than they are 'like' the
visual environment of West Penwith.[4]

Though his intervention is valuable, Harrison replaces the simplistic
romanticism of the dominant accounts with a narrow discussion of purely
technical developments. In his thesis, the landscape is little more than a
vehicle for formal exercises. I would certainly not want to reduce Lanyon's
use of landscape to such an incidental role. Rather, I would like to consider
how landscape is signified in his work, and why.

 It has been claimed that 'almost singlehanded Peter Lanyon
remade English landscape painting'.[5] I would not disagree with that, but
the purpose of this book is, in part, to make a greater claim for the artist by
not only seeking to establish how he treated his theme but also by asking,
'to what end?' I shall try to establish a more complex understanding of
Lanyon's idea of landscape, and to consider the significance of his
development of the theme at that specific historical moment. This is
determined to some extent by recent landscape theory, and especially by
the artist's own articulation of his project, which can be seen to anticipate
aspects of that theory.[6] Rather than simply a tract of land framed by the
eye (or the picture frame), the landscape will be seen as historically and
culturally loaded and mediated. In this way, Lanyon's treatment of it lends
itself, more accurately, to the concept of 'place'. More than that, his concern
with the subjective experience of a place means that at the heart of his
work is an attempt to address the fundamental question of one's being-
in-the-world. In this, he can be seen in relation to the interest in
existentialism and phenomenonology current at the time. I would suggest
that the paintings are as much *about* the body and the self as they are
about landscape. We know that Lanyon read such philosophers as Martin
Heidegger, Karl Jaspers and Teilhard de Chardin, but in positioning his
work in relation to existentialist concepts, I am not suggesting that his
paintings should be seen as some sort of illustrations to those theories.[7]
Rather, the proposal is that the way in which he viewed landscape and art,
and the manner in which he brought the two together, locates him within
a particular set of ideas.

 One needs to recognize the historical specificity of the concepts
of 'landscape' and 'place', and their treatment by the artist. What was the
condition of the Cornish landscape in the post-war period? What status,
artistically and socially, did 'landscape' then have in Britain? What may
be concluded from an artist's decision to paint landscapes and to associate
himself with a national tradition at that point in time? It is the proposition
of this book that, in remaking landscape painting, Lanyon was not merely
concerned with an issue within the discipline of painting, but that he was
using his attack upon artistic convention to address a fundamental

question of particular significance at that historical moment. This, I believe, was an act of great humanity.

Peter Lanyon was one of the most technically and conceptually innovative painters working in Britain after the war. Aesthetically, one might say that his paintings of the 1950s are some of the most sophisticated examples of the practice that was then loosely dubbed 'action painting' or 'abstract expressionism'. His attitude, not only to artistic production, but to society, the individual, identity and the environment, reveals him to be firmly situated within the dominant intellectual discourses of the time. His verbal statements reveal his awareness of the need to redefine modernist painting, continuing to use the term 'constructive' to describe both his artistic practice and a broader, humanist ambition for his art. He addressed the major modernist theme – a response to the experience of modernity and the effects of modern life – through the traditional concept of landscape, and acknowledged the changes to modernism's project demanded by the events of the 1940s and 1950s. It was the historical pertinence of his thought that underwrote an originality and an achievement that was, therefore, much more significant than mere technical innovation. That, I propose, is the mark of greatness, if such a quality exists: the combination of originality within his own chosen practice with the expression of a contemporary, human reality in the hope of affecting it for the better.

During the 1980s, when art historians examined their own practices and challenged the boundaries of their discipline, the single artist monograph was brought into question. An account of an artist's production in isolation, as a single autonomous development determined only by personal biography and stated intent, was seen to ignore the contingencies of art as a social practice and to obscure the ways in which art objects carried meaning at particular historical moments. The monograph, a key tool of a connoisseurial practice rooted in the art market, perpetuated the myth of art as nothing more than a series of individual geniuses. While a majority of monographs undoubtedly deserved such criticism, there has been a recent revival of the format. This book is based on the belief that a wide range of issues must be considered in any art-historical analysis, but that the artist's individual practice, of which the stated intention is a crucial element, is one of those issues. In focusing on a single artist, we are not only better able to study the minutiae of ideas and specific factors that determined their output, but also to reassert the importance of the work of art itself – the process of its making and its final physical state. While the status of art as an ideological and social practice is fundamental to our study of it, we must also address those elements that distinguish it from all other such practices. A painting by Lanyon may be part of a wider historical cultural process that also includes material from many different areas of activity, but in seeing it within that wider context we must consider those

elements that distinguish it from other activities. It is not sufficient to analyse them purely in terms of the signified – their content – but also of the signifier – style, technique and so on. The main intention here, then, is to carry out an historical assessment of Lanyon's work with regard to wider issues and historical conditions, incorporating analyses of individual paintings and groups of works.

One of the problems with the standard artist's monograph, as with many retrospective exhibitions, is the insistence on an evolutionary model of the artist's individual development. A preamble about their childhood and family is followed by their education and early work, from that their oeuvre grows inevitably and levels out until their late career. The structure of this book is largely chronological but avoids, I hope, some of the problems with this format. The first chapter presents an overview of Lanyon's work, the development of his painting style and the ways in which he claimed to use landscape as a source, and introduces the main proposals of the book. The subsequent chapters look at groups of works in a loosely chronological arrangement, but also explore particular themes that may be specific to the works or period under examination, or may represent a longer trajectory. The poignant brevity of Lanyon's career (less than two decades of mature work) facilitates such a treatment, as his output can be seen to occupy a fairly homogeneous historical space without a procrustean simplification of its historical development. That said, it is one of my concerns to avoid the mistake of applying to paintings from one period statements by the artist from a quite different date as if history were irrelevant.

What follows, then, is an account and analysis of Peter Lanyon's painting in relation to the artistic and intellectual debates of the period. The book focuses on the works that I believe he considered to be his major statements: the paintings and those constructions and collages that were made as finished works for exhibition, as opposed to those made as tools in the development of a painting. I shall not attempt a study of the artist's many gouaches, drawings and prints as, though interesting and powerful in their own right, these were generally seen as less important. One should note, however, that while the gouaches were produced for exhibition (as more easily saleable objects than the oils), drawings were frequently used as components in the production of paintings.

In this treatment, the artist's writings – both public statements and private discussions – play a key role. This is partly in recognition of their distinctive, if sometimes elliptical, eloquence, and partly a reflection of the artist's own apparent need to add verbal annotations to his works. I would not claim, however, that Lanyon's writings offer definitive explanations of the paintings; an artist's stated intentions (even those that coincide with the production of the object, let alone those formulated in retrospect) are not synonymous with the meaning of the work. Rather, I think of them more as adjuncts to the paintings or constructions and,

as such, parts of a larger 'work' that is the subject of our interpretation. Meaning here is a more fluid concept, excavated by our explorations of the objects and their original historical circumstances. That is to say, Lanyon's statements are indivisible parts of the work, and subject to scrutiny and interpretation along with the rest of it. In performing this act of reading, reference will be made to a variety of writers, with whose ideas the work seems to accord, in order to locate Lanyon's painterly and verbal statements within a broader conceptual framework.

Lanyon saw himself as a simple, down-to-earth figure who preferred a game of dominoes with the locals in the pub to mixing with other artists. As a painter, he insisted on his distinctness from other artists and artistic groups, and claimed an authenticity for his work, as the sincere expression of genuine, individual experience as opposed to the product of intellectual or aesthetic concerns. This extended into his studio practice and was epitomized by his grinding of his own pigments and mixing of his own paints. My purpose is to incorporate this self-fashioning within an analysis of his work as an artist. The notion that everything is open to interpretation should not be seen as excessively sceptical, however, but as a means to presenting Lanyon's work in such a way that it will be seen to be not just a contribution to modern landscape painting but of major significance within the narrative of British culture.

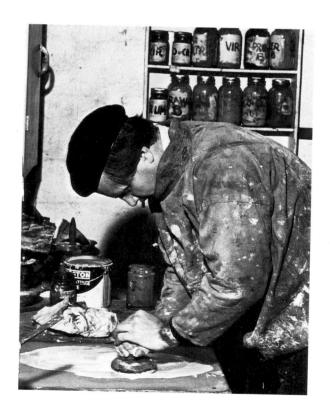

2
Lanyon grinding pigment
in his studio, 1954

An overview of themes

'The paintings ... are not abstract, nor are they landscape. They use abstraction as a method and landscape experience as a source.'

'Uneasy, lovable man', is how the poet W.S. Graham addressed Peter Lanyon in his elegy for the painter, *The Thermal Stair*.[1] The adjective 'uneasy' was carefully judged and, characteristically, the poet used its ambiguity to the full. Lanyon was much loved by many, not least for an enormous and mischievous sense of humour that also informed his work. He was, however, not easy: at times demanding of those close to him, or irascible, he would pick an argument, and in several cases maintained the ensuing enmity for many years. Easily offended, to many he seemed almost paranoid, and his vigorous response could cause great hurt. He was difficult in the sense that his was a complex character, and he was also 'uneasy' in that he was ill-at-ease. Recurrent bouts of depression, which led to related problems such as stomach ulcers and attacks of claustrophobia, became necessary parts of his artistic process. He was, as it were, on edge, and in explaining his art and, in particular, when describing his approach to landscape, he made frequent reference to edges. An unpublished text was entitled 'The Edge of Landscape' and, at a crucial juncture in the development of his work, he wrote: 'I would not be surprised if all my painting now will be done on an edge – where the land meets the sea where flesh touches at the lips'.[2] His obsession with the cliffs of Cornwall's north-west coast demonstrated his attraction to such liminal zones.

Lanyon spoke of the importance of the sense of physical disequilibrium in those precarious places, and in this too we can see an idea of edginess that was central to his artistic process. In describing the initial stages of a painting's development, he often spoke of a sense of 'apprehension' in a place, and used the term to imply both a process of assessment, and understanding, and a feeling of foreboding. It is this quality of unease that provides a clue to the human and psychological significance of Lanyon's art beyond its engagement with landscape. That is to say, in his recovery and fundamental redefinition of the genre he addressed basic issues of human existence, both in the existential sense of defining one's 'being-in-the-world' and in that of searching for a new meaning for life in modern society. He insistently associated his work with landscape and particularly with his native west Cornwall, but saw this rootedness not as a conservative parochialism but as an answer to the problems of what was frequently referred to at that time as 'the condition of man'.

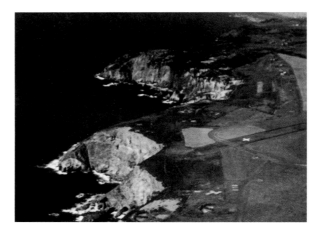

There is a tension in Lanyon's art between his stated interest in landscape and both the technical aspects of the paintings (how they are made) and his conception of the function of art. And yet, the last, the way in which he perceived art and the art object, is inseparable from the way he approached landscape. Subsequent chapters will look at how the artist's use of landscape, his style of painting and his intellectual and artistic concerns changed at different times. Here, I want to establish a conception of landscape and of the work of art that remained constant throughout his career.

From the outset, Lanyon's work was concerned with the external environment to which he always applied the term 'landscape'. As a genre that had its heyday in Britain between the seventeenth and nineteenth centuries, landscape derives from a certain idea of nature, determined by spiritual or ideological conditions, and by a particular way of seeing. Though in common usage 'landscape' refers to a tract of land, it originated from the Dutch as a term for the pictorial representation of natural scenery, and it is impossible to discuss landscape without introducing notions of value that stem from seeing it in a pictorial way.[3] The concept of landscape presupposes the definition of a particular section of the earth by some sort of framing device – the painting or the eye – and implies a single viewer whose gaze determines that framing. In the last twenty years, the traditional idea of landscape has been undermined by the exposure of the 'dark side' of the genre – the economic and ideological subtext that underpinned its rise and continued dominance in British culture for two centuries.[4]

Lanyon can be seen to have made a similar assault on the material 'reality' of the landscape as well as the painters' conventions and devices that obscure it, and upon the notion of a landscape determined by the static viewer. One might argue that, in attempting to do all this, he was really engaging not with landscape but with notions of place, and his awareness of that is indicated by his statement, 'I paint places but always the

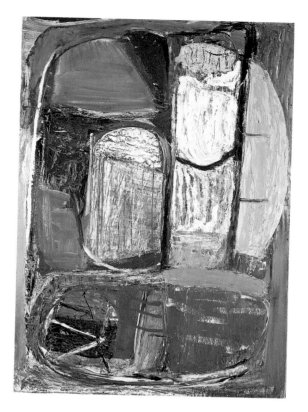

Placeness of them'.[5] The distinction is absolutely fundamental, for, whereas landscape has generally been seen to lay claim to a purely, or largely, visual definition of the external world, the concept of place is loaded with meaning. 'Place' pertains to a specific location, but also to its symbolic, social and historical associations; it is as much to do with culture as it is with nature. Its relevance to the artist or the viewer is far more profound than the optically determined 'landscape'. For, as the philosopher Martin Heidegger wrote, '"place" places man in such a way that it reveals the external bonds of his existence and at the same time the depths of his freedom and reality'.[6] These shifting meanings and ideas will emerge as the basic theoretical structure for Lanyon's work and this examination of it. In his revision of landscape, Lanyon addressed both the issue of place as a socially constructed, historical entity and as a subjective experience central to the definition of the self.

Lanyon constantly returned in his work and in his explanations of it to the region of West Penwith – the tip of Cornwall, defined by a line drawn from St Ives on the north coast to St Michael's Mount on the south. It is a landscape that rises gently from the greenery of the lea of Mount's Bay to inhospitable, high granite moors that run down to the narrow shelf of green that tops the sheer cliffs of the northerly Atlantic coast. He saw this region as 'home', the basis for a construction of himself as

4
Farm Backs, 1952
Oil on board
41 × 28
Private Collection

Cornish as opposed to English or British. In his treatment of this area
of land, Lanyon addressed the issues of its geological and natural history
and, most particularly, the history of its human population. An apparently
untamed, 'primitive' place, West Penwith is also a post-industrial
landscape, scarred – physically and socially – by tin mining and its decline.
In reinserting that history and the declining fishing industry into the
landscape, Lanyon sought to paint the place as a cultural entity from the
perspective of one tied to it through a common history. Thus, he established
the convergent themes of the social and the individual in the definition
of his own cultural identity through that of his home country.

The painting of place was not, in itself, radical. The concept of a
genius loci – a spirit of place – was already one of the dominant interpretive
frameworks for landscape painting, and latterly it has been particularly
associated with the neo-romantic treatment of British topography from
the late 1930s to the early 1950s[7]. Thus, John Constable's paintings of
Suffolk and Essex and Graham Sutherland's depictions of south-west Wales
are felt to possess a quality peculiar to the feeling of those places. Lanyon
was pleased to compare his attachment to west Cornwall with Constable's
immersion in the countryside around Dedham, but saw his own employment
of modernist devices as a means of extending the concept of place:

> Linear perspective with its static concepts of mass gives
> way to plane surface design and space construction.
> The painting of views from a fixed point is succeeded by
> a construction out of experience in the presence of place.
> The genius loci succeeds the genius homini.[8]

By which he showed how he saw the painting of place as part of artists'
search for 'objectivity after subjective orgies in the near past ... a shift of
genius from the idolatry of a single man to that of place' – and, implicitly,
a common humanity.[9] He frequently drew such a contrast between his own
work and other St Ives artists' commitment to abstraction. He summarized
his position in 1961:

> (my paintings) are not abstract, nor are they landscape.
> They use abstraction as a method and landscape experience
> as a source ... (they) reject the conventions of landscape but
> remain recognisable in the county. They are concerned with
> environment rather than view, and with air rather than sky ...
> The country is used to make something, just as clay is used
> to make a pot.[10]

In Lanyon's theorizing of his own work, the concept of constructive
art that he had adopted from Naum Gabo was intimately linked to the
treatment of landscape through the unifying element of space. It was
'a painter's business ... to understand space – the ambient thing around
us', he asserted,

what I'm concerned with is moving round in this space and
trying to describe it ... The problem of landscape painting
is to try to understand this vast thing in which we live and
which is so much bigger than ourselves. You might say I'm
trying to paint my environment both inside and out.[11]

For him, the distinguishing characteristic of Gabo's constructions in
transparent plastics was their creation of an inclusive space in contrast
to the production of an object within space: they were 'fully spatial and
sensuous sculpture(s) which can embrace humanity'.[12] In its method of
application and evocation of space through colour and form, painting for
him combined aspects of both carving and spatial construction to become
an art of involvement. As Lanyon defined constructive art as one derived
from actual experience and from the artist's physical and emotional
engagement with the subject, so it served to locate the viewer, to
'establish the "whereness" for people to inhabit'.[13]

His work can be seen as an attempt to develop a post-Cubist
landscape painting in that he rejected the hitherto paradigmatic single
viewpoint in favour of a multi-directional, experiential depiction of a
place. From the late 1940s, drawing on modern ideas of time and space,
he produced paintings that were composed of shifting views of the same
location. Again, this was not merely a formal issue, as the experiential
landscape reinserted the artist's body within the place he sought to
represent. Rejecting the usual distanced, separated view, he formulated
a new visual vocabulary to signify his emotional and physical engagement
with a place. In contrast to the depiction of landscape as if it were a still life,
then typified by Ben Nicholson's paintings of mugs and jugs set against a
view through a window (5), Lanyon described his painting as an attempt
'to throw open the window – to get out of doors'.[14]

5
Ben Nicholson
1943 (Towednack, Cornwall), 1943
Oil and pencil on board
15¼ × 19
Formerly in the collection of Peter Lanyon
Whereabouts unknown
© Angela Verran-Taunt

In his claim to paint the experience of place there is an ambiguity between that place's historical experience and the artist's subjective, phenomenological experience of it. The two can be seen to be in tension within individual paintings, just as their relative balance in his work can be seen to shift at different periods. For Lanyon, space was more than simply one of the formal elements of art; it was crucial to his understanding of existence. He spoke of human beings existing in space as in a continuum with it, each being a part of the other. So, he saw the production of an art in which actual space is defined as, also, the definition of our literal and metaphorical position in the world. It was in this way that he retained for his work the term 'constructive' with its artistic and ideological implications.

That Peter Lanyon's art is concerned with much more than landscape or place is borne out by the fact that many works were not 'about' particular locations: here is a major theme of this book. While much of the work he made just before and during the war was totally non-representational and frequently sculptural, the paintings produced immediately after his return to Britain are related to non-specific organic forms and processes. As we shall see, it was around 1948 that west Cornwall became a preferred theme and continued to be so until the late 1950s, though even during that time he also painted locations beyond the Duchy, in such places as Somerset, Dorset, Derbyshire and, most notably, Italy. From 1957 he became increasingly interested in natural phenomena, particularly the weather, and this was further enhanced when he took up gliding in 1959. Though he frequently related individual works to experiences in specific sites, this revealed an engagement with certain types of place rather than with one particular location or another. So, in 1963, he introduced an overview of his past output with this assertion of his fascination with the edges of landscape:

> I like to paint places where solids and fluids come together,
> such as the meeting of sea and cliff, of wind and rock, of
> human body and water.[15]

Such places as coast and sea remain as culturally and psychologically loaded as any particular location.

The sea has recurred as a symbol in literature and painting that address questions of identity, as in Virginia Woolf's *The Waves* (1931) and the poem *The Nightfishing* (1951) by Lanyon's friend W.S. Graham. Woolf drew upon childhood memories of St Ives and the view across the bay to Godrevy Lighthouse for her novel *To the Lighthouse* (1927), and echoes of the book and its use of a voyage and painting as metaphors of a personal quest are found in several paintings by Lanyon based on Godrevy, including *Trip round the Lighthouse* (1946).[16] More recently, Rosalind Krauss has described the sea as

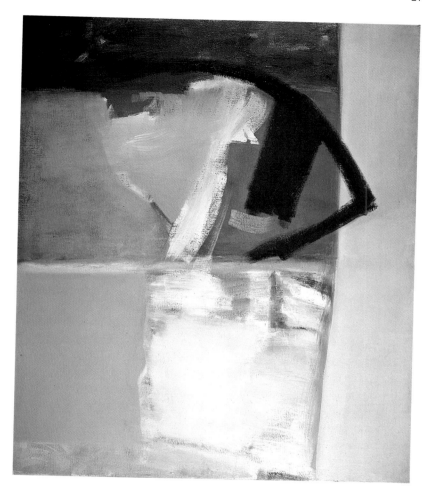

a special kind of medium for modernism, because of
its perfect isolation, its detachment from the social, its
sense of self-enclosure, and, above all, its opening onto
a visual plenitude that is somehow heightened and pure,
both a limitless expanse and a sameness, flattening
into nothing.[17]

Such metaphorical levels can be found in Lanyon's works, in which the
artist used natural sites and events as symbols of the human condition
and as potential engines for subjective restitution. As Krauss's statement
suggests, one might see the refocusing on such general locations as the sea
as a move away from a concern with the ideologies and histories addressed
by paintings based on specific places, and towards a renewed individualism.
Those themes, then, echo the artist's interest in myth, which has been
seen as 'depoliticized speech' in its naturalizing of history.[18]

6
High Tide, 1959
Oil on canvas
72 × 60
Private Collection
Courtesy Bernard Jacobson Gallery, London

Lanyon saw the encounter of land and sea as gendered, the male sea penetrating the nurturing female earth. He also saw such sites in terms of danger and instability, and, while the combination of sex and danger is telling, it is the sense of threat that is especially revealing of his approach to landscape and his use of it for broader ends. Descriptions of the artist's attempts to unsettle his perception of a place are numerous: he would look at it from different positions – standing up, lying down, upside-down through his legs; he would run up a hill in order to 'catch the landscape unawares', and he would lie at the cliff's edge looking down to the sea and rocks below. This was not simply a question of establishing a multi-directional image of the place, but also an attempt to achieve a sense of physical, and perhaps psychological, imbalance. He said he sought out vertigo – a condition from which he suffered – as it was in such states of disequilibrium, when one is responsible for one's own fate in the face of a mortal threat, that identity can be established.[19] His fascination with, and painting 'of', those places where solids and fluids meet was not simply an extension of the established aesthetic of the picturesque, but a development of the Sublime, wherein the decentring of the subject by the immensity of nature necessitates a recovery of the self.

Even with the earlier paintings of specifically Cornish sites, such grand issues were in the artist's mind. Lanyon's reformulation of landscape must be seen in relation to the historical moment at which it occurred and to a post-war consciousness. The war years saw in Britain a resurgence of landscape in the work of Sutherland and John Piper and of such younger artists as John Minton and John Craxton that drew upon a native tradition epitomized by the romanticism of Samuel Palmer. In the late 1940s, in the wake of the genocide of the war, and in the face of a nuclear future, landscape and nature became refuges for modernist-minded artists seeking a replacement for the disappointed idealism of the 1930s. For Lanyon, some form of meaning could be found in a return to the wild places and, specifically, to West Penwith. In 1951, he wrote to a German critic, 'I believe it is in the bare places like West Cornwall ... that many artists will find an answer for their times'.[20] It was the apparently untamed, uncultured expansiveness of such places – and especially of the coast – that offered an opportunity for people to face up to the truth of their existence and so to initiate a necessary act of self-reparation:

> In the real sense of landscape ... the effort to understand and
> to live with and to adjust to vastness calls out an equal depth
> in our own psyche creating anxiety intense enough
> to trigger off a rescue operation.[21]

It was through this position that Lanyon argued for landscape painting's contemporary relevance in opposition to a common perception of its provincialism. Towards the end of his career, he argued passionately for its centrality to the existential concerns that dominated post-war culture:

> I believe that landscape, the outside world of things and
> events larger than ourselves, is the proper place to find our
> deepest meanings ... landscape painting is not a provincial
> activity as it is thought to be by many in the U.S., but a true
> ambition like the mountaineer who cannot see a mountain
> without wishing to climb it or a glider pilot who cannot see
> the clouds without feeling the lift inside them. These things
> take us into the places where our trial is with forces greater
> than ourselves, where skill and training and courage
> combine to make us transcend our ordinary lives.[22]

Through ideas of place, resonant with cultural significance,
and through this notion of danger and transcendence, Lanyon conceived
of landscape as the key to self-definition in defiance of the anxieties of
modernity. While, in the late 1940s and 1950s, this idea represented a
radical recasting of modernist painting, by the 1960s the continued
insistence on ideas of transhistorical permanence could be seen as
conservative next to younger artists' engagement with the commodities
and technologies of modern life.

The idea of placing oneself in a position of risk in order to execute
a process of self-recovery and so establish a sense of one's own identity was
clearly related to the contemporary fascination with existential thought,
but it was also associated with Lanyon's earlier contact with the writer
Adrian Stokes. Stokes articulated an aesthetic theory that derived from
the psychoanalyst Melanie Klein's theory of art as an act of psychological
reparation. In Lanyon's work one can see a dual process of self-definition:
firstly, through the endangering and recovering of the self in the landscape,
and secondly, through the notion that the making of art was the creation
of a 'plastic otherness' by which one defined one's own identity through
difference. That art should serve to define a sense of self was implicit in
the realist conception of its function, which Lanyon maintained in defiance
of others' reception of his work as abstract. 'It is the purpose of Art', he
wrote, 'to create from the substance of life an image of life in the form
of an object'.[23] That object provided the 'other' against which one could
establish one's own identity, and served as a reassuring representation
of a permanent reality:

> painting is the creation of a plastic reality a substance which
> stands over against ourselves and outside the concerns of
> the immediate wishes of the heart. It is not there to console
> us or to teach but to present an image which goes on
> through time unattainable inscrutable but underlying all our
> immediate desires as an assurance of reality.[24]

His aim was, he said, 'to make a face an "actuality" or "thingness" for
experience',[25] and he felt that a painting was completed when it 'answered

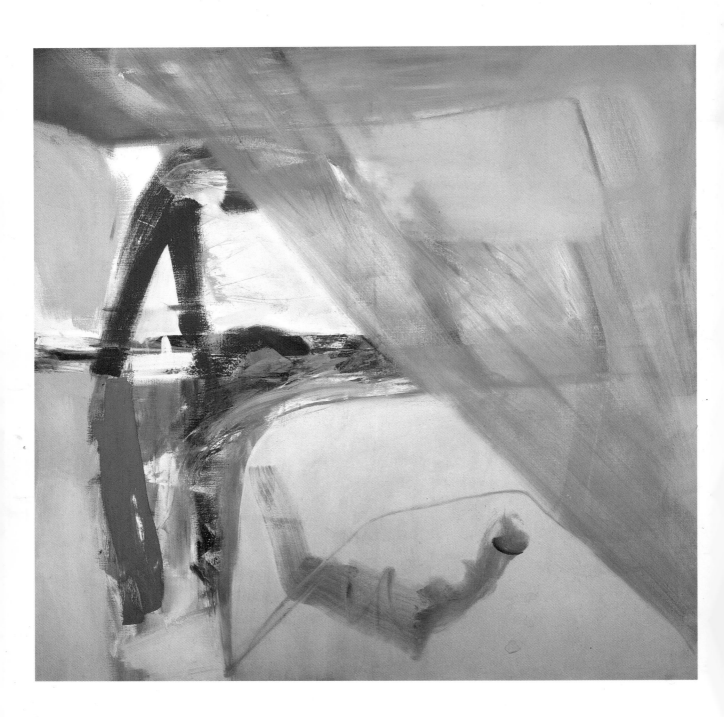

7
Soaring Flight, 1960
Oil on canvas
60 × 60
Arts Council Collection, London

back'. Thus, the importance he placed on the wholeness of his image, an overall visual coherence overriding the painting's individual parts, was as much a symbol of his conception of the work of art as an act of subjective reintegration as it was a reflection of the organicist aesthetic, which valued the 'all-over' appearance of the work, that came to prominence in the 1950s.

In a similar way, he aimed for an art in which the spectator was an active participant. In painting, he sought to recreate his experience of a place or an event so that viewers could re-experience it themselves. In entering into a dialogue with the painting, the viewer takes the place of the protagonist – the depicted figure – in traditional landscape paintings: 'The actual action which the picture sets up in the spectator should be to help the spectator to become, as it were, the figure in the landscape'.[26] So he saw the viewer of the painting as 'the subject' because the work 'doesn't come to life until somebody looks at it. And this person who is looking at it, participates in it, just as we participate in jazz'.[27]

Mikhail Bakhtin wrote that 'the body is not something self-sufficient: it needs *the other*, needs his recognition and form-giving activity'.[28] For Lanyon, the painted canvas or board became, like the space around one's own body, an 'other' in opposition to which one's own identity is established. For this reason, he frequently drew a comparison between artistic production and sexual intercourse, because both depended on an engagement with a 'plastic otherness' that might indeed be fruitful. He also felt that both involved some sort of nakedness, the artist's re-creation of his original disequilibrium being an act of self-exposure. He saw this state reflected in the final forms of the paintings, in which he endeavoured to avoid symmetry or overly harmonious compositions in favour of 'an awkwardness and incompleteness such as I find in all human events. An openness representing nakedness is what I aim for because in this way I think of revelation'.[29] The dramatic, heroic rhetoric reflected Lanyon's belief in the artist's responsibility, which was nothing less than the articulation of existence and its meaning: 'There is no worthier suffering', he wrote, 'than to do so for others and when we think of Art as no longer self expression or protest but a communication of life to the living … our suffering more intense, will be more bearable.'[30]

Beginnings

'We are either the fathers of a new hopeful
but austere and courageous world or we are
the lost generation.'

Lanyon was, essentially, a post-war artist: his work flowered with his
redefinition of landscape in the late 1940s and 1950s, and it spoke to
the needs of the post-war world. He was, however, inevitably and by his
own admittance the inheritor of a recent tradition. To understand his
mature work one needs to recognize the degree to which it grew out
of the modernist art of the late 1930s. Like those of many artists of his
generation, Lanyon's artistic attitudes were first defined in the years
immediately preceding the war, and the degree of his success may be
judged by his ability to appreciate the changes wrought by the events of
the first half of the 1940s, and the accommodation within his work of the
new ideological map that emerged as a result. Specifically, it is possible to
link Lanyon's development to his encounter with a few individuals. His
conception of art and the art object was fundamentally influenced by his
friendship from 1937 with Adrian Stokes, while the priority he gave to
pictorial space as well as to the role of the artist in society was deeply
affected by his association, through Stokes, with Naum Gabo, Ben
Nicholson and Barbara Hepworth.

 Lanyon grew up within the artists' colony of St Ives. Born
on 8 February 1918, he was the son of Herbert Lanyon, who, as a semi-
professional musician, composer and photographer, was a member of the
St Ives Arts Club. His mother came from a prominent local family, the
Vivians, whose wealth had derived from Cornish tin mining. Like its close
neighbour Newlyn, St Ives had become a centre for artistic production
following the arrival of the railway in the 1870s. The two towns'
reputations as 'artists' colonies' grew in parallel, though in general the
works that emanated from St Ives tended towards the picturesque and
broad Whistlerian seascapes in contrast to the representation of fisherfolk
by Newlyn's Stanhope Forbes, or Walter Langley's sentimental depictions
of female anxiety and bereavement. As with other such colonies, the
development of St Ives and Newlyn as artistic centres relied upon good
communications with the metropolis, where such low-life, rural subjects
took on new meanings. Brunel's Great Western Railway facilitated other
migrations and, in parallel with its development as an artistic site, St Ives
also became a holiday destination.

 By the 1920s and 1930s, the art made in Cornwall would generally
be called late Impressionist (then the dominant style of the Royal Academy)

and is best illustrated by the work of such painters as John Park from St Ives and S.J. 'Lamorna' Birch, who took his name from the wooded, seaside valley where he settled. There was some involvement with more modern-minded artistic work, however, including the establishment in Newlyn of the Cryséde silk works by Alec Walker, a designer linked with a variety of modernist artists in London and Paris. When Walker was joined by the Fabian socialist Tom Heron and the factory moved to St Ives, a schoolboy friendship formed between Peter Lanyon and Heron's son Patrick. After the war, Patrick Heron, as a prominent critic as well as a painter, would become an influential advocate of Lanyon's work.

Lanyon, then, grew up in an artistic milieu and, following a private education at Clifton College near Bristol, decided on a career as a commercial artist and enrolled at Penzance School of Art in 1936. The curriculum there followed a standard programme centred on drawing from casts of antique sculpture, which Lanyon supplemented with informal study under the painter Borlase Smart, a stalwart of the St Ives Society of Artists. Smart's work was characterized by his preference for the wild coastland west of St Ives and his vigorous painting of cliffs, rocks and waves. His influence is apparent in Lanyon's own paintings of that area, in particular his clifftop view of *Battleship Rock, Bosigran* (1936) (8), a site that came to possess an iconic significance for the painter. In 1962, looking back on that training through the lens of his subsequent work, Lanyon recalled that it was Smart's

> character which was so important ... he was very tough, very direct ... he loved the open coast and the cliffs and he'd get me out there and make me draw the rocks as they looked, not just like rocks but he would say ... remember there are thousands of tons of weight here and the sea has been battering this for years and years ... this ... connected up with my own feelings for the country and I wasn't particularly strong, physically strong at all and it used to interest me that here was a tough way of approaching painting.[1]

In a later chronology of that period, a note, 'Posters with Smart', indicates that Lanyon's association with the older artist, who had designed posters for the Great Western Railway, also related to his planned career in commercial art.[2] In addition, he noted the influence of another St Ives painter, Fred Milner, who was more concerned with light effects than Smart. Echoes of Milner's sparer style and thinner paint surfaces can be discerned in pictures Lanyon made of the village of *Zennor* in 1936 (9), and in several works produced during a trip to Belgium and Holland in the spring of 1937. Following the death of his father in September 1936, Lanyon had been taken to Bruges by his mother to meet Louis Reckelbus, an artist who had borrowed Herbert Lanyon's studio during World War I.

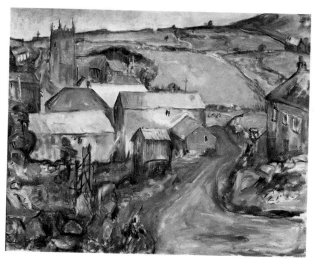

However, it was another encounter, later in 1937, that would mark a turning point in Lanyon's development.

Adrian Stokes recalled seeing Lanyon painting beside the road that runs westward from St Ives to St Just in the summer of that year, and he was so impressed by the younger man's work that he immediately bought the painting made on that day.[3] Stokes would undoubtedly have recognized the echo in this anecdote of Giorgio Vasari's account of Cimabue's discovery of the prodigious Giotto, but, though Stokes had recently begun painting himself and was in Cornwall for that purpose, it was his writing and aesthetic theories that would affect Lanyon's outlook. The significance of their encounter is reflected in a note that seems to mark the point at which Lanyon committed himself to a career as a painter: 'Meet Adrian & read Colour and Form. Decision to give up Posters'.[4]

Previously associated with the Sitwells and Ezra Pound, Stokes was by then closely linked to the modernist circle of Ben Nicholson, Barbara Hepworth and Henry Moore. His reputation rested on *The Quattro Cento* (1932) and *Stones of Rimini* (1934) in which he formulated a theory of sculpture that distinguished between masculine carving and feminine modelling; with *Colour and Form* (1937) he addressed this theory to painting. The starting point for the book is Roger Fry's concept of Significant Form, a milestone in the formalist history of modernism, which proposes that it is the forms in a painting that determine its reception and its quality. Stokes argued that form was meaningless without colour, that a cohesive image was dependent on 'an identity in difference of which colour is both the means and the symbol'.

Stokes's idiosyncratic aesthetic was fundamentally determined by his fascination with psychoanalysis and his personal experience of analysis under the Freudian Melanie Klein. Klein's belief in art as a

← 8
Battleship Rock, Bosigran, 1936
Oil on canvas
25 × 30
Private Collection

9 →
Zennor, 1936
Oil on canvas
25 × 30
Private Collection

reparative process associated with the individual's need to establish a distinction between themselves and the rest of the world underpins Stokes's theory. Thus, he wrote, for example, 'colour … emphasizes for us the outward and simultaneous otherness of space', and argued that 'the true colourist … is recreating by his use of colour the "other", "out-there" vitality he attributes to the surface of the canvas'.[5] Several of Stokes' comments on landscape take on a particular resonance when read in the light of Lanyon's later painting, but it seems to be the Kleinian conception of the work of art that most affected Lanyon. In his copy of *Colour and Form*, he underlined a sentence that suggests how he came to see inner states indexed in the landscape that he chose to paint:

> Art is the mirror of life, just because the creative process mirrors and concentrates the character common to all the processes of living, namely, the identification of inner states with specific objects, animate or inanimate, in the outside world, the conversion entailed when fantasy life is attached by the conscious mind to the world of reality.[6]

Despite the long-term influence of Stokes on Lanyon's conception of the art object, the immediate effect of their meeting on his work was small. It is more likely that the writer was attracted to Lanyon because his paintings, with their muted palette and even tonal values, already displayed the qualities Stokes advocated. Lanyon gave little indication of his knowledge of modern art at this time, but from his work we can see that he was familiar with the paintings of Cézanne. In addition, the broad, expressive brushwork with which he sought to evoke the massiveness of hills and cliffs bears a superficial similarity to the paintings of Spain that David Bomberg exhibited in London during the 1930s (from an early date, Lanyon's drawing style was comparable with Bomberg's in its use of bold, charcoal gestures). Lanyon must have been aware of contemporary art in London: in later years he recalled reading the modernist periodical *Axis* (1935–7) and *Circle: A Survey of Constructive Art* (1937), and one or two abstract works from 1937 probably indicate his response to *Colour and Form*.[7]

Though the resulting paintings indicate the same interests as before, a trip to southern Africa in 1938 may have encouraged a brighter palette and looser forms. Accompanying his mother and sister Mary, Lanyon sailed to Cape Town in March and remained until late June. They stayed with an uncle in Johannesburg, from where they travelled north to Southern Rhodesia, visiting such places as the Victoria Falls and the ruins of Great Zimbabwe, and south through the Orange Free State to Mont-aux-Sources high in the Drakensberg mountains.[8] Lanyon painted all the time and was driven in the country around Johannesburg. He would later recall how the place and the landscape affected him:

> South Africa had an immense influence on me. I suddenly
> met a country which was uncultured, a country which was
> wide open and had no sensibility.

He felt that the experience stimulated his 'interest in ... frontier civilization, something which is not established and small and tidy ... the open places'.[9]

Lanyon's first exhibition was staged in Johannesburg in the President Street studio of Zaida Bullock. He had clearly taken work with him as a review records that the display consisted of drawings of fishermen and oil studies of St Ives, Belgium and Holland. The writer noted 'a sure eye for colour with a marked preference for subdued tones' and reported that Lanyon was 'anxious to do some figure work, especially of natives'; the artist later recalled his deep unease when a black servant was summoned to sit for him.[10] Sketchbooks from the trip include some drawings of black South Africans and of violent situations, but it is unclear if some overtly political studies in the same volume with such titles as 'Poverty' and the ironic 'The Approach to Peace' are African, British or more general in origin.[11]

Lanyon was always prone to depression, a condition that was frequently linked to his painting process and its final result, and his notes of this time record a 'slack period' following his return from Africa, and 'illness' and 'Dark Period' in the first few months of 1939. He later explained that he had 'a sort of nervous breakdown', having become 'extremely disillusioned with painting what was in front of me ... going down to the coast and painting say a bit of Hannibal's Carn or Zennor Carn ... I found it very boring because I had sort of tricks in way of doing it.'[12] This crisis and the artist's political conviction were reflected in the fact that he considered joining the International Brigade fighting for the Republican government in Spain.[13]

If Lanyon was now uncertain of the direction his art should take, it is indicative of his attitude that, on Stokes's advice, he enrolled at the Euston Road School in London in May 1939. Established by William Coldstream, Graham Bell, Victor Pasmore and others, the Euston Road was committed to an 'objective' painting and a rather vaguely conceived 'realism', which, for some at least, related to a socialist politics. Lanyon shared their admiration for Cézanne: like many associated with the school, he had made a pilgrimage to Aix-en-Provence in April, where he painted Mont St Victoire more than once, and in June noted that he had seen an exhibition of the painter's work in London. He remained for no more than two months at the Euston Road, where his principal teachers were Coldstream and Pasmore, but believed the experience had been 'exceedingly good training'.[14] Coldstream's obsessive technique of fixing a pictorial composition by the careful mapping of key points with small 'ticks' on the canvas was by then well established; it was offset by what

Lanyon described as the 'wonderful succulent' quality of Pasmore's rapidly produced paintings. Though a little later he dismissed the Euston Road as 'stagnated in a worship of dead masters', in time he came to believe that his subsequent work was affected by both 'the careful structure concern of Coldstream and Pasmore's extreme enthusiasm and beautiful use of paint'.[15] Perhaps the most important thing about Lanyon's time at the school is that he chose to go there at all. If he knew of the London avant-garde, and of the debates between the Constructivists and the Surrealists, and the question of whether a radical art should take new forms or use traditional methods for politically radical ends, it is telling that he aligned himself with a form of realism.

The brevity of Lanyon's time at the Euston Road suggests a persistent uncertainty, and he recalled that he returned to Cornwall to explore formal experiments. By that time, Stokes and his young wife Margaret Mellis, fearing impending war and the destruction of London by bombing, had moved to a large house in Carbis Bay, to the east of St Ives (Lanyon would later purchase the same house, Little Park Owles). In late August 1939, Ben Nicholson and Barbara Hepworth came to stay, followed a few weeks later by Naum and Miriam Gabo. Lanyon later noted the 'start of disintegration in (his) painting' during July and August, and in September, at Stokes's suggestion, he took lessons with Nicholson. A series of works, marking a radical departure, demonstrate the exploration of spatial issues that dominated their sessions.

By 1939, Nicholson was well established among the leading figures of British modernism, a status confirmed by his co-editing of *Circle* – a self-styled 'international survey of constructive art' – in 1937. Until that moment, his works had been characterized by an emphasis on the texture of their surfaces: he had made figurative and then abstract paintings over rough gesso grounds from which had developed painted reliefs culminating in the white reliefs produced from 1934. If these showed a purification of hue, many of the paintings made after 1937 consisted of interlocking areas of unmodulated pure colour with a new smooth surface quality. As an inheritor of the legacy of Cubism, one of Nicholson's primary concerns was the creation of shallow pictorial space and the interleaving of separate planes. The consistency of this aspect of his work was demonstrated by his 1941 discussion of his painting *Au Chat Botté* of nine years earlier, the source of which he identified as a shop window in which three planes – the painter's reflection in the window, the name of the shop painted on the glass, and the objects inside – were incorporated into a single image.[16]

It would appear that Nicholson directed Lanyon in the exploration of such formal aspects of abstract composition, an investigation for which the younger artist was prepared. In 1943, reflecting on the development of his work, he identified a turning point while at the Euston Road. Faced with the crisis in the painter's subject matter, he described drawing people, pets and water on the Thames at Cookham and 'scattering

interpretations of movement all over the paper and by doing so breaking up the paper into spaces and rhythmical relations. The plane of the paper became my interest and my subject'.[17] He later recalled that, faced with an impasse, he had drawn a ruled pencil line down the middle of a white board to find himself confronted with two areas and was, consequently, hugely excited on seeing a white relief on his first visit to Nicholson.[18] Lanyon recalled that, for their classes together, Nicholson might set up a still-life arrangement with the instruction to make the objects 'not like they are but something else, draw lines around them and draw lines out from them and so on'; or he might suggest putting 'a piece of wood on top of this board, another piece of wood at the bottom … and so I'd find I had a space in front … he made me understand that there were actual plastic values which I'd lost due to my cleverness at looking at the landscape'.[19] Thus, rather than a particular style or practice, Nicholson insisted on certain formal issues as fundamental concerns. Towards the end of their time together, he reported on his pupil's progress:

> (Lanyon) has immediately a simple and profound understanding of the new ideas & has already made some interesting discoveries of his own … He is a very good example of the <u>liberation</u> that our ideas produce … Gabo & Barbara & I, too, think he's about the most promising of the young artists in England. [20]

Lanyon explored the issues raised in these sessions in a series of objects, mostly destroyed, made in late 1939 and early 1940. The two survivors of this group, *Box Construction No 1* (1939–40) and *White Track* (1939), were later presented as a complementary pair, the former being 'about space' and the latter 'about movement in painting'.[21] In fact, the artist listed a number of such works made in this important period of experimentation and, shortly afterwards, made several attempts to rationalize their evolution. In a list of 'Work done from September 1939 to March 8th 1940', he itemized first 'Mauve object collage. Collage no. 1. other

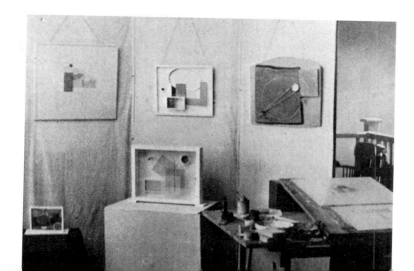

10
Lanyon's studio,
late 1939 or early 1940

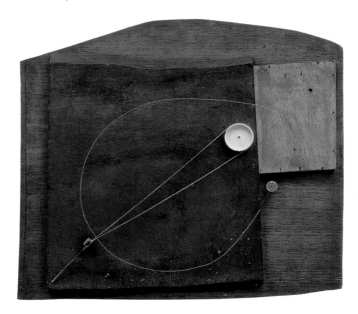

collage / Painting of Porthleven & Still Life';[22] though it is not possible to identify these works with certainty, two of them may be visible in a photograph of the artist's studio (10). After these he made 'Object no.1, i.e. Pink Object', which was the piece suggested by Nicholson.[23] The main form of this was made from two pieces of wood attached to the top and bottom edges of a board to create an imaginary plane across the top and parallel to the main support. An unidentified photograph may show that three strings and several more solid forms defined this extra level (11).

This was followed by 'object no. 2', later retitled *White Track* (12), which suggests a knowledge of Giacometti's *Circuit* (1931), a sculpture incorporating a ball that actually moves along a groove in its wooden base. Lanyon wrote that with *White Track* he had tried 'to find out how to reproduce the weight of things … to reduce the heaviness of the wood in the centre by the use of dynamic elements'.[24] Like a stone in a sling, the white disc seems to pull a cord out from the fixed point of the pedestal that raises it above the board, while a drawn white line apparently traces the elliptical course of the small red element. Despite the emphasis on movement and balance, the contrast of two pieces of wood, one attached to the other, with a continuous line demonstrates the increasing sophistication of the artist's understanding of the tension between pictorial surface and shallow depth. As he wrote shortly afterwards, it was with *White Track* that 'space became my conscious sphere of operation'.[25]

In Lanyon's list *White Track* is followed by more collages and drawings and a 'Small object ie Wood on white ground with string. "Box falling downstairs"', which photographs show to have been very similar to the 'Pink Object'.[26] Soon after completing *White Track* he stood primary-coloured boards on a white base, at various distances and positions, as in

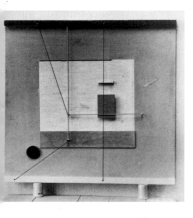

← **11**
? Object No 1, 1939
Mixed media
Dimensions not known
Destroyed
Photo: Tate Gallery Archive, London

12 →
White Track, 1939
Mahogany, jarrah,
other woods & string
18 × 19
Tate Gallery, London

a stage set. He pursued this failed attempt to unite a horizontal element with the '"backwards forwards" space' of *White Track*, and eventually resolved the 'horizontal-perpendicular problem' in *Box Construction No 1* (**13**).[27] This work consists of a white-painted box closed by two sheets of glass sandwiching gelatine filters of different colours, behind which, attached to the backboard, are a red square projected forward of the back plane, a brown rectangle and a cylinder with a blue internal base. Thus, in a very literal rehearsal of Nicholson's description of his *Au Chat Botté*, Lanyon used actual space, colour and different materials to explore illusory and real shallow spatial divisions.

He continued to investigate new materials and practices – including 'experiment in lights. Transparencies' – and *Box Construction No 2*, (c1940) (**14**) seems to have incorporated more complex forms standing on two unusual bases. This body of work seems to have reached an end with *Triangle Construction* (1940) (**15**) shortly before his enlistment in the RAF. Subsequently destroyed, this consisted of two frames standing upright on a rectangular board at an acute angle to each other. Between them, two rectangles, a triangle and a disc or cylinder (presumably all of card) were suspended on strings running from the various corners of the frames. The ensemble stood on a turntable, which was itself set upon a bevelled square base. If *Box Construction No 1* had solved the 'horizontal-perpendicular'

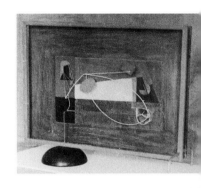

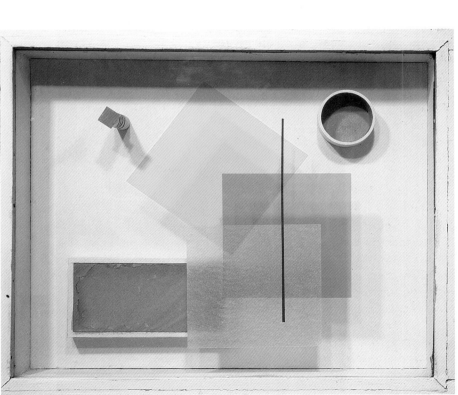

← **13**
Box Construction No 1, 1939–40
Wood, glass, gelatine filters
15 × 18 ½ × 3
The Pier Gallery, Stromness, Orkney

14 →
Box Construction No 2, c1940
Mixed media
Dimensions not known
Destroyed
Photo: Tate Gallery Archive, London

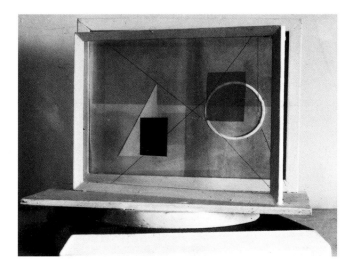

issue, this work represented for Lanyon the solution of the 'circle-square + horizontal-perpendicular' problem.[28] Writing at the time of its completion, he was more expressive: 'I have brought my beloved relation of movement to static to some conclusion. Where next?'[29]

The theme that Lanyon had explored in *Triangle Construction* had been suggested by his observation of nature. This was the first work that he associated with the unsettling phenomenon of standing on a clifftop and watching birds swirling in the air beneath his feet. The way that the birds' flight articulated space was subsequently used by several artists associated with St Ives and remained a point of reference for Lanyon in later years. He wrote:

> (For) many years, every week I have been to Bosigran, to look at the rock. I worship it. I absorb it a bit more every time. One day I watched the seagulls, how they fly around the rock and play in currents at the back of it. They fly around it, caressing its shape as the sea caresses its base, and glide up and down behind it, always moulding the space between the rock and the shore.[30]

He related this sight to *Triangle Construction* specifically, describing the 'theme' between its two frames as 'like the seagulls at Bosigran, explaining the space behind by their movement behind the rock giving the rock a back and making it sculptural'.[31]

The development of a sculptural view on these spatial issues and the use of such natural imagery reflects the influence that Gabo had on Lanyon. If Nicholson had helped the young artist's understanding of shallow pictorial space, the Russian opened up the possibility of an art that would define actual space. In later years, Lanyon recalled that Gabo would telephone him if he had a new work to show, but it is hard to say which

15
Triangle Construction, 1940
Mixed media
Dimensions not known
Destroyed

works he actually saw. Though Gabo's diary records that he made little or no new work in the few months preceding Lanyon's departure from St Ives in March 1940, the two artists could have met during Lanyon's occasional periods of leave prior to February 1942, when he sailed for the Mediterranean. In any case, it would appear that Gabo had taken earlier works with him to Cornwall. The key constructions he made in Carbis Bay in the early years of the war were *Construction in Space with Crystalline Centre, Linear Construction in Space No 1* and *Spiral Theme* (**22**). These have been seen as the works that most clearly signalled a growing emphasis in his work on pure aesthetics as opposed to the claimed functionalism that had underpinned his earlier constructions.[32]

The use of unorthodox materials, specifically plastics, in the box constructions must be the first sign of Lanyon's engagement with Gabo's work, and it was that aspect that he was to develop during the first years of the war, when he made a small number of industrial-looking constructions. Later, he had a photograph of *Spiral Theme* with him in North Africa and a number of drawings can be associated with that sculpture's spatial extrapolation of the circle. However, it may be more useful to consider how Gabo might have legitimized Lanyon's fascination with the coast at Bosigran and the degree to which he adopted the constructivist conception of art.

Constructivism had first appeared in Moscow during the first World War and became associated with the early years of the Russian Revolution. Under Stalin's rule, and following internal disagreements, the group divided and Gabo, with his brother Antoine Pevsner, left the Soviet Union for Berlin and, later, Paris. Thenceforth, there was a contest between an exclusive Constructivism, which adhered to the original Russian principles, and an inclusive constructivism. The latter, as used by Gabo and others, implied particular forms and methods in art, a collective approach, and a social function for the artist and their products. The term has also been more loosely applied to a particular type of sculptural practice (based on construction) and to a range of abstract styles. During World War II, constructivism once again became the subject of a bitter debate between Gabo, Nicholson and Hepworth: while Gabo insisted on his prior claim to what he maintained to be an internationalist, socially-minded modern movement, Nicholson identified a 'constructive tradition' running from Giotto through Masaccio, Raphael and Poussin to Cézanne and abstraction. Though Hepworth understood the word in broader, social terms, Gabo feared that the couple were trying to establish a specifically British school. In fact, Gabo's own use of the term was gradually changing as constructive art became increasingly aimed at individual, spiritual renewal rather than collective change.

In 1937, he had defined the 'Constructive Idea', in contrast to the fragmentation of Cubism, as 'a general concept of the world, or better, a spiritual state of a generation, an ideology caused by life, bound up with

it and directed to influence its course'. It was not restricted to the
realm of art, but was 'discernible in all domains of the new culture now
in construction'. In the artistic field, however, it entailed 'an entirely new
approach to the nature of Art and its functions in life … (and) a complete
reconstruction of the means in the different domains of Art'.[33] In an
earlier article, he had explained that this involved the abandonment of
external references in pursuit of an expression of 'the spirit and impulses
of our time', and that 'the vocation of the art of our epoch is not to
reproduce Nature but to create and enrich it, to direct, harmonise and
stimulate the spirit to the creative attainments of our time'.[34] For this
the constructivists chose elementary shapes for their universality and
availability to a general human psychology.

It was in Cornwall that Gabo began to modify his position, and
by 1944 he was happy to announce natural sources for his abstract work.
His response to the question of where he got his forms established a
model for much St Ives art:

> I find them everywhere around me … in a torn piece of cloud
> carried away by the wind … in the green thicket of leaves
> and trees … in the naked stones on hills and roads … in a
> steamy trail of smoke from a passing train … I look and find
> them in the bends of the waves on the sea.[35]

In the 1940s, landscape and the organic were important points of
reference for such artists as Graham Sutherland, whose 1942 description
of his natural sources reinforced the idea of a new romanticism.[36] Gabo's
rhetoric signalled a realignment for his Constructivism that echoed
Lanyon's own use of such natural metaphors as bird-flight at Bosigran.

Though the 1940s have repeatedly been portrayed as a period of cultural
reaction, when the avant-garde of the 1930s was forced into seclusion and
overshadowed by a nationalistic romanticism, Nicholson continued to
promote the 'movement' in which he believed. Lanyon was one of several
younger recruits, and one can see a common set of concerns and values
in the work of the extended group. Margaret Mellis, encouraged by
Nicholson, produced collages that used transparent papers and plastics
to create shallow depth. John Wells, a doctor on the Scilly Isles, made
sculptural 'constructions in space'; a series of his relief constructions,
which used raised elements and thread to suggest successive spatial
planes, were especially close to Lanyon's work in their concerns and clear
debt to Nicholson and Gabo. Lanyon and Wells did not meet until 1946,
but Nicholson encouraged the cohesion of the small group by showing
each artist's work to the others. He was adept at propaganda and lobbied
critics, curators and collectors in Britain and America. As a result,

Triangle Construction appeared alongside work by Wells, Hepworth, Nicholson, Gabo and others in the radical New York journal *Partisan Review*. The collector Margaret Gardiner purchased *Box Construction No 1*, and, after his work had been shown to Peter Watson, owner of *Horizon* magazine, Lanyon wrote to Nicholson: 'Your home seems to be a sort of convenient gallery for me'.[37]

This small group sought to keep the modernist flame burning in defiance of the war, as was signalled by Nicholson's uncompromising statement in 1941 that audaciously linked the 'liberation of form and colour' to the other freedoms for which the war was being fought.[38] The group contributed to several important exhibitions, but its major manifestation was in the London Museum's 'New Movements in Art', which toured in 1942. It included work by Surrealists and Constructivists and drew from Herbert Read the observation that, though the Surrealists were depleted, 'so far as constructivism is concerned … the column is advancing'.[39] Alongside Gabo's *Spiral Theme*, Nicholson's reliefs, Hepworth's new constructivist paintings and the work of others – including Piet Mondrian – Lanyon showed two drawings and two constructions – one of the latter being reproduced in *New Road* – that revealed a new mechanistic quality (**17**).[40]

Presumably prompted by the work and rhetoric of Gabo, Lanyon had extended his activity into fully three-dimensional constructions shortly after joining the RAF. He enlisted in February 1940, was called up on 8 March, when he went to Uxbridge, and was subsequently stationed in Morecambe from April and in Chester for about a year from December. Prevented by migraines from becoming a pilot, he served as an engine mechanic, though towards the end of the war he was able to fly and, despite his own uncertainty, in May 1944 was passed as fit for aircrew. Though he found the atmosphere in the barracks unsympathetic and frequently felt alienated, the work in the hangars appealed to him and, despite his initial assertion that he had 'forgotten all about (his) work (and didn't) want to do any now & couldn't', it contributed to his artistic production.[41] He admired the beauty of the aircrafts and their parts, which reinforced the idea, learnt from Gabo, of the parallel between modern technology and modern art. He reported to Nicholson that he was modifying airscrews – 'bright polished steel, anti-corrosive treated white matt steel, black painted blades standing like a Brancusi with yellow tips'.[42] Similarly, he enthused about the Spitfire: 'the shapes are wonderful, forms like graceful birds, elliptical forms, triangles and aerofoil shapes. Shapes I used before I came here. Is there not a germ of spiritual revival in the work of people like Gabo, with machines in his blood'.[43] Revival, regeneration and renewal became important themes, running parallel to popular discussions of post-war reconstruction, that would persist to define the work made in Cornwall after his return from the war.

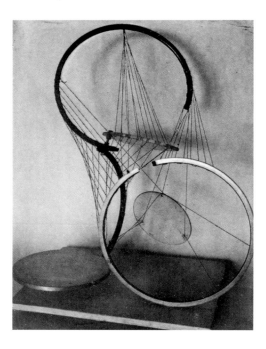

In December 1940, Lanyon sent Nicholson and Hepworth a photograph of a construction made from aero-engine piston rings (**16**). Exploiting their small holes, he ran string between two rings and a section of a third and between them suspended an oval of perspex, which he had drilled, and a saucer-like piece of glass; a circular metal plate was attached about $\frac{1}{4}$ inch above the base to which the construction was bolted. The use of old engine parts may be seen as both expedient and symbolic of a regenerative aspect to the artwork. It was echoed in the work of Wells, who used medical materials in his reliefs, as if suggesting a healing role for them. Later in the war, Lanyon reported that his RAF work involved 'taking bits out of old crashes and building them into rigs to make more aeroplanes'. He recognized the ironic interchange between this and his artistic activity, doubting whether he should send a new work home, as 'the construction appears to most people as a mass of scrap and scrap has very many uses these days. After all it may be melted down to make another bomber!'[44] This reconstructive process took on a personal significance as he looked forward to the end of the war. 'I think a bomber outside the studio would be a fine idea and then I could gradually dismantle my past and build up a way from the bits'.[45]

Lanyon remained uncertain about the piston ring construction, and the two pieces he exhibited in 'New Movements in Art', if still mechanistic, were more refined. Only one is known from photographs, but a sketch of the other by the exhibition's curator shows that it was similar in form and content.[46] *Construction* (1941) (**17**) appears to have been made up of pieces of perspex, some of which have been subtly

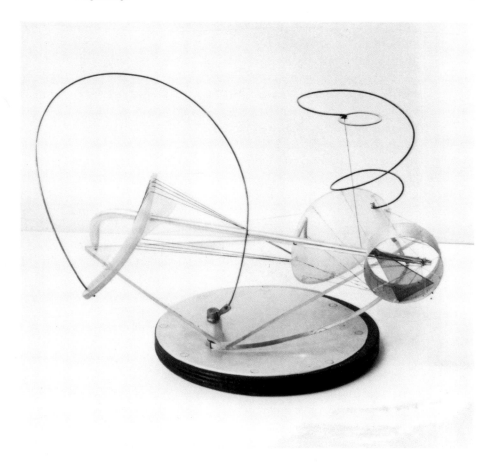

manipulated, a metal rod and thin metal cylinder with the spaces around
and within articulated by cotton and thick wire, one piece being twisted
into a spiral, and the whole set on a reflective metal base. With a greater
complexity than Gabo's perspex pieces, it seems to balance between
lyricism and engineering, to define the space within which it sits and,
like a machine, to promise some sort of generative power.

By the time *Construction* was exhibited at Lancaster House in
March 1942, Lanyon was overseas. In February of that year, he left for
North Africa, where, with Air Rescue Maintenance units at Burg-el-Arab
in northern Egypt, he witnessed the Axis bombing of Alexandria before
retreating to Palestine prior to the reversal of military fortunes at El
Alamein. By 18 June 1942, he had been in Jerusalem for a while and
remained in the Middle East, spending time in Agir and Tel Aviv, before
sailing to Tripoli and on to southern Italy in late 1943 or early 1944. In
Palestine he was able to expand his knowledge of modern art through the
collections of various Jewish refugees settled there. He reported to Gabo
that in Tel Aviv he had 'met the works of Marc, Marc Chagall, the Italian
Futurists, Bauhaus design, Lissitsky, Feininger and many others who

17
Construction, 1941
Metal, perspex and cotton thread
Dimensions not known
Destroyed

have been in the revolution'.[47] In Italy he was stationed near Brindisi in Puglia until the end of 1944, when he was able to travel around, apparently visiting Florence and Rome before settling for a while in Naples. The war had largely moved on by the time Lanyon arrived in Italy and he was able to pursue other activities. In December 1944, he described to Gabo a mural he had painted on the theme of 'Wine, Women and Song', and a friend recalled sharing a studio with him in Foggia.[48] At the war's end he joined the Educational and Vocational Training scheme, which provided tuition and recreational pursuits for servicemen, and seems to have toured Italy organizing an exhibition of work from RAF art clubs. A visit to Rome left an especially strong impression and a determination to return after Germany's defeat. However, shortly after VE Day, Lanyon arrived in Naples where he joined another RAF artist, David Goodman, in teaching art – including Bauhaus drawing techniques – and giving a series of lectures on the development and decline of perspective, entitled 'Piercing the Picture Plane'.[49] Together they worked on more murals at the Three Arts Club, a centre for culturally-minded allied servicemen in Naples.[50]

One of the techniques that he taught was the definition of space by shading rather than line, which can be seen in several of the abstract drawings that he made during the war.[51] This seems to have been a later development, as the drawings from the early part of the war continue his exploration of pictorial space and movement and, as Lanyon wrote at the time, are essentially linear equivalents of such pieces as *Construction*. Some pursue the idea of a point moving across the paper, as used in *White Track*, and several can be related to Gabo's *Spiral Theme* in the way arcs, spirals and straight lines conjoin to create the illusion of space. In *Construction on a Frustrum: the path of a moving point* (1940) (18) lines and shading suggest both the three-dimensional form of a construction and the movement of its planar elements. Later, from such sculptural pieces developed the drawings based on shading rather than line, which depicted more enclosed forms (19). With their suggestions of internal space rather than outward extension and movement, these were reminiscent of seeds or wombs and anticipated the works that Lanyon would make on his return to Cornwall. Similar forms were produced as photograms – images created by placing objects on photographic paper. Lanyon had become an avid photographer and covered an album of enigmatic shots of Italy with a photogram produced with a wire construction.[52]

The course of his work was not as certain as the continuity between the wartime and post-war pieces would seem to suggest, however, and in Palestine and Italy he produced a considerable number of paintings of figures, buildings and, especially, landscapes. His self-criticism was often harsh and he was particularly disdainful of the superficial nature of many of these works. Of a painting of the Church of the Holy Sepulchre, he wrote, 'that silly little painting only told of the beauty of it all, not noticing the wickedness that might pervade it ... When they say "How beautifully done"

they do what travellers do in Jerusalem, look inquisitively into the means and not the end'.[53] For much of the war Lanyon produced little – even drawing was difficult in the barracks – but towards the end he was able to paint much of the time. In particular, he and Goodman travelled to Capua, a town that had been close to the fierce fighting of the winter of 1943–4, and painted in the wreckage of a church. *Ruins at Capua* (1945) (**20**), however, is characterized by a sense of uncanny alienation rather than the destructive violence of the war. That its de Chirico-like figuration is so unusual suggests a degree of uncertainty in his approach, though the theme of destruction, while understated, can be seen as a prelude to the concern with restitution that would come to dominate his work back home.

 The war inevitably occasioned profound changes in Lanyon. He had enlisted at the age of twenty, conscious of his limited experience – of the world, of the opposite sex and of the working class. His initial feelings about service life seem to have been shaped by his experience of bullying at school, and his early letters record a familiar sense of alienation. He failed twice to gain a commission, though on the first occasion he maintained that he had applied in the mistaken belief that, for the sake of his family, he should 'get the rank it entailed to return to my class'.[54] A little later, however, the realization of the clichéd caricatures of the working class and a disgust at their exploitation by the 'self-made man' – from whom he was descended – fuelled his belief that he needed experience of command to prepare for his active involvement in post-war reconstruction (he left the RAF as a Corporal):

← **18**
Construction on a Frustrum:
the path of a moving point, 1940
Pencil on paper
11 × 9
Private Collection

 19 →
Drawing in Oval:
Agir, Palestine, 1943
Pencil on paper
7 × 6
Private Collection

> The values of life which were held in trust by the ruling
> classes, the church, the academics, must now roll down
> to everyman ... I blame myself and my kind for (the working
> class's) condition, because rightly it is our duty to teach
> them and then hand over to them the power to develop
> into complete moral beings and societies.[55]

The paternalistic radicalism was typical of the modernist group with
which he had become associated: echoes can be heard in the rhetoric of
Barbara Hepworth and Herbert Read. Reviewing four years in the RAF,
Lanyon recognized that the war had also been a process of self-realization:

> I left the studio knowing that I was in for a new life – well I
> have had it, sweated in boat holds, sweated in sandstorms,
> idly written of an easy life, created machines, painted, met
> men and seen places and I have lived all this time within a
> class. These are the people I misunderstood and even feared
> before – now I know them. ... I know that I still fear myself and
> that I shall fail, this has not altered. I understand why artists
> are rare and those only the greatest who come from such as
> these men (*sic*). Too much Art is the result of the luxury of
> psychological disorder in the rich.[56]

His conception of art and the role of the artist was closely tied to this developing political position and, as such, can be seen as continuous with the ideology behind the constructivism of Gabo, Nicholson and Hepworth. From the middle of the war, such ideas had fed into broader discussions of reconstruction in which social change at home had become fused with international war aims. However, the growing personal tensions between the three older artists reflected their deeper differences in opinion over politics as well as art. While Gabo maintained his belief in a new spirituality embodied in the 'Constructive Idea', Hepworth believed increasingly in the necessity of sacrificing individual liberties for the greater good of a planned, socialist society, and Nicholson retained his belief in the creative individualism that had always made his association with Constructivism problematic.

Lanyon's own position is difficult to discern. While clearly subscribing to a constructivist belief in social change, he objected to Herbert Read's trenchant restatement of modernist ideals in *World Review* – a journal that pioneered the campaign for social planning and with which Nicholson was associated. Condemning all 'isms' as a disease, Lanyon wrote that it seemed 'peculiar that anyone should want to make cast iron programmes about today and tomorrow and then stick to them … is there no room for instincts and intuition, the vague things, which science does not label?'[57] He always maintained a belief in the individual over the crowd and in the artist, or at least 'Art', as holding a privileged position within society. He reiterated this point towards the end of the war, as he lamented the persistence of 'conservative elements (and) vested interests':

> All these plans for houses for the New World, nothing is any good without a plan for living and life itself permits of no plan. 'Planning' is the last resort of suburbia gone scientific. It replaces the 'isms'. Art alone can supply the organic force needed in human relations.[58]

However, his experience in the programme of adult education organized for servicemen seems to have filled him with optimism: 'Here on the unit we have seen the beginnings of the new Britain, of education schemes, of clubs and hobbies'; he identified the emergence of a concrete idea, the need for

> a more conscious community, community centres etc. … a more vital electorate. The integration of Art in life … the need for constructive liesure (*sic*) … a consciousness of directing and coordinating forms of human behaviour – in fact the bases of Constructivism in Art.[59]

Within his maturing sensibility and developing ideological position, one can observe Lanyon's awareness of the profound changes wrought by the war: the individual and collective psychological scars of violence and genocide, and the expectations of a new social and cultural order.

For him a constructive art was absolutely integral to the processes of reconstruction and regeneration that these necessitated and, for that reason, we can see him continuing the idealistic hopes of pre-war modernism even as he recognized change. A week after VE Day, Lanyon wrote to his sister:

> We are at the balancing point of a greater danger than man has probably ever faced ... We either find more in life: meaning and beauty or we seek the prostitutes of our selves ... this War is part of a revolution in men's minds ... We are either the fathers of a new hopeful but austere and courageous world or we are the lost generation.[60]

Generation and reconstruction

'The spiral expresses in me a sense
of protective solitude.'

Lanyon's wartime letters to his sister Mary reveal a longing for Cornwall that imbued certain sites, in particular the cliffs at Bosigran, with a personal symbolic significance. Some years earlier, painting a view of nearby Pendeen Watch from Levant, he had told Mary that he felt the presence of their father – then not long dead – when he worked, and perhaps some sort of recompense for paternal loss may be seen behind his attachment to that area.[1] While in Italy, he found the coast near Brindisi to be comparable to West Penwith's north coast and a visit there prompted poignant memories: 'Do you know what the coast means to me?' he asked.

> It means the sea and generations of waves coming in to be broken on the shores, it means a rock like a hand in the Gulf of Bosigran and the crying of the gulls and the seapinks by the old mine houses at the edge of the land.[2]

He looked forward to driving fast along the coast road once more.

Lanyon returned to Britain at the end of 1945 and was demobbed in the spring. He was, by then, engaged to Sheila St John Browne, the daughter of an army officer who had grown up in India and studied at Guildford Art School; they were married in April 1946. In his absence, his father's studio, a two-storeyed building in the garden of the Red House, the family home in St Ives, had been renovated to provide living accommodation downstairs and a studio above. In May 1947, a son, Andrew, was born, the first of six children. Home had become bound up with a particular landscape and place, and the idea of family – ancestry, wife, child – became a part of it. For Lanyon, his return initiated a process of self-discovery, the recognition of his ancestral roots representing a personal rebirth. In the immediate aftermath of the war, such feelings of individual renewal were widespread, and they echoed and contributed to the ongoing social reorganization that led to and was reinforced by the incoming Labour government and its promises of reconstruction and a Welfare State.

For many, the liberation of peace meant relocation, and artists began to gather around St Ives, becoming a collective manifestation of regeneration. It was, wrote the sculptor Sven Berlin, who had been invalided from the army, 'as though the destructive forces released in a world war had slowly turned into their opposites'.[3] So, poets such as George Barker, David Wright and John Heath-Stubbs settled for a time around Zennor, and such artists as Berlin, Bryan Wynter and John Wells moved

to St Ives and surrounding districts. The result was a vibrant, modernist art scene that would eventually wreak huge changes upon St Ives' artistic community. This had long been an objective of Lanyon's and he would become a major figure in this transformation (see Chapter 5). Berlin, Wynter and others sought personal reparation through creative work and an engagement with nature and ideas of the primitive. The same was true of Lanyon, though a nationalistic identification with Cornwall would emerge as a dominant feature of his thinking. For the others, the place represented an escape, but for him it was a flight home to the familiar and a sense of belonging.

The works that Lanyon made in the first year or two following his return from the war varied quite considerably in their forms, but returned repeatedly to the themes of birth, growth and renewal. In some, these ideas were addressed through a personal symbolic vocabulary that the artist would narrate in a manner that anticipated his accounts of later paintings. In others, such themes are suggested through the morphology of the work more than its content, and the artistic and theoretical sources for these forms, and the adaptation those sources went through, reveal the concerns and processes then in hand.

Lanyon was one of several artists who produced a body of work based on enfolding, organic structures derived from Gabo's three-dimensional constructions and, perhaps especially, from the wartime paintings with which the Russian had elaborated his description of space into two dimensions. In *Construction in Green* (1947) (**21**), for example, one sees Lanyon adopting Gabo's use of thin glazes of subtly differentiated colours to suggest a transparent three-dimensional structure. Such forms had been anticipated in the drawings that he had made on active service. They belong to a wider group of works, including the precise, geometric paintings that Hepworth produced during the 1940s, which can be related

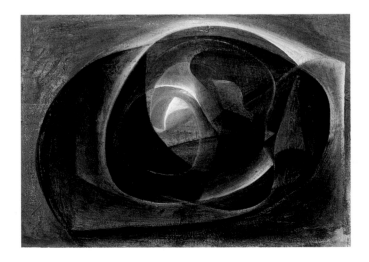

21
Construction in Green, 1947
Oil on board
11¾ × 16
Austin/Desmond Fine Art, London

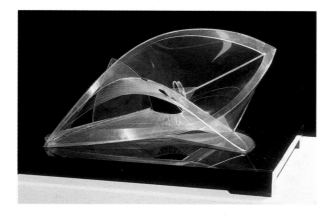

to Gabo's *Spiral Theme* (**22**). They also relate to Hepworth's sculpture of the time, which was dominated by ovoids and curling forms (it was the former, egg-like pieces that supposedly prompted accusations of plagiarism from Gabo). Similarly, John Wells's work was dominated by the form of a soft-angled triangle, a sort of triangular ellipse, and in one painting this evolved into an iconic egg, the symbolism of which provides a counterpoint to the formalistic title *Blue Oval* (1943).[4] For other paintings, closer to Lanyon's and made up of a series of enfolding, translucent layers, Wells coined the phrase 'Gaboid'.

 The association with Gabo implies a formal priority for such works that Lanyon's titling of *Construction in Green* ratifies. However, there was a more allusive level of intended meaning that was signalled by the frequent occurrence of the term 'involute' – meaning a form that rolls inward, but implying some sort of involvement or entanglement. All of these artists identified in their output the theme of reproduction or regeneration, and an 'erotic undertone' has been discerned in *Construction in Green*.[5] Wells made this evident in the title of one Gaboid – *Embryonic* (1947) – and, in a schematic description of her imagery, Hepworth set out a reading of the 'unconscious (unknown) symbols (curves, spirals, ovoid-foetus erotic, prenatal, dream, childhood, primitive etc.)' in her work.[6] Gabo had, himself, implied a sense of immanent renewal in his art when he wrote of trying 'to guard in my work the image of the morrow we left behind in our memories and foregone aspirations'.[7] That his constructions were seen to possess such symbolic values at the moment of recovery at the end of the war was reflected by the reproduction of *Linear Construction in Space No 1* (1938–42) in Alex Comfort's *Art and Social Responsibility* (1946).

 In 1949, Lanyon was able to look back on his post-war work and identify a group of eight paintings, which he dubbed the 'Generation Series' after the culminating work, *Generation* (1947) (**24**). These were made, he said, over an eighteen-month period that presumably ran from the middle of 1946.[8] The artist described the elongated, turning image

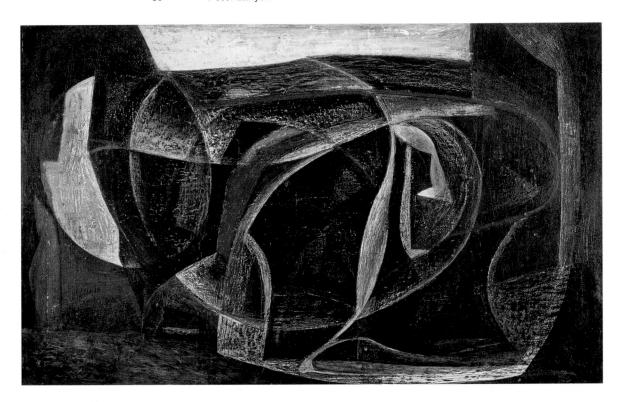

of *Generation* as two interconnected spirals and said that the other works
in the series were all based on the same form, which he linked back to
Gabo's *Spiral Theme*. The spiral, he wrote, 'expresses in me a sense
of protective solitude – a prayer'.[9] Lanyon suggested a subconscious
association of this form with birth and growth when he asked Gabo
whether his construction had been 'done during the formation of (his
daughter) Nina or after her birth'. He summarized the group:

> The first series then appears to be Inner. They all derive their
> information from the tin mines here and other things under
> the soil. They are organic in their nature. It does not seem
> extraordinary that I should find these inner forms and dark
> colours (in) the only country in which I could live.[10]

However, if the artist's interpretation of the eight oil paintings is relatively
clear, their actual identity is not.

Four of the series are identifiable as they were exhibited under
the title 'Generation Series' at Downing's Bookshop in St Ives in August
1947; these showed considerable stylistic variation.[11] *The Yellow Runner*
(**31**) was completed by September 1946, when it was shown in the first
Crypt Group exhibition (see Chapter 5), and an inscription dates *Earth*
to that month.[12] *Prelude* (**23**), which alluded in its title to the imminent
birth of Lanyon's first child, is inscribed '4/4/47. Series Generation Four';

23
Prelude, 1947
Oil on canvas
24 × 38
Private Collection

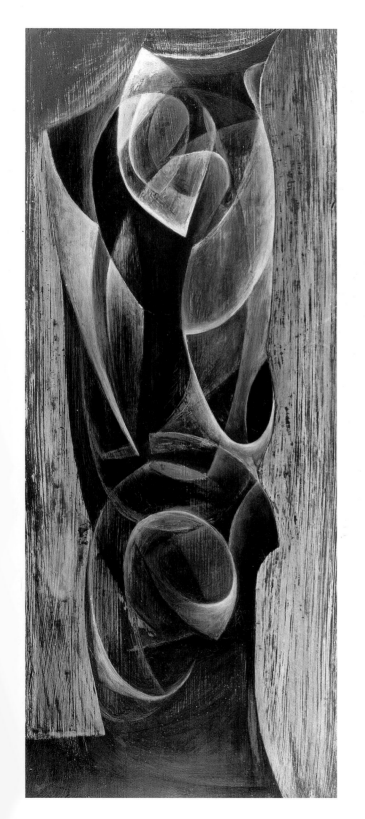

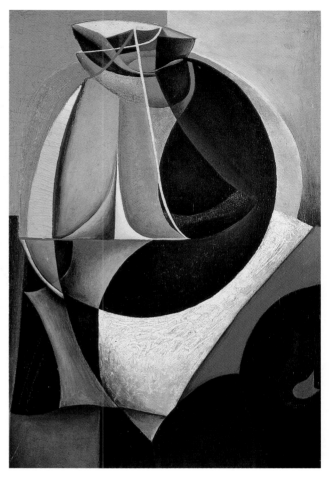

← **24**
Generation, 1947
Oil on board
34 ½ × 13 ¼
Private Collection

25 →
Generator, 1946
Oil on canvas
30 × 20
Private Collection

Generation was the fourth exhibited. While *Earth* is consistent with the Gaboid idiom, *The Yellow Runner* combines such an enfolding structure with figurative elements – a horse and a landscape – and *Prelude* steers a middle course, combining Gabo-esque forms with the suggestion of a rolling hill at the top. A photograph of an early state of the painting shows it to have been more enclosed, and the suggestion that it was originally vertical in format indicates that the landscape association came later. Proposed candidates for the other four works in Lanyon's retrospectively-defined series have varied: they include *Generator* (1946) (**25**), *Construction in Green*, *Tinstone* (1946) and *Landscape and Cup (Annunciation)* (1946) (**26**). The last is distinctive in its clear depiction of houses and a hill, against which is set a goblet; an inscription on the reverse indicates the specificity of its subject: 'St Ives. Farm near Zennor. October 1946'. The date and the title associate the work with the announcement of Sheila Lanyon's pregnancy, elevating that personal event to a mythic level while locating it within the local Penwith landscape.

The relative realism of *Landscape and Cup (Annunciation)* is undermined by a blue circle that balances the rich red of the chimney on the left. The combination of royal blue and red might be seen as a symbolic reference to the Virgin – the archetypal mother to which the subtitle 'Annunciation' already alludes. The same colours recur in the wooden core of an aluminium construction made during the 'Generation Series', *Construction* (1947) (**28**). Similarly, Lanyon explicitly saw 'a curious relationship to a mother and child' in *Generation*.[13] The nurturing, maternal figure would prove to be a recurring element in Lanyon's art, another instance being his reference to the Egyptian goddess Isis in several works (**27**). In *The Golden Bough*, a book much read among artists in

26
Landscape and Cup
(Annunciation), 1946
Oil on board
12½ × 15½
Private Collection

St Ives, James Frazer identified Isis as a corn-goddess, 'Creatress of green things', who, having enabled the resurrection of Osiris, her brother and husband, became a symbol of immortality, renewal and maternal nourishment. As such, she paralleled the Virgin, and representations of Isis were said to anticipate the Christian Madonna and Child.[14] Lanyon's vertical composition might contain such a reference, while its intertwining forms also recall Eric Gill's *Ecstasy* (1910–11), a representation of sexual intercourse and, as such, an erotic symbol of generation.

The device of an enwrapped and protected focal centre in *Construction* (1947) is found in the work of the various artists producing these organic forms. Prefigured in Gabo's *Construction in Space with Crystalline Centre*, more than anything it suggests a foetus in the womb, or a germinating seed in its pod, and so the idea of generation. This had been anticipated in the work that may have been the first of the 'Generation Series', *Generator* (1946), a distinctive painting that, in its title and its form, plays on an ambiguity between the mechanical and the organic. It shows Lanyon's skilful management of the tension between the picture surface and pictorial space by means of interlocking solid forms and the suggestion of overlap and shallow recession. The apparently steely coldness of the white areas, which seems to invoke machinery, is offset by their thickly-worked surfaces. The form is suggestive of some sort of protective cavern – a womb, a seed-pod – from which a small form at the top seems to emerge or bud. The feeling is of spring, of germination reaching for fruition, and its overriding theme is of organic reproduction, fertility and a fecund nature. This, it would seem, was the starting point for the rest of the series and the moment at which its subject was established.

The predominance of such enclosing, 'wombic' forms reflects the prevailing interest in psychoanalysis amongst artists in St Ives. This is unsurprising given the involvement of Adrian Stokes (though he left in 1946), whose writing at that time addressed his own autobiography and a psychoanalytic interpretation of place.[15] In particular, his book *Smooth*

27
Isis, 1948
Oil on board
14½ × 4
Private Collection

← **28**
Construction, 1947
Painted aluminium and plywood
9½ × 12 × 11
Tate Gallery, London

and Rough includes a portrayal of wartime Cornwall as a rocky chamber in which his pregnant wife might shelter that complements these painted and constructed images and echoes the theme of a protective home.[16]

There was considerable interest amongst St Ives artists in the writings of the analytical psychologist Carl Jung, and one might relate the holistic urge that is apparently behind the works they made to his theories of the mandala. Though stylistically distinct, the embryonic forms of Lanyon, Wells and Hepworth share with the mandala a concentration on a central point that compensates for disorder, for the subject's disorientation, and so serves to counter feelings of insecurity and confusion. In the context of the post-war search for a new mythology and a return to natural relations, in contrast to the belligerent, urban, modern world, Jung's theories were welcome for their emphasis on a collective unconscious that transcended cultural and historical divisions. However, though Lanyon clearly drew upon Jung's theories, it remained the work of Melanie Klein, mediated by Stokes, that seems to have engaged his attention.

In her reworking of Freudian theories of infant development, and, in particular, of the Oedipus Complex, Klein identified two early, contrasting, psychic relationships with the mother. Initially, the child relates to 'part objects', especially the breast, which are split into 'good' and 'bad' objects, and this division is eventually extended to the mother's body as a whole. During the first stage, the child, in Oedipal rage, fantasizes attacking the mother's body and, in particular, its contents – the father's penis and the resultant foetus. In the second stage, the recognition of the mother's complete body stimulates feelings of guilt for these earlier attacks and anxiety for the damage caused. Klein proposed that the creative urge, the making of a work of art, was a symbolic act of reparation for these aggressive infantile fantasies. One should be wary of overstating the case, but it seems feasible that Hepworth's and Lanyon's imagery partly derived from their awareness of such theories of reparation. Though one should not consider their work as illustrations of a theory, their enclosing, involuted forms suggest, consciously or not, the womb that the infant seeks to restore. To extrapolate further, one might suggest that they used symbols of individual psychological reparation to stand for a broader, collective, social process of reconstruction and regeneration.

Lanyon had adopted, and sought to stay true to, the principles of the 'Constructive Idea' defined by Gabo before the war. In the adaptation of Gabo's formal vocabulary towards a more organic morphology and the theme of generation, Lanyon, like others around him, tried to adjust that idea for the post-war, post-nuclear world. This organicism was a common phenomenon as the crisis of modernism, occasioned by the war's subversion of the optimism of the 1930s, witnessed a recourse to ideas of nature and a flight from history and dogmatic political ideology to the more stable ideologies of myth. For many in St Ives and elsewhere, this meant a continuation of the romanticism that had enjoyed a resurgence during

the war, but Lanyon stands out for his subtle exploration of the possibilities
for an art that was both 'constructive' and attached to the permanent
truths of the natural world.

One senses his disdain for those artists, perhaps epitomized by
Sven Berlin, who seemed obsessed with their own alterity and with the idea
of a lost world. Disparagingly, he reported on this to Gabo, using some of
their statements to illustrate their belief in '"a gradual decline of creative
force"' and the mind's lost contact with '"the primeval forces of creation".
"a violation of the instincts by the will"'.[17] The great text for these others
was *The White Goddess*, Robert Graves's extraordinary treatise that called
for a return to natural relations and the reassertion of poetry's original
function as the invocation of The Muse, the Moon-goddess.[18] Lanyon's
conception of art and its function was more material, more grounded than
this, being based primarily on the conscious construction of form in paint
and resisting total abstraction. In a commentary on the second Crypt
Group exhibition in 1947, he warned that

> just as the picturesque has become the picture-postcard,
> so the abstract may become the toy or plaything. To remain
> in the realm of great Art … there must be a central image
> whether it is a pot, a portrait, a landscape or as in much
> modern work an abstract idea of process.[19]

That is not to say that he did not engage with ideas of myth himself. Rather,
he seems to have used personal mythology and traditional myths as a
means of developing a constructive art relevant for its time. The recourse
to a personal imagery was both part of his individual process of recovery
and a contribution to this new art, in so far as the psychological and social
reintegration of the individual was seen by many as a prerequisite for
future culture. If works such as *Construction in Green* focused on organic
constructive forms, others of the period combined such forms with

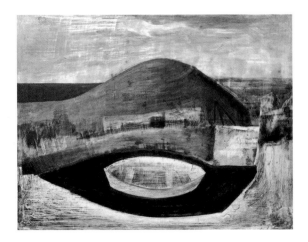

29
The Yellow Boat, 1947
Oil on board
15 × 19
Michael Wright Fine Art, Bristol

landscape and a symbolic figuration to elaborate the theme of generation. In a work such as *The Yellow Boat* (1947) (**29**), the motif of a boat in a harbour provided a subject of local social and economic significance that also served as a symbol of protection. Similarly, *Prelude* combines allusions to growth and germination with a hilly landscape and what has been seen as an abstraction from the goblet in *Landscape and Cup (Annunciation)*;[20] both pictures are concerned with the artist's forthcoming fatherhood.

The major work in which Lanyon combined Gaboid forms with this personal mythology is *The Yellow Runner* (1946) (**31**), which combines a relatively literal representation of a coastal landscape with the figure of a horse enfolded within abstract forms. Lanyon produced several pictures incorporating similar horses, and an unusual sculpture of the same moment shows the synthesis of constructive elements – a triangular piece of wood, steel tube and wires – with a carved wood form that alludes to a horse's head (**30**). This was shown in the first Crypt Group exhibition at a slightly elevated angle, so that it suggested a whinnying horse, but it was also photographed without its attachments and pointing upwards, so obscuring its equine allusions. For Lanyon, the horse served as a symbol of ancestry, as demonstrated in a poem written at that time:

In the side of my eye
I saw a horse
(My ancestor horses
My brothers in wisdom)

I will ride now
The barren kingdoms
In my history and
In my eye.

From the islands of my race
Is the horse's hoof
Beating terrified
By a vision in the sky

My boat takes me
To the island and I
In my journey
Ride
Again
My ancestral horse.[21]

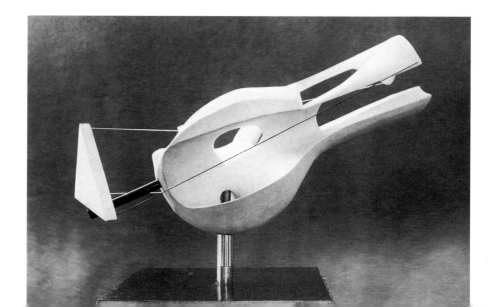

30
Sculpture, 1946
Painted deal and metal
Dimensions not known
Destroyed

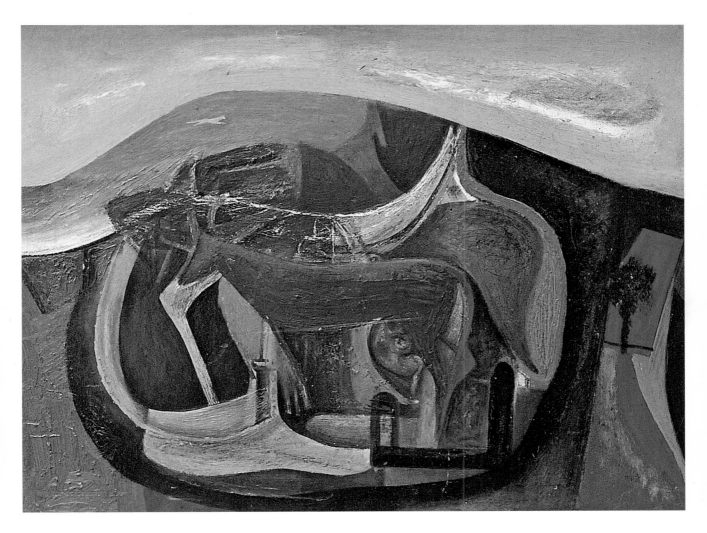

In *The Yellow Runner*, then, the enclosed horse at the centre could
well represent the protective family. The artist's notes itemized some
of the symbols:

> The subject 'the yellow runner' is given speed by the
> dynamics of the composition. It is the pollen and the flower,
> the sperm and the egg and a whole range of rituals
> connected with fertility. Painting of a story. Runner with
> message on way to stockaded horses. Fox as field. reference
> (*sic*) to horses cut in hillside. Yellow Runner as fertilising
> agent. Stockade as womb. A homecoming.[22]

Thus, the yellow horse in the background refers both to ancient
civilizations and to the artist himself returning to the safety of his
homeland and his family to, in Kleinian terms, the reconstructed maternal
womb. Here, for the first time, one sees the fusion of these ideas, so that
family, womb and the subterranean world come to occupy the same

31
The Yellow Runner, 1946
Oil on board
18 ½ × 24
Whereabouts unknown

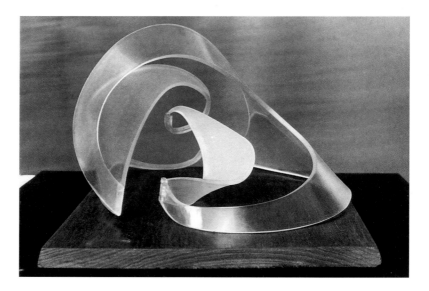

pictorial space: the land is the protective site to which the artist returns, and the germinating seed beneath its surface is the promise of the artist's regeneration. Lanyon related the subterranean aspect to Cornwall's history of tin mining and, specifically, to his family's associations with the industry. 'When I came back from the war', he said in 1963,

> I really began to realise that I came out of a family which was concerned with mining ... I think my own myth was built up over this thing of miners working under the ground, under the sea, coming up to the surface.[23]

This has been related to *The Yellow Runner*, but, as we shall see, it relates more closely to later works in which his identification with Cornwall became more nationalistic and polemical. Here, the theme seems to be fertility and the promise of renewal and, as such, the painting encapsulates, in its form and content, his attempts to forge a new constructive art.

 That Lanyon's search for a new artistic intention and visual vocabulary was not easy is suggested by the diversity of the works he made. While *Construction* (1947) (**28**) is intimately related to the spiralling, wombic forms of the contemporaneous paintings, other perspex constructions of 1946 and 1947 hark back to the transparent lyricism of Gabo's wartime work (**32**). Similarly, *Construction – The Wing* (1946), visible in photographs of the first Crypt Group exhibition (**47**), was close to the mechanistic *Construction* (1941) (**17**). At the same time, he continued to produce representational paintings of a relatively conventional nature, mostly landscapes but also a rather ghostly self-portrait in which the artist's face seems to emerge through a brown haze.[24] This last piece demonstrates, however, a continuity of method. It shares, with such works as *Prelude* and *Generation*, the technique of successive layering of paint,

32
Perspex Construction No 1
(Quaker Grey), 1947
Perspex
Dimensions not known
Destroyed
Photo: Tate Gallery Archive, London

almost like glazes, onto a white gesso ground, followed by the variable scraping of it to create a translucent quality. This practice derived from the work of Ben Nicholson, who during the war had started to make a series of still lifes set against the landscape in which the paint was scraped with a razor blade in a development of his concern with the interpenetration of successive spatial levels (5). The practice was widely adopted by artists in St Ives, including Hepworth, Wells and Wilhelmina Barns-Graham, as well as Lanyon, and for a time they were dubbed the 'scratch and scrape' school. The technique allowed for parallels to be drawn with natural processes, such as weathering, and a comparison was made with the then current view of landscape as a palimpsest.

Lanyon's uncertain experimentation was not isolated, as a range of British artists sought to find a new form of painting. This was determined in part by the sense that world events had occasioned changes that demanded new artistic forms just as they stimulated new ideological and philosophical positions. The horror of the war and the Holocaust seemed to ridicule both the idealism of Constructivism and the iconoclasm and absurdity of Surrealism, while the crisis in Communism following the murder of Trotsky and the recognition of the despotic Stalin undermined hopes for Socialist Realism. Within the specific practices of painting, the problem was perceived to be one of finding a way of moving forward after Picasso, whose innovations had had such widespread and profound effects that it was hard to conceive of advancing further.

When Herbert Read reported to Gabo on responses to Ben Nicholson's 1945 exhibition at the Lefevre Gallery, he observed that 'more than one person said to me, "we are tired of this austerity – we have had enough of it during the war"'.[25] The post-war reappraisal of artistic practice witnessed a return to a more humanistic, perhaps transcendental, art. The response to two key exhibitions – 'Braque and Rouault' at the Victoria & Albert Museum and 'Paul Klee' at the National Gallery – signalled this change. The down-to-earth Georges Braque – *le patron* – was celebrated as the revolutionary protector of tradition, providing a soothing escape from the upheavals of the world; at the same time, Jankel Adler's wartime claims for Paul Klee as the bearer of a spiritual heritage in contrast to the 'scholasticism' of such artists as Nicholson and Mondrian were borne out.[26]

In Britain, Robert Colquhoun's melancholic figures represented a late manifestation of Cubism, echoed in France in the work of the Communist Edouard Pignon, while Victor Pasmore worked through the theoretical texts and styles of earlier modernist art before arriving at a total abstraction and a new art of construction at the end of the 1940s. However, with the benefit of an historical perspective, the key engagement with the coincident crises of artistic representation and human consciousness has been seen to be Francis Bacon's *Three Studies for Figures at the Base of a Crucifixion* (1944). A similar tone of contemporary

anxiety, and later of organic process, was set by the work of Graham Sutherland, and the fact that he used landscape and the natural world to articulate those themes provides an important marker for our considerations of Lanyon's work. It was amongst calls for a renewed humanism in art and the crisis in painting that Henry Moore emerged after the war as the pre-eminent Western sculptor with a major retrospective at the Museum of Modern Art, New York, in 1946, and a prize-winning exhibition at the Venice Biennale in 1948. Developing from a credible modernist position before the war, his anxious heads and nurturing female figures acknowledged the anxieties of the age while offering a hope of transcendence. A little later, Alberto Giacometti's emaciated epitomes of the fragile, threatened body, offered a complementary sculptural statement.

It was within this climate of diverse practices and uncertainty that Lanyon – with others – tried to adapt the constructivism to which he remained loyal. Towards the end of the 1940s, his work changed from the organic abstractions and symbolic figuration of the 'Generation Series' to more focused treatments of landscape. By the time he wrote to Gabo in February 1949, offering an account of his work of the preceding two years, he was unsure if he could 'claim to be a Constructivist any longer' as his paintings were 'all landscapes or in the sense of landscape'.[27] Landscape was the motif through which he chose to rehumanize his art, but that is not to say that the human body was absent. Not only could figures be read within the forms of the painting, but in his theorizing of landscape and space the human body was always implicitly located at the centre of his art.

Landscapes of experience

'... the problem of landscape becomes one of painting <u>environment</u>, <u>place</u> and a revelation of a time process.'

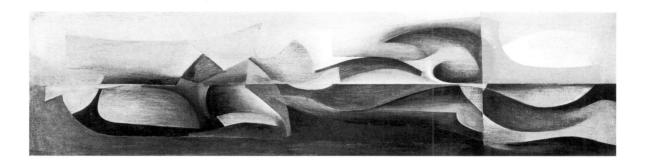

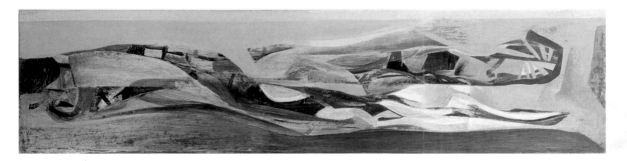

In the winter of 1948–9, Peter Lanyon painted over the top of his *Horizontal by the Sea* (1947) the painting *West Penwith* (**33, 34**). The following year, 1950, was largely taken up by his tortuous attempts to complete the Arts Council's commission for a large painting for its Festival of Britain exhibition, '60 Paintings for '51'. Such was his struggle that the canvas with which he had been supplied disintegrated as a result of the repeated scraping down and reworking to which it had been subjected, and the final image, *Porthleven*, was painted in four hours (**42**)[1]. Between these two events – the reworking of *Horizontal by the Sea* and the laboured resolution of *Porthleven* – is marked a crucial moment in Lanyon's career: the rejection of an abstract style for what he portrayed as a more rooted semi-abstraction based upon his self-fashioning as a landscape painter and Cornish nationalist. Despite that shift, he hoped to be able to lay claim to the label of constructivist, an aspiration which reflected his working practice and pictorial concerns, and his attitude to landscape.

33
Horizontal by the Sea, 1948
Oil on board
11 ½ × 43
Private Collection

34
West Penwith, 1949
Oil on board
11 ½ × 43
Private Collection

The change in title from *Horizontal by the Sea* to *West Penwith* appears to be the first public sign of Lanyon's association of his art with that place. Though he subsequently related the realization of the importance of west Cornwall to his return from the war,[2] it was only now that this particular place succeeded the generalized organicism of the 'Generation Series' of 1946–7 as the primary source for his work. He wrote later that *West Penwith* marked 'the initial breakthrough from Gabo, Hepworth, Nicholson abstraction and (was) the basis of all my painting since'.[3] In this work, the illusion of three dimensions created by the use of a 'hollowing out' technique is subverted, and the long curving forms of *Horizontal by the Sea* that might be thought to have alluded to both the nurturing female figure and landscape are fractured in an attempt to suggest a landscape of personal experience, human occupation and history.

Writing to the owner of *West Penwith* in 1960, Lanyon recognized the importance of this change:

> Abstract construction illustrated in 'Horizontal by the Sea' is already evocative but is resolved only as far as all the forms curves and planes operate successfully in themselves. References outside these are impurities. It is these references and impurities which I developed in the later painting and so by choice opted for a richer and in fact more local vein. Subsequently, moral and aesthetic differences led me to break with Nicholson and Hepworth, though not with Gabo.[4]

The painting, in the artist's estimation, signalled the advent of several features of his subsequent work. It was then, he believed, that he moved away from works that were purely concerned with the technologies of painting and, for the first time, tackled issues beyond the focus of pure abstract art. He asserted this to the painter Terry Frost in 1949: 'The trouble with abstract art', he wrote,

> is that it has no image. It exists in space and time but has no image. It can become a vanity or just a game unless it is used to practice five finger exercises etc. The development of abstract Art towards construction is the significant move, that is the creation of actual new forms and relationships, new canons of beauty ... it is necessary to forget all arty claptrap and get down to the fundamentals – surface, space etc.[5]

The casting of his materials and sources as somehow outside or other to conventional cultural practice would recur throughout his career. Despite the later association of the painting of *West Penwith* with his rejection of Nicholson and Hepworth, it was made at a time when Lanyon still enjoyed and valued their support.[6] The point is significant because one can associate a later change in practice with his conscious rejection of the

elder artists' art and attitudes.

In a lyrical description, Patrick Heron recognized in *West Penwith* both its landscape source and the artist's use of visual metaphor. Saying that the painting 'plays a sort of hide-and-seek with visual reality', he wrote:

> We recognise a headland, round and smooth at the top,
> sharper and more angular below with the long horizon of
> the sea behind; and then the sweep of land towards a cove
> and another headland ... It is a beautiful composition of
> interweaving, taut, slim, sculptured forms. But ... Lanyon
> seems to allow his images to dissolve here and there into
> something quite different – into an analogy of bone
> overlapped by tendons, perhaps.[7]

The earliest of this new type of paintings were shown in Lanyon's first London exhibition at the Lefevre Gallery in October 1949, which also included work from the preceding five years. One reviewer admired his 'slim, cool, near-abstractions',[8] while Lanyon's friend David Lewis welcomed the new development the show revealed, though in so doing he dismissed the earlier work as derivative and clichéd. 'Lanyon is at last beginning to assert himself and not those from whom he has learnt', Lewis wrote, and he felt that the artist was using what he had gained to his own ends. This transformation had been enabled by Lanyon's '*personal* realization that his own sensuous awareness to things could no longer be denied ... that as an artist craft could no longer be an end in itself but must be interpretative'. More to the point, as an 'insular Cornishman', he had found his subject: the qualities of the Cornish environment.[9] Undoubtedly, this reading of the work was informed by Lewis's discussions with the artist; he would later recall them 'struggling to articulate not what the landscape looked like, but how to explore it inside and out, its rocks and fields and sea, its textures and saturations, its opacities and transparencies of colour, and how to *experience* it through art'.[10]

Lanyon saw *West Penwith* as the culmination of a second group of paintings that followed on from the 'Generation Series'; the other works in the group have not been identified.[11] Here, the spiral of the 'Generation' works had become elongated into a serpentine line, 'rather like the regular wave on a Cathode-ray tube', and he felt he had achieved a more precise organization of space in which colour played a greater part. If the first series had been 'inner', this second group had 'left the inner forms of the mines and of seeds and begun to evolve a relationship of these forms to the outer forms of the surface'.[12] In this way he sought to represent a specific landscape in a manner that would reveal its external appearance and its internal forms. *Horizontal by the Sea* had served to establish the spatial relations of the final work, or, as Lanyon later put it, it 'exercises the spatial illusions and construction. This exercise releases imagery ... the activity

of creating illusion precipitates images which would otherwise remain dormant'.[13] The tension between illusory, constructive space and imagery derived in some way from external sources would become a major aspect of his work. During the prolonged struggle with *Porthleven*, the role that the first state of *West Penwith* had performed in the formulation of the final work was filled by a series of three-dimensional constructions; this practice would recur in later works.

West Penwith, the peninsular that reaches westward from St Ives into the Atlantic, which it confronts with the northern cliffs at Zennor, Gurnard's Head, Bosigran, Pendeen and Cape Cornwall, had long been a site of special significance to Lanyon. He said that the reworking of *West Penwith* had coincided with a reacquaintance with his old favoured environment. 'I have found for the first time after years of absence', he wrote, 'a real love for such things as the sea and granite rocks, the forms of ivy and the dark vicious growth of pine trees'.[14] An idea of the associations embedded in the imagery of *West Penwith* and related paintings can be gleaned from a lyrical essay on the region written by Lanyon in the same year, in which, he later felt, by eliminating the first person he had 'distilled the meaning' to achieve 'a density and compactness of statement which I ... desire in my painting'.[15] There he presented an image of the Cornishman as different and multi-faceted, and of the place as a complex agglomeration of natural and historical elements. He wrote of West Penwith as a place where 'the most distant histories are near the surface ... (and) an outline of earthworks makes evidence for a primitive brotherhood of man'. In his description, this primitive landscape is combined with the heroic economy of fishing, the melancholy remnants of industry, and 'lichen-covered, castellated and pinnacled' church towers. 'Here', he wrote, 'sea and land answer the deep roots of man and present him with a face ... and in commerce of man with granite and Atlantic the transitory is made immediate, each facet being related elementally to the next as aspect and image of a whole'.[16] One might see these paintings as an attempt to represent in paint this rolling together of a place with its human population, economic and social activity and historical past.

West Penwith also seemed to offer a way out of a deep depression that was intimately tied to the artist's struggles in the studio. In May 1948, he had told Gabo that

> the work has become harder and harder, every picture a more deadly struggle than the last ... every work seems to reach the stage of utter hopelessness and blackness before some last weak effort pulls it into something ... The fight during the last few months has reached a fever pitch and I have been unable to stand it physically, so I collapsed. I have been in bed for weeks ... in the category of the very ill. I felt like death and in fact at one time had little wish to return to the hell of painting.[17]

In February 1949, he wrote that since this illness he had 'lived a rather terrifying public life being subject to attacks of claustrophobia' and speculated that '6 years of repression during the war and the fight to get my image (as I call it) were finally getting their "release"'. He was now, he hoped, overcoming the inhibitions that had arisen as a result of the inactivity of the war years and that had threatened to kill his 'whole creative ability'.[18] It was this breakdown, a condition he had experienced before and that would become all too familiar, that prompted a trip to Italy in summer 1948, at which time he visited the Venice Biennale, where he saw Henry Moore's exhibition and a display of Peggy Guggenheim's collection of modern European and contemporary American art.

Despite Lanyon's proclamation of a new facility in the generation of his images, the small group of paintings that were made between late 1948 and 1951 marked the first appearance of a formal awkwardness that would become characteristic of his work. As well as in *West Penwith*, a similar style is observable in *Cape Family* (**36**), *Portreath* (**38**), *Godrevy Lighthouse* and *North*, all of 1949, *Carthew* (1950) (**37**) and, from 1951, *Trevalgan* (**35**) and *Trencrom*. These works are all painted on board that was prepared with a gesso ground to provide a hard, resistant surface. This gives a quality of luminosity, especially where the artist has scraped the paint away with a razor blade. An image is created that seems to be

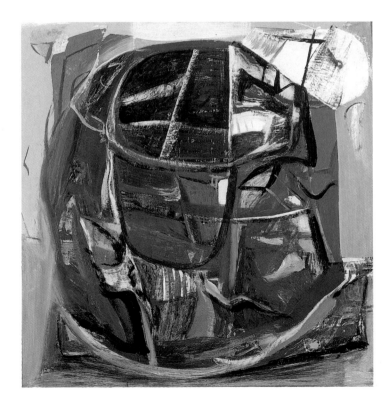

35
Trevalgan, 1951
Oil on board
48 × 45
Collection David Bowie

made up of, at once, strata of different colours and semi-transparent planes curling in shallow space. The scraping also creates a complex structure in that it reveals obscured colour to create an ambiguity in the recession of the layers. Finally, in an unsettlingly definite manner, the pictures have been completed by the painting of pale blue around and over certain areas in a sort of parody of the sky in conventional landscapes. The artist recalled this practice a few years later, saying that he had 'used a convenient "lumping together" device in painting by lopping off sections … and putting a sky in and calling it landscape'.[19] That this pale area surrounds and, in places, penetrates the scraped-down greens, reds and browns gives the paintings an ambiguity, as they appear to be, at once, both horizontal landscapes and aerial views of a coastline invaded by the sea.

If *West Penwith* is named for the western-most 'hundred' of Cornwall, the titles of all but one of the other works of this group refer to specific sites on the north-western coast of the county; the exception is *North*. It is not always easy, however, to discern the relationship between the actual sites and the paintings that bear their name. The complexity of possible readings is demonstrated by *Cape Family*, a major work that continues the concerns of the 'Generation Series'. The title refers to Cape Cornwall, a headland north of Land's End that is remarkable for the lone chimney that rises from its hillock to ventilate the extinct mine beneath. If travelling westward from St Ives, this seems to be the end of the land, where one is forced to turn south. It is close to the mining town of St Just and the area is studded with archaic sites: ancient fortresses on the cliffs, neolithic villages and an early Christian chapel. Lanyon's painting, however, shows a family embedded, or embodied, in the land in a manner that alludes to the forms of the granite cliffs thereabouts. The artist identified in the painting a 'family in the granite. Based on primitive carving and ivories. Also medieval manuscripts', and said that it referred

> to a family who lives at the edge of the sea, on a cliff at the Cape … A family which lives on the edge of the sea is closest to the land and is the land when seen from the eyes of the father – hence the identification of the mother-figure and two children with the county – in this case a county of granite rock, bones and no trees – Cornwall.[20]

This painting brings together the themes of family and immersion in the landscape, though the extent to which a similar reading might be found for the other works of this kind is less certain.

When the first few were exhibited in London, they were received as invocations of a generalized idea of place. Patrick Heron discerned in them abstract archetypes of such features as rocks and cliffs, and identified 'the cold grey-white light of an imaginary, almost a lunar world' as characteristic of sea-bound west Cornwall.[21] Heron's comments anticipated the enigmatic *Carthew* (1950), named for the rocky promontory, properly

36
Cape Family, 1949
Oil on board
72 × 48
Art Gallery of Western Australia, Perth

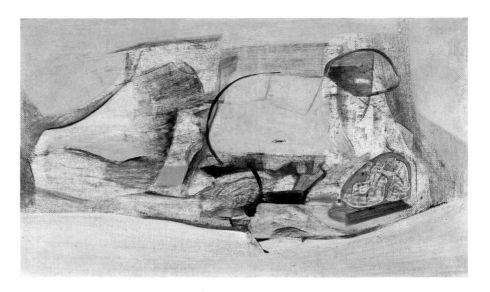

known as Carrick Du, at the western end of St Ives' Porthmeor Beach. The title translates from the Cornish as Man's Head, and this may have been the stimulus for the mysterious skull-like, rocky form on the right-hand side. This work, which the artist insisted was 'not an abstract painting', is more severely scraped down than any other, and it is this, with the texture of the rough face of the hardboard support exposed, that creates a sense of Heron's lunar landscape.[22] The 'skull' appears to have been defined negatively, as it were, by the wiping off of paint with a solvent, so that the residue is more concentrated along its edges.

Heron saw such paintings as reflections of the artist's 'subjective feeling for the bones of Cornwall'. David Lewis voiced a similar opinion:

> Lanyon is a Cornishman. Being sensually apprehensive of white gales on grey granite, of sheer granite face broken into crust and plane, of the dense weight of solidity in grey and green, of the blue space-piercingness of silver light shafts, might previously have (?seemed) to him as ordinary as breathing, but suddenly becoming aware of his own breathing has, thank heaven, come to Lanyon as a shattering revelation. It's a revelation which, he shows us, is full of portent.[23]

Several such paintings, including *West Penwith*, *Cape Family* and *Carthew*, were shown alongside contemporary French paintings at the important 'London-Paris' exhibition at the Institute of Contemporary Arts in March 1950. In contrast to Heron and Lewis, Douglas Cooper, concerned only with formal issues, lambasted them with the rest of the selection. He criticized both French and English artists for retaining superficial aspects from the work of Picasso, Matisse and Braque, while rejecting 'the fundamental pictorial reality' that was their greatness. For example:

37
Carthew, 1950
Oil on board
19½ × 33
Bernard Jacobson Gallery, London

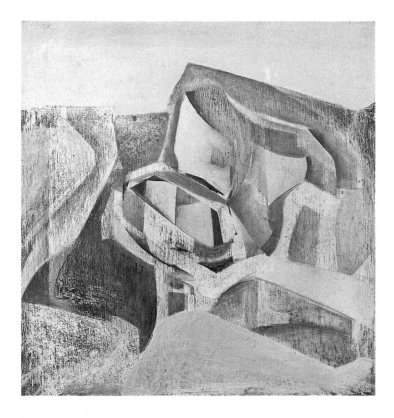

Mr Peter Lanyon – who rolls pale greens and blues over a
panel and then, like Mr Ben Nicholson (his teacher), starts
to scratch and scrape the paint until the surface looks like
an old wall covered with *graffiti* and fungoid growth.[24]

Reproduced in the catalogue of Lanyon's Lefevre show was the painting
Portreath (1949). Apparently very different from other works of the same
period, it depicts a small harbour village and the hills that enclose it in
a matrix of thinly painted and scraped flat planes. The artist described
it in literal terms, calling it 'a portrait of a place ... there's a pier that runs
round the edge of a very steep cliff, and the curious blue shape is the way
that water forms around the bottom of the cliff'. The style reflected the
nature of the subject: 'The rock at Portreath is all slate, and slate tends
to come away in big flat planes, and I use these throughout the picture'.[25]
Lanyon saw this as a pair to *West Penwith*; though this pairing seems
largely dichotomous, a common feature would appear to be an overriding
concern with space.[26] He saw *Portreath* as a return to the issues raised by
Box Construction No 1 in that 'it is a very frontal picture with shapes
looking out at you ... it might almost have been made in a square box ...
that place is for me an excuse to construct a square picture with planes
working in depth and on the surface'.[27]

38
Portreath, 1949
Oil on board
20 × 16
Private Collection

Space was his major concern at this time and his writings reveal this to go beyond a formalist's desire for shallow pictorial space, which he had learnt from Nicholson, to address the relationships between the painter and his subject and between human beings and space. It seems to have been around the idea of a space that embraces humanity that Lanyon forged a link between constructive art – itself concerned with the definition of real, inclusive space – and humankind. While working on *West Penwith*, he drafted a statement that described the theory of space and time that was coming to inform his work. Contrasting the new 'conception of the time space nature of existence' with 'the conception of the static', he wrote of a painted object that rejected visual mimesis for 'the nature of (an) experience in its time space arrangement' that drew on the dynamic theory of matter revealed by 'the discovery of the subconscious and developments in mathematics and the Sciences'. The manuscript revealed Lanyon's project to be nothing less than the development of a landscape art that went beyond the achievements of Cézanne. One could argue that landscape artists had still not learnt from the lessons of Cubism, and that even the Cubists had not applied the multi-dimensionality of their still lifes and portraits to the wider environment. Cézanne, Lanyon wrote, 'creates out of his surface a space construction in the same way as a sculptor carves an image from the stone'. But, he went on,

> the mechanics of the artist today are concerned no longer
> with space perspective, tone rendering or any of the
> formulae invented for the creation of verisimilitude because
> his aim is not to "photograph" nature but to re-present
> nature of which he himself is part ... he is concerned with
> the fundamental reality of space-time.[28]

Thus, in contrast to the 'static reality' of traditional landscape, he sought to represent 'the reality of space-time in which (the artist) exists as much as the objective facts (sea and rock)'.[29]

We can see, then, that Lanyon's conception of reality was one in which subject and object – the painter and his environment – are a single continuum. By relating this back to the model of Gabo, whom he described as an artist who worked with space and time, he saw this approach to landscape as a continuation of the 'Constructive Idea'.[30] He explained that, unlike traditional perspective or Nicholson's setting of objects against a landscape, the space in his work seemed both to recede into the picture and to project from it. This was 'derived from a physical involution with my subject', that is to say the artist and the place became involved with, rolled into, each other. This came from Gabo's demonstration that a 'constructive image develop(s) a spatial configuration of a quite definite nature'. For himself, Lanyon concluded, the 'problem of landscape becomes one of painting environment, place and a revelation of a time process as an immediate spatial fact on a surface'.[31] Rather than set apart from the

landscape, occupying a position that provided a commanding, ordering view, Lanyon saw himself immersed within it. This idea would come to mean both a physical, bodily immersion and a sensual and emotional engagement.

In his theorization of a new art of landscape, Lanyon reverted to many of the ideas that had provided a theoretical backdrop to the artistic innovations at the beginning of the century. He seems to have read Einstein, and his understanding of space-time as a continuum clearly indicates his understanding of Relativity's attack on time and three-dimensional space as distinct absolutes.[32] He told Gabo in 1948 that, 'only in the work of philosophers and scientists (as revealed in their quite frequent talks on the radio and in books) is there any sanction as it were for what I do. The artists are hopeless'.[33] We do not know which philosophers interested him at this time, but clearly from his verbal commentary on his work his predominant concern was with the nature of existence and the relationship between the individual subject and his environment. It is at this time that we can see the emergence of what would become a major strand in Lanyon's art, the sensual experience of the body within a place.

In his essay on 'Time Space and the Creative Arts', Lanyon described the phenomenological experience of the body on a clifftop. Looking down at the water swirling two hundred feet below, he wrote,

> presents a disturbance of equilibrium in the observer. A readjustment is necessary either by removal to solid ground or a fall towards the engulfing sea play. An alternative readjustment can occur in the observer when he realises he is seeing an image of his own fundamental existence.[34]

A few months later he made a construction that apparently sought to create a similar sensory imbalance. When telling Gabo of his new paintings in February 1949, he had speculated on whether they would produce a construction in the same way that *Construction* (1947) had emerged from the 'Generation Series'.[35] In June, it seems to have been made, as he then described an object consisting of two curving metal forms that rocked on a piece of glass. He told Terry Frost, 'they have different speeds and are related to one another like man and woman both individuals with separate rhythms but combining to create one whole image'.[36] Years later he recalled how successful it had been in reproducing the effect of a vertiginous imbalance, when he described showing it to Philip James of the Arts Council:

> I gave him a prism and I said, '... If you put it that way you will have reversed the object ... now we'll work it with the window', and there he had a reversed object and the ordinary vision ... superimposed on it. And I said, 'come over here and look at this thing', and I rocked it and he fell over.[37]

Lanyon told Frost that the construction was 'being transformed into colour and line on a surface 6 feet by 4 feet. The whole is essentially landscape – or of the rocks and substance of here'.[38] The only painting of that size made in 1949 was *Cape Family*, but, despite the gendered imagery in that work, it is hard to discern a formal relationship between it and the construction. Eventually, the latter came to be employed in the preparation of the larger *Porthleven* and it is visible on the right-hand side of a photograph with an early state of that painting (40).

The phenomenon of physical imbalance, of a disharmony in one's relationship with one's environment, would become crucial to Lanyon's work. This disturbance revealed, as he wrote in 1948, the fact of the subject's 'own fundamental existence'. This conception of existence, like the artist's approach to the painting of landscape, reflects the way that he placed the body at the centre of things. In so doing, it implies an appreciation of contemporary philosophy – notably existentialism and phenomenology – though it remains unclear to what degree Lanyon read contemporary philosophical texts or whether his ideas were more influenced by a general intellectual current. As we have seen, this also marks a return to the thought of the early part of the century, specifically that of Henri Bergson. Though it has been suggested that Lanyon first encountered the theories of Bergson when he was teaching at Bath Academy of Art at Corsham Court after 1950,[39] his 1948 text may reveal an earlier awareness that would have supplemented his interest in Jung and Einstein, amongst other writers.[40] He could have learnt of Bergson from Bernard Leach whose own activity, like that of other potters, had been informed by Bergson's vitalism since the 1920s.[41]

In *Matter and Memory* (1896), Bergson proposed a conception of the body as the centre of one's perception and action in the world – the touchstone to which all other things must be referred. Because of the body's movement in the world, its perceptions are informed by memory and anticipation; this notion might be compared with Lanyon's formulation of a landscape art that encompassed historic events and personal associations, as well as a perception of a place by all of the senses.[42] The centrality of the sensate body was also a major theme in contemporary philosophy, and so one can see Lanyon's work as part of a dominating intellectual discourse rather than dependent upon a single author. The emergence of this approach came shortly before other artists and writers engaged with ideas of phenomenology. During the 1950s, the phenomenology of the body and its susceptibility to outside forces became a persistent theme in European sculpture and was seen, for example, in Francis Bacon's painted treatment of the nude.[43]

Perhaps more significant for Lanyon at that time was Bergson's theory of duration (*durée*), which proposed a model of time as perpetual flux, as opposed to a series of separate static moments. This concept has been associated with the work of the Cubists, and it provides a useful theoretical

frame for Lanyon's desire for an art of landscape in which space is welded to time in concord with contemporary ideas of reality. According to Bergson, 'duration is measured by a body in motion', and, in keeping with Stokes's statement that 'space is simultaneity', Lanyon sought to express in two dimensions the intricate webbing of time and space as experienced by the body.[44] Subsequently, what he understood by 'time' changed, and in later work historical time and memory would play a more prominent part; but in the works of 1949–51 we can see the artist developing a means of painting his environment that placed experienced time – or 'duration' – at its centre.

Porthleven (**42**) is a good illustration of Lanyon's employment of the Bergsonian concept of time, its forms deriving from the artist's movement through the spaces of the eponymous fishing village. He described a two-stage breaking down of the space-time relations of his subject: the first was one of 'Identification with a place by walking or climbing, in fact moving in a dancing sense within that place. Picking of flowers, or stones, making contact with the substance of the place', followed by the second stage of approaching the place, 'from different aspects', in order to disturb the single viewpoint. The painter then, in making his work, had to 'take these time and space experiences to construct them into reality' (**45**). Something of his approach is also suggested by the way he taught landscape in his first year at Corsham (1950): he began by having the students gather different objects – bark, stones and so on – so that they might obtain information 'from within an environment and not standing apart from a view', in the hope that 'they would find an approach to understanding space in this way'. 'The essence of constructive landscape' that he sought to convey 'was that objects as such ... do not exist but only the whole. That is to say the place exists'. He seems to have drawn a parallel or equivalence between this experience of place and the generation of a painting: he went on to say that 'the image ... is arrived at by (this) expedition of discovery' and, consequently, that 'no element of the picture exists by reference to known objects but only in reference to the whole image'.[46]

In Lanyon's approach there is perhaps another echo of Adrian Stokes's aesthetics. For Stokes, the individual's subjectivity is defined against those things 'other' to it, and in *Inside Out* (1947) he defined the outside world as the embodiment of such an otherness. For Stokes, the function of the painter is to dismantle their environment and to reconstruct it as a whole. 'To paint a picture', he proposed, 'is metaphorically to take things to pieces in the outside world and to put them together again; a re-enactment of an early state'.[47] Thus, 'the otherness of the outside world is affirmed, mitigated, by the intrusion of this artist's organizing mind'. To extend the Stokesian reading, if the pictorial reconstruction of the painter's object is an act of reparation for infantile attacks on the mother in fantasy, then a special poignancy attaches itself to these highly subjective evocations of a Cornwall that represents both Mother Earth and the maternal protection of home.

If the idea behind such works as *Porthleven* seemed clear, the working practice was not. For their competition '60 Paintings for '51', the Arts Council invited sixty contemporary painters to produce a large-scale composition for which a canvas (then scarce) was supplied; the results were to be exhibited around the country and prizes awarded to selected works. Lanyon's invitation was a reflection of his growing reputation and, though not awarded a prize, the success of his entry was indicated by its selection as one of five works to be purchased by the Contemporary Art Society. Nevertheless, he was far from certain about the work's merit and had been exhausted by the struggle for its resolution. He received the invitation in February 1950 and spent much of that year working on the painting. It thus coincided with his resignation from the Penwith Society in May 1950 and his impassioned and irredeemable split from Nicholson and Hepworth (see Chapter 5). He blamed this situation, the lack of support and personal isolation, for the problems he had with his painting. As he wrote to one friend, 'it is very difficult when all ones hopes and ideas have been shat on'.[48] In fact, similar, apparently intractable, problems had already emerged as typical of Lanyon's studio practice, but the means by which he sought to solve them are indicative of their basic cause and his intention.

Porthleven is a large Victorian village, at the end of a valley, with a harbour built within the estuary. Its exposed, south-westerly position necessitates two harbours and they, in their turn, are protected by a long quay curving out into the sea on the village's southerly, left-hand side. This quay and the clock tower of the Working Men's Institute that stands at its landward end appear at the top of the painting. Along the inner harbourside are a series of large buildings – net lofts, salt cellars and stores for the china clay that was shipped from there. On one side, the antiquated Ship Inn nestles into the slate cliff face, while the opposite side is dominated by a terrace of white-painted Victorian villas. Porthleven's dour, Victorian structures – including a large Methodist chapel – deny it the picturesque character of St Ives but make recompense with a certain pragmatic ruggedness.

Lanyon described the place in order to explain the painting: he noted the long, steep valley leading to the village on which you could look down from the hills on either side, so that its setting was one of green fields. With the two harbours – the inner protected with timber gates – and an outer breakwater, the structure of the place echoes its topography and 'the water runs right down through the middle of the picture, which is rather like an aerial view. … There are some frontal planes, but down at the bottom are a number of shapes which roll and pitch – like boats moving around in the inner harbour'.[49] The imagery appeared less specific to some of those who saw it. While one regional critic described *Porthleven* as 'a sombre hued explosion in a scrap yard' and noted 'Peter Lanyon did it. Only he can explain why',[50] John Berger pointed it up as the most obvious success of the '60 Paintings for '51' exhibition:

> Previously, I had thought the effect of Lanyon's landscape
> cross-sections too fortuitous, their textures and shapes
> liable to so many interpretations that they were almost
> meaningless. But in this picture the forms are solid and
> strong ... while the rhythm of the apparently casual
> gestures of paint ... is quite precisely evocative of the
> rhythm of the sea and the elements. One gains not only a
> generalised sense of weather and place but of geological
> and tidal change.[51]

It was with *Porthleven* that Lanyon established a methodology for his
painting; as he put it, the work 'proved to me that I could hold a complex
image inside and might one day be capable of fusing the image and the
mark'.[52] By the term 'image', he meant a mental picture of the place
and how it might be represented in paint, that is to say something more
complex than simply an idea of how the painting should look in the end.
To resolve the problem of the final picture necessitated a large number
of preparatory devices. Lanyon made numerous drawings, some more
finished than others, of varying degrees of representation, of different
parts of the village, some broad views, others small details (**39**). In these
one can identify elements, or the germs of them, of the final painting, or
earlier states of it. One can also see in some of the drawings some of the
ambiguities that would characterize the final work. This seems to have

39
Study for Porthleven, 1950
Crayon on paper
22 × 15
Private Collection

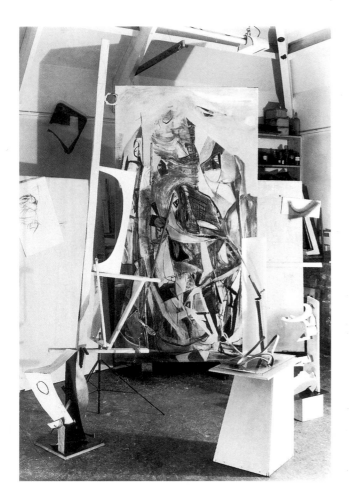

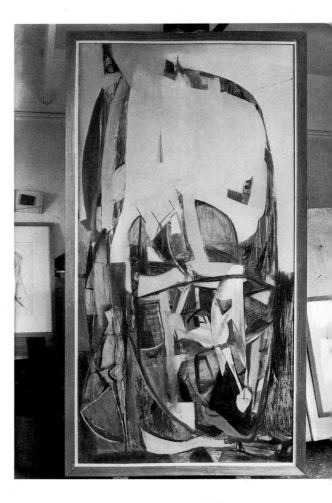

← **40**
Porthleven in process, 1950–1,
showing constructions in the
foreground *(left to right)*
'Porthleven Boats', 'Armature',
'Mobile' (with an untitled work
behind), 'Space Articulator'
Photo: Tate Gallery Archive, London

41 →
Porthleven in process, 1950–1,
showing 'Study for Porthleven'
on the right
Photo: Tate Gallery Archive, London

been a method akin to collage, as Lanyon attempted to bring different
evocative details together in a coherent whole, and it was probably that
act of assemblage that presented him with problems. One drawing appears
to be an imagined aerial view of the harbour, and may also have served
as a mapping of the structure for the upper section of the painting.[53]

In the production of *Porthleven* Lanyon made a number of
three-dimensional constructions (he once claimed to have made a dozen[54]).
These were not finished works but devices with which he tried to establish
the space of the painting or, as he later put it, 'to test how the image (was)
cooking'.[55] That he should make three-dimensional structures from a
variety of materials for such a task shows the importance he attributed to
space. Specifically, the use of structures that defined and articulated space
reveals his desire to retain, in two dimensions, the illusion of an embracing
constructive space. He wrote later that such constructions were 'not
complete things in themselves but are experiments in space to establish the
illusion and content of the space in the painting … I had not evolved a way
of developing an image in my mind and had to explore it in actual space
before painting it'. They were, he said, like 'scaffolding' for the painting.[56]

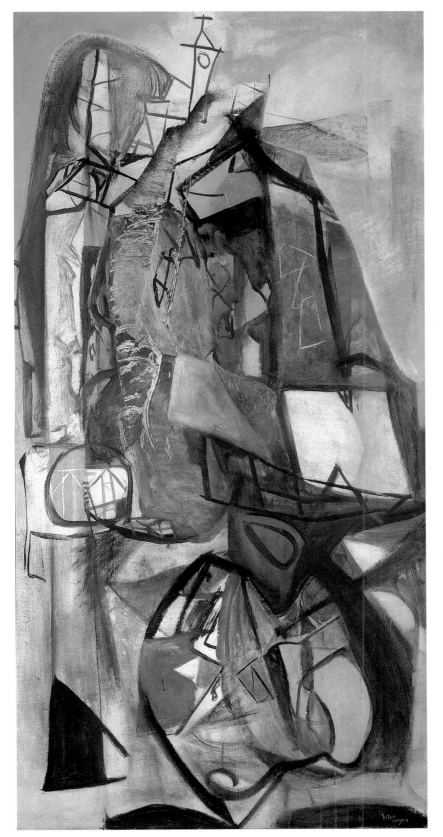

42
Porthleven, 1951
Oil on board
96 × 48
Tate Gallery, London

He compiled an album of photographs that documented the painting's progress and a number of the constructions. The main one, which presumably served to work out the main structure of the painting, he called *Armature*. Eight feet high, it was made of white-painted wood set on a metal tripod and was described by the artist as 'not truly three-dimensional but essentially a form suggestive of depth, motion and horizontal motion on a plane'.[57] Near the top he attached a red photographic filter and there was a green one towards the end of an arm – 'the "flag" structure' – that extended up and outward: these, presumably, referred to the navigation lights that serve to direct ships around the perilous coast and into the harbour of Porthleven. Another construction, visible standing on the floor on the right of the studio shot and called *Space Articulator*, was made up of carved wooden forms, painted white and green, attached to either side of a board. The artist noted that 'the space between these forms and the space extensions off the vertical board comprise the essential spatial factors of the painting'.[58] The third construction was the rocking two forms set on a glass base, which he now called *Mobile*. In the photograph one can also see a mechanism made up of two thin pieces of wood attached by a complex, articulated joint set against a white board. In addition, on the left-hand side is the metal and wood construction now known as *Porthleven Boats* (**43**), with which he seems to have explored the possibilities for curving boat forms in the painting.

The relationship between the constructions and the final painting is unclear. The blue curling line at the bottom of the final work can quite easily be related to one of the two rocking elements of *Mobile*, but such a direct relationship is rare. One possible reason for the opacity of the translation of the constructions into two dimensions is that they contributed to the development of the first version of the final work. However, one construction, the vertical *Tall Country and Sea Shore* (**44**), is thought to have been made later than the others and so has been specifically related to the second version of *Porthleven*. This proposal is based on its apparent similarity to the main vertical axis of the painting. Lanyon worked on his canvas for about a year – painting, over-painting, wiping off, repainting and scraping down – until the support disintegrated under the assault. In the rapidly produced final state, the paint is unusually thin and the design has a strong linear element – notably in the clock tower that binds the composition at the top. This was one of the major compositional changes made in the second version, as photographs of the first state at various stages of completion show the clock rising up the left-hand side of a denser composition.

The painting, then, presents a visual record of Lanyon's physical experience of Porthleven: the structure follows his movement through the town and some of the visual phenomena encountered there, such as the rocking boats. One can identify less literal signs: the oval, for instance, may be seen as a reference to the inner harbour, its egg-like form adding

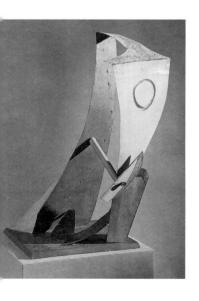

43
Porthleven Boats, 1950–1
Painted wood and sheet metal
24¾ × 14⅛ × 16½
Tate Gallery, London

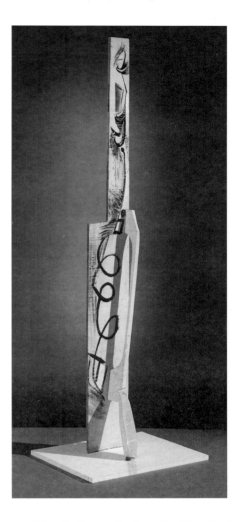 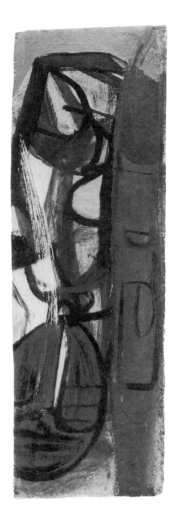

a subtext of germinal protection that recalls the use of harbour imagery during the 'Generation Series'. Retrospectively, Lanyon also identified figures in the work, and such interpretations after the event became commonplace. On the left he discerned 'a very tall masculine shape holding up something that looks like a lamp: and on the other side there seems to be a woman in a shawl – someone you could meet anytime walking around the Porthleven shore'.[59] These were archetypes, the fisherman and his anxious wife – classic images from nineteenth-century representations of Newlyn – revealing an embodiment in the place of its human history and activity.

Lanyon's painting of an experiential landscape, the representation of an environment as seen by a subject moving through it, was one of a number of contemporary representations of landscape modulated by changing technologies, such as Richard Hamilton's *Trainsition* series – a group of paintings based on the view from a moving

44
Tall Country and Sea Shore, 1951
Painted wood and perspex
70 ½ × 11 ⅜ × 7 ⅞
Tate Gallery, London

45
Bicyclist in Penwith, 1951
Oil on board
18 × 6
Arts Council Collection, London

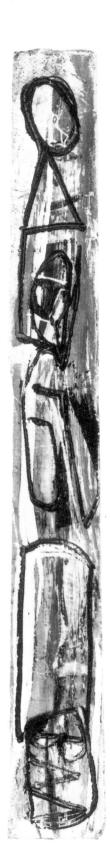

train. Those, however, reproduced the Nicholsonian device of the window that renders the landscape as the object of a distanced gaze, while Lanyon sought to intermingle the viewer and space. The spatial movement on which *Porthleven* was based secured a pronounced verticality as central to Lanyon's production. The reversal of the horizontality of conventional landscape painting served to highlight the artist's emphasis on the experience of a place in time as well as space. As a young man before the war, he had enjoyed driving fast along the coast and he now drew on such activities for his art. In *Bicyclist in Penwith* (1951) (**45**), a sense of progress through space, of narrative, is suggested by the long, thin board.

The proportions of such works, and the very small size of others, seem to accentuate their status as objects, which was reinforced by their presentation on white boards within simple frames that let the viewer see the rough-cut edges. This is also a quality of many of the larger paintings and it is likely that the artist wished to make reference to the work of Alfred Wallis, the St Ives rag-and-bone man and sailor turned painter. Lanyon had bought a large work from Wallis shortly before leaving for the war and it could have been a source for his long paintings. Wallis's renditions of the space of the town were based on lived experience rather than artistic convention and so often included the inversion of houses as the composition moved around the edge of the board. This was an important precedent for Lanyon who recruited Wallis to his self-definition as an authentic local artist.

Though Lanyon continued to use a vertical format, it was at this time that he produced such gaunt works as *Pendeen Rose* (1951) (**46**). As well as the narration of his movement across a place, he related these to his climbing of Cornish cliffs and the consequent experience of vertigo. A state of physical instability and psychological anxiety, vertigo also served as a symbol of human frailty that resonated with Louis Aragon's description of the 'vertigo of modernity'. As such, one may usefully draw a comparison between a work such as *Pendeen Rose* and the contemporaneous presentation of Giacometti's emaciated figures. Thus, based on the experience of place, Lanyon's paintings signalled in their format their engagement with states of being.

46
Pendeen Rose, 1951
Oil on board
36 × 6½
Private Collection

Lanyon and St Ives

'... perhaps the most appropriate monument to
St Ives will be a large stone with a hole through
the middle.'

Lanyon was inevitably included among the loosely defined group of artists
known by the label 'St Ives'. Though lacking a common agenda or style, the
idea of a St Ives school of semi-abstract painters and sculptors whose work
was derived in some way from the natural environment proved expedient
and resilient. It continues to be so, though little has been done to try to
reach a clearer definition of what common ideas constituted 'St Ives'. In the
years immediately following the war, Lanyon was among the most active of
the modernizing artists who set out to make changes to the town's artistic
infrastructure. From 1950, however, he continually and vociferously
resisted any attempt to associate him with any school or group, especially
that of 'St Ives'. On one level, this was a case of deteriorating personal
relationships and local art politics. On another, the various disputes that
he maintained until his death determined, to some degree, Lanyon's self-
definition and his work. They also reflected variant attitudes to cultural
production and the role of place and regional identity within it. His disdain
was not reserved for the artists of St Ives but also for the town itself. The
two issues were linked, but, over and above his disagreements with his
fellow painters and sculptors, he grew increasingly disgusted at what
he saw as the self-inflicted cultural decline of the town.

 During the war the St Ives Society of Artists, a conservative
organization, seems to have symbolized or epitomized the reactionary
position for Lanyon. Away in the Mediterranean, he wrote at one point of
a neo-conservatism he saw in British culture and politics: he feared that
'a spiritual renaissance' would lead to 'a return to myth, folklore even
ritual and (so) ... to sentiment and the resurrection of the dillitante (*sic*)',
and with regard to the resurgence of the Tories, he said, 'the St Ives Society
of Artists rears its ugly head! I fear a bogus return to prettyness acceptable
to the cushion bred fancifuls of the elite ... couldn't we quietly set a delayed
action mine there?'[1] He was puzzled, therefore, when he heard that his old
teacher Borlase Smart, secretary of the Society, had befriended Nicholson,
who had then exhibited in Smart's studio on St Ives' traditional Show Day
and contributed to the Society's spring exhibition. Lanyon saw this as an
optimistic sign: 'I hope to be able at last to show my own work at the
society', he told his sister,

St Ives may wake up. I hope it will and hold many of the
contemporaries, take them away from London. There is
no better place for the new movements in Art to grow
than a place like St Ives, not too closely connected with
the intellectuals of London and near the cliffs and hills
of Cornwall.[2]

Lanyon was not alone in such aspirations and, following VE Day, he was
contacted while still in Italy by Sven Berlin and John Wells who were
discussing plans for the peace.

　　　One of Lanyon's pre-war views of Ypres was exhibited on Show
Day in 1945, and from that year the so-called 'moderns' were allowed to
hang works in the St Ives Society's gallery, the former Mariners' Chapel,
though marginalized to the corner around the font. Lanyon also showed
in a number of less formal venues that became available for exhibitions
of modern art in the town, including the Castle Inn and George Downing's
Bookshop, where he had a one-person display in 1951 and took part in
several mixed shows, notably with Nicholson, Hepworth and Wells in July
1947. In 1946, Lanyon, Wells, Berlin, Bryan Wynter and the printer Guido

Morris founded the Crypt Group, so called because they exhibited in the crypt beneath the Society's gallery. Lanyon later wrote that this had been suggested by Borlase Smart who, as secretary, was keen to incorporate the modern artists into the Society. Conservative elements in the Society took exception, in particular Harry Rountree whose attack on the show in the local press was undermined by the revelation that he had not seen it. The Crypt Group had no constitution and the work was acknowledged to be diverse in style and intent, though one might now see the theme of renewal through an engagement with nature as a common concern. It would appear, however, that it had a broader agenda than simply functioning as an exhibiting mechanism. In 1948, following his return from Italy, Lanyon tried to arrange for a London exhibition of the Group; having failed to mention it to Duncan MacDonald of the Lefevre Gallery, he reached a verbal agreement with Erica Brausen to show at her new Hanover Gallery in September 1949, but by that time the Group had disbanded.[3] The Crypt enjoyed considerable success, attracting dozens of visitors each day, receiving reviews in the national press and on local radio, and even selling some work. The 'third Crypt Group Exhibition' was opened by the Director of Visual Arts at the British Council, Francis Watson, and was visited by his equivalent at the Arts Council, Philip James.

By 1948, the Crypt Group had considerably expanded and diversified the type of art it showed. For their second Exhibition, in 1947, they were joined by Wilhelmina Barns-Graham, showing slightly naive views of St Ives and Penwith, though Wynter was unable to participate; the third Exhibition, the following summer, also included Patrick Heron's Braquean interiors and harbour views, David Haughton's sombre images of St Just, Adrian Ryan's exquisite oils in the manner of Soutine and Utrillo, and Kit Barker's stylized pictures of nature that were akin to Wynter's work. In November that year, Lanyon resigned his role in the group, and his letter to Berlin shows that he saw himself as 'founder and director of the Crypt'. He felt that the group was no longer co-operative, and feared that the strong opposition from some of the members – primarily Berlin – would be damaging to him at a time when his own work was maturing.[4] A few months later he recorded

> that the three exhibitions there were outwardly calm,
> but rarely so in the personal relations. I found a peculiar
> antipathy to Sven Berlin, which still goes on. This is a matter
> of aesthetic preferences ... a tension was set up between
> the "Primitive" of Sven Berlin and the constructivist
> attitude of Gabo ... represented by Nicholson, Wells,
> Hepworth and myself.[5]

These differences were expressed in Berlin's article, 'An Aspect of Creative Art in Cornwall', in *Facet* magazine, to which Lanyon wrote a rejoinder. The differences between the two artists were later reflected in Berlin's

barely fictionalized account of his years in St Ives, in which Lanyon was portrayed as a wealthy upper-class painter who could entertain collectors and critics with croquet on the lawn and was alleged to have tried to run Berlin down with his car.[6]

Lanyon wrote that he 'believe(d) the 3 years of shows have completed the revolution in the society which I aimed to achieve',[7] meaning presumably that the Society had been forced to incorporate a degree of modernist work. As the organizer of the Crypt and a local person, he had been elected to the committee of the St Ives Society of Artists in 1948. Following the death of the moderate Smart, Lanyon 'turned on the heat as far as the "Moderns" were concerned' and sought a higher representation for them.[8] As well as expanding the membership of the Crypt Group – for which he was censured by the committee – he invited such modernizing artists as Tom Early, Denis Mitchell and David Haughton to submit work. He acknowledged that these attempts to revitalize the Society alienated many members and led to a confrontation that would end in secession.

Despite an apparent strengthening of the conservatives' position early in 1948, an extraordinary general meeting of the Society was called in February 1949 by ten members who felt that the chairman Leonard Fuller and secretary David Cox had given too much to the modern wing. The result was that members would be ensured of inclusion in all of the Society's exhibitions and Lanyon feared a 'return to a type of work which may have been of cultural value in the last century but no longer has any significance except as a commodity of some sort'.[9] Following the meeting, Fuller, Cox and Lanyon resigned as officers and left the Society along with 'the entire section of modern artists'.[10] The first suggestions for the foundation of a new society seem to have come independently from Barbara Hepworth and the potter Bernard Leach, and at a meeting at the Castle Inn on 8 February the Penwith Society of Arts in Cornwall was founded. The founders were largely those who had resigned from the St Ives Society and some local craft workers, and others were invited to join, including Wynter, Haughton and Dod Procter RA.

The Penwith was conceived as a regionally constituted, catholic body, encompassing the work of traditional and modern artists and craftspeople. That catholicity was a vital quality, as the Penwith was setting itself up, not as representative of a particular ideologically defined constituency, but as a regional, communal art group. As such, it hoped to become the principal local Arts Council client. To this end the ex-chairman and secretary of the old Society took up the same posts in the Penwith, which was declared a tribute to Borlase Smart. The ensuing public row about which society really represented Smart's views was finally resolved by his widow's declaration of support for the Penwith. The debate was more important than might appear because, in January 1948, a trust established in Smart's name had bought the Porthmeor Studios – one of the primary studio spaces in the town – with the aid of a generous Arts Council loan.

Under the terms of the trust, tenants were chosen by representatives of the Arts Council, the Tate Gallery and the St Ives Society of Artists, but following the secession of the Penwith, the third deciding member was altered to a local resident. Shortly after this change and following personal approaches to the Arts Council representative Philip James, Ben Nicholson secured one of the studios.

Lanyon played a major role in the early days of the Penwith, having been appointed as liaison officer to deal with press interest in the split from the St Ives Society. The Penwith became increasingly regimented, with Nicholson suggesting that the committee, professional members and lay members should be segregated at General Meetings, while Hepworth proposed that the hanging committee should be made up of two sculptors, two craftspeople, two traditional and two modern painters, and that works should be marked accordingly. Following a successful first Summer Exhibition, in November 1949 Lanyon proposed that the division of work into 'Representational' and 'Abstract' should be replaced by the letters 'A' and 'B' respectively, and crafts should be designated as 'C'.[11] The slight alteration presumably reflected his own rejection of the label 'abstract', but a few artists, including Berlin, refused to assign their work to any particular category and resigned from the Society in February 1950.

A series of events served to raise doubts in Lanyon's own mind about the conduct of the Penwith. The reading out of the letters of resignation was barred on Hepworth's instigation, and she, Nicholson and David Leach opposed the suggestion that the committee should hold a meeting of reconciliation with the dissenters; when Lanyon met with one of them he was accused of disloyalty by the rest of the committee, to which his response was to demand that they call a vote on his expulsion at the next General Meeting. Finally, following the resignations, Hepworth proposed that membership should be boosted by a change in the rules to allow a certain number of members from outside Cornwall. This last proposal seemed to Lanyon to signify an attempt by the Hepworth–Nicholson circle to use the Penwith as a vehicle for a particular artistic agenda in defiance of its regional constitution. The controversy was made more fraught by its coincidence with the lobbying, primarily by Hepworth, for Arts Council funding and a visit from Philip James.

Lanyon resigned from the Penwith Society in May 1950 and immediately joined with the other former members in a public denunciation of the A-B ruling. His antagonism to the Penwith would persist for many years and he launched frequent attacks in the local press on it and the Hepworth–Nicholson group that continued to dominate it. In 1959, he refused an invitation to contribute to a touring exhibition marking the Society's tenth anniversary and warned that he would publish material in support of his objections wherever the exhibition was shown.[12] A softening of his position came in 1963, when he finally agreed to show

three paintings on the invitation of his friend Breon O'Casey.[13]

In splitting from the Penwith, Lanyon opened up a lasting and damaging animosity to Nicholson and, most especially it would seem, to Hepworth. Their response seems to have been more one of confusion than a reciprocation of his fury. In April 1950, he wrote to Nicholson explaining that the events of the Penwith had caused him 'almost unbearable misery' and that he could not understand why his friends had treated him with 'such coldness' while he was 'fighting against the most destructive bitterness' in himself. 'I would prefer it if you considered me deranged as Barbara has suggested', he wrote, revealing perhaps the reason for his particular bitterness towards her.[14] Despite Nicholson's suggestion that they exchange works of art as a sign of mutual respect, and later attempts by Lanyon to restore relations, this feeling persisted until Nicholson left St Ives in 1958; the rift with Hepworth continued until Lanyon's death. As a result, alongside more public verbal attacks on the sculptor, Lanyon with Denis Mitchell – Hepworth's senior assistant throughout the 1950s – instigated a campaign to undermine her garden by regularly urinating against her wall at night.

As well as the technicalities of painting, Lanyon had learnt from Nicholson the importance of professionalism and strategic promotion. When he resigned from the Penwith, he immediately wrote to the influential critic Herbert Read (the Society's president), Philip James and Lilian Somerville, who, as the new Visual Arts Director of the British Council, was arguably the most influential figure in British art. For many years he perceived plots against him and, in particular, he saw his exclusion from the highly effective patronage network that 'St Ives' represented as a deliberate attempt by Nicholson and Hepworth to keep buyers from his studio. On several occasions he stated his belief that visitors to St Ives were told that he was away when he was not. His vitriol was extended to others close to Nicholson and Hepworth, and he frequently told his dealers, Gimpel Fils, not to include him in exhibitions that might be seen as presenting a particular group; indeed, he resisted displays under the label 'abstract'. When the gallery showed work by those he opposed he was furious, writing, 'I have no desire to send paintings there to rub shoulders with the myxomatosis ridden rabbits of St Ives'.[15] Lanyon believed that Nicholson and Hepworth had broken the Penwith to promote a particular dogma, as they had the 7 & 5 Society in the 1930s, and was determined to defend his territory in London.

Over and above the immediate reasons for Lanyon's split from Nicholson, there is a clear Oedipal subtext to the row, a desire or need to assert his artistic independence from his teacher. Whether cause or effect, the break coincided with a change in the technique of his painting and a further distillation of his attitude to landscape and to Cornwall. This change

emerged at the time of his departure from the Penwith, when he wrote
that, though his resignation may have seemed like ingratitude to his three
teachers – Smart, Fuller and Nicholson – he had 'another teacher in this
rich district of Penwith and the generations of my ancestors who have
lived in it'.[16] From that point on, his stance on Cornwall was increasingly
nationalistic and, with regard to the artists of St Ives, he repeatedly
insisted upon his status as a native of the town in contrast to theirs as
visitors or, as he would have it, 'foreigners'. Thus, for an exhibition that
coincided with a competition organized by both Societies in the town for
the Festival of Britain and boycotted by Lanyon, his cousin Rosalie
Mander (the novelist Rosalie Glynn Grylls) wrote:

> Here is the work of a true Cornishman, born & bred in West
> Penwith, not one of the cuckoo orphans come down to claim
> the home where the rightful heirs belong ... Peter Lanyon's
> work has a backbone of granite underneath its charm; when
> this trips up the foreigner there is a chuckle of laughter on
> the Downs, from knockers deep beneath the soil and ghosts,
> never laid, that haunt Lanyon Quoit. You take risks here,
> Stranger.[17]

Lanyon articulated his desire for a painting that involved
human beings, and in which a relationship to place and local cultural
tradition was central. This became bound up with his rejection of a
Nicholsonian abstraction for an art with external references. He believed
that contemporary painters' concern for a space that seemed to project
from the picture plane was a rejection of the dogmatic abstraction of
Nicholson and Mondrian – 'unassailable and virginal' – for an art that
'will not violate human integrity'. The art that had to emerge from a
reaction to their 'immaculate' and distanced work should be 'a more
generous and "giving" one', he said, 'and the spectator's involvement
in my work is a reflection of its humanity'.[18]

While Lanyon's refusal of the label of 'abstract' reflected his
belief in both the function of his art as a human object and its necessary
relationship with an external source, it may also be seen as a typical claim
by an artist for uniqueness and a desire not to be grouped with a collective
phenomenon. For Lanyon, this became no less urgent after he had
established his distance from Nicholson, as the growing hegemony of
contemporary American painting and the associated formalist aesthetic
of Clement Greenberg in New York and Heron in Britain inevitably cast
him as an abstract expressionist. In the late 1950s he was wary of what
he saw as attempts, often mediated through the newly opened Waddington
Galleries, to include him in a group – consisting of Heron, Wynter, Frost
and Roger Hilton – that Waddingtons dubbed the 'Middle Generation'.
With those four and William Scott and Alan Davie, Lanyon was seen as
participating in a particular form of semi-abstract painting. His refusal

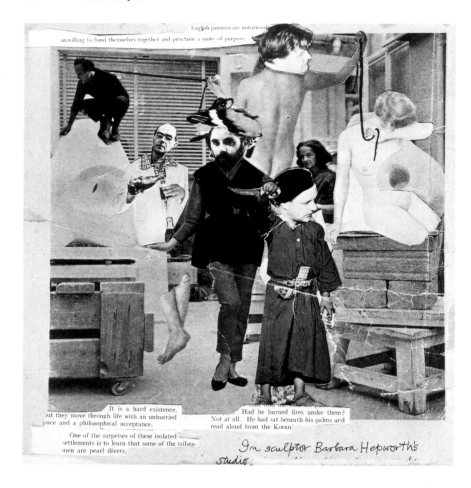

Within the collage:

English painters are notoriously unwilling to band themselves together and proclaim a unity of purpose.

It is a hard existence, but they move through life with an unhurried pace and a philosophical acceptance.

Had he burned fires under them? Not at all. He had sat beneath his palms and read aloud from the Koran'

One of the surprises of these isolated settlements is to learn that some of the tribesmen are pearl divers.

In sculptor Barbara Hepworth's studio.

48

'In sculptor Barbara Hepworth's studio', early 1960s, collage sent to Roger Hilton, showing *(left to right)* Patrick Heron, Roger Hilton, Victor Pasmore, two Peter Lanyons, Barbara Hepworth
Private Collection
Photo: Tate Gallery Archive, London

to be grouped with others was crucial to his self-construction as a unique creator whose work derived from an involvement with a particular place. Thus, he resisted what he saw as a covert establishment of a new 'St Ives school' and a debt to other painting – specifically the work of the American Abstract Expressionists – rather than an external source. He wrote to Gimpel Fils in 1957:

> I have wind of an attempt to club us all together like a herd under some odd label and you know I will not suffer this indignity too often or too much – and I do not want to be included among the action painters or the Sam Francis boys (irrespective of my personal regard for them) I belong, if anything, to the club started by Adam or Noah. I have no liking for 'Attachism' or 'Reaction' painting but merely for painting as a way of life.[19]

In 1960, when invited to show in a group exhibition in Nottingham, he wrote to Peter Gimpel:

> If Nottingham want a St Ives School, then its best bet
> is to get the (Waddingtons) gang and that will do. If they
> want painting which owes its existence to this place and
> not to New York or the moon, then they can show Lanyons
> by themselves. When the time comes I shall do a show
> but I am not going to boost a hybrid.[20]

Though he later fell out with Heron, and despite his professional rivalry
with Davie and occasional fight with Hilton at parties, Lanyon nevertheless
enjoyed friendships with the 'Middle Generation' artists and united them
in several comic collages (48). Wynter's use of natural sources for his
gestural paintings was not too distant from his own approach, but Lanyon
differed with Hilton especially on aesthetic issues. Immersed in the Parisian
tradition, until the late 1950s Hilton insisted upon the non-figurative aspect
of his art and on form as the only criterion for artistic judgement. A mutual
friend recalled one extended debate:

> (Hilton said), 'Why don't you admit that you're an abstract
> painter, instead of all this stuff about Cornwall?' But Peter
> maintained his position ... Hilton was never convinced, as he
> loathed 'views', and felt ... that Peter was unable to jettison
> this figurative attachment ... Hilton ... (asserted) that Peter
> was ... not facing up to the abstract and structural problems
> of the painting, which were his real preoccupation, and not
> 'all this Cornish nonsense'.[21]

In his behaviour in St Ives, Lanyon identified himself as a local
rather than an artist colonist, a stance epitomized by his preference for the
Golden Lion pub, where he would play a variation on dominoes with local
men, rather than the more 'arty' Sloop. His attitude was summarized in
an autobiographical note in 1957:

> A non-Conformist, dislikes groups and isms, international
> abstract art and systems. Plays dominoes every evening
> when at home. Is proud of the host of artists colonising West
> Penwith particularly his own contemporaries, but considers
> himself to be THE HOST.[22]

However, he did not, of course, separate himself off from all the other
artists. From 1950 to 1957, he was one of a number of painters and sculptors
who taught at the Bath Academy of Art, then housed in the splendour of
Corsham Court. Artists would be asked to teach for a period of a few weeks
or perhaps a term and distance seems to have facilitated many friendships.
There they were freed from the politics of St Ives and from domestic ties.
Colleagues included William Scott, Head of Painting, and painters Bryan
Wynter, Terry Frost and Peter Potworowski, and Lanyon forged an
especially strong bond with the Head of Sculpture, Kenneth Armitage.

He also participated in some artistic events in St Ives: while Bernard Leach was away, he visited Warren and Alix Mackenzie, who were working at the Leach Pottery, and produced a number of strangely shaped pots, which he included in his 1954 exhibition at Gimpel Fils and in a display of contemporary ceramics at Charing Cross railway station; he showed in an exhibition of 'Works by fifteen artists and craftsmen around St Ives' organized by Denis Mitchell and Tom Early for the Heal Mansard Gallery in London; he made silkscreen prints with the Mackenzies, and exhibited 'Prints under £1' with them and Patrick Hayman at Robin Nance's furniture workshop in St Ives; he contributed a design to a scheme for table mats initiated by Mitchell and Stanley Dorfman.

In 1954, Lanyon co-founded with William Redgrave, a conservative painter, the St Peter's Loft School in St Ives. Advertised nationally, the school promised practical and theoretical tuition: 'Instruction in technique from the ground to the frame … subject and medium are considered together'; traditional practices – 'preparation of grounds, the making of oil and water colours, emulsions, general chemistry and framing' – were combined with lectures in art history including 'contemporary developments' and the encouragement of 'Experiment with materials for abstraction, space construction, and design'; an etching press was installed after the first season.[23] This was a summer school that offered students bed and breakfast accommodation at the Redgraves' house and an eclectic mixture of teaching methods. St Peter's Loft continued an established pattern of seasonal schools in such places as St Ives. In the first year it had six students for about two months, but in later years there were more, and some of these were visitors from abroad sponsored by the British Council. In the first summer Lanyon spent a lot of energy on the school, teaching every morning, but later other teachers were brought in, including Terry Frost and younger painters whom Lanyon supported, such as Karl Weschke and Anthony Benjamin. It ran until 1960.

The primary motivation for St Peter's Loft seems to have been financial, as Redgrave was very short of money and Lanyon was having great trouble with his painting and had ceased teaching at Corsham. Some felt, however, that for him it was also part of a strategy to establish a 'school' in the traditional sense of a stable of followers. Though Lanyon was as scathing of those who adopted a 'neo-Lanyon' style as he was of the 'Cornish Academy', St Peter's Loft did produce several artists whose work shows a fundamental debt to their teacher's, including Jeremy Le Grice, Tony O'Malley and Nancy Wynne-Jones.[24] Nevertheless, his teaching was eclectic and not related to a particular style. He taught the preparation of gesso grounds and the grinding of pigment, promoted 'good drawing' over academic convention, tried to instil the idea that painting should include fantasy, and, most importantly, encouraged almost indiscriminate experimentation. He passed on a constructivist aesthetic, including a sculptural idea of pictorial space, but also highlighted the importance of Surrealism.

St Peter's Loft was, perhaps, part of Lanyon's strategy to establish an alternative power-base to Nicholson and Hepworth. To this end, he would welcome newcomers to the town, especially if they were not abstract artists. Thus, for example, Anthony Benjamin, as a young realist painter, was taken under his wing and, most notably, Lanyon tactically promoted the career of Weschke, whose expressive figuration was clearly outside the dominant aesthetic. Similarly, he was effusive in the welcome extended to Francis Bacon when he borrowed Redgrave's studio in 1959, and to Jack Smith, the 'Kitchen Sink' realist who later worked in an abstract idiom. Of course, such things were not just strategies of self-promotion; Lanyon was generous with his time and with materials. From 1953, he was a member of the Newlyn Society of Artists, where the director Michael Canney provided 'a sort of casualty clearing station for the battle of St Ives', and invited sympathetic artists to join.[25] He also encouraged smaller local galleries interested in showing more than the Nicholsonian abstraction, and so, despite his international status by that time, in the 1960s he showed at Elena Gaputyte's Sail Loft Gallery and the Fore Street Gallery in St Ives, and at the new Porthleven Group.

In March 1958, St Peter's Loft became embroiled in a local difficulty when Patrick Heron, through a misunderstanding, gave tuition to a Greek student registered there.[26] This small event contributed to the increasing tension between Heron and Lanyon. Since their early friendship, Heron had promoted Lanyon's work in the *New Statesman* in the late 1940s, in *Art News and Review*, in New York's *Arts* (previously *Arts Digest*) from 1956 and in the exhibition 'Space in Colour' at the Hanover Gallery in 1953. There were, however, fundamental differences in their attitudes to painting. As early as 1948, Lanyon was alarmed to find Heron to be a 'complete reactionary' in his belief in 'Poetry and Form Colour and Form etc.', in opposition to his own constructivist position. 'The difference lies', Lanyon wrote, 'in that he can take a poem to pieces and rebuild it, while I can take an engine to pieces and rebuild that.'[27]

This last statement encapsulated the differences between them: Lanyon saw himself as the tough, masculine artist in contrast to Heron's effete aestheticism. His rigorous, constructivist space was contrasted with Heron's 'greedy delight in any mark on the surface'; Lanyon believed that all relations with women were 'basically sexual', while Heron believed in 'an elegance in relationship which ... belongs to the true meaning of Bourjois (*sic*)'. In politics too, while Heron was 'buzzing around doing political campaigning' during the crises of Suez and the Soviet invasion of Hungary, Lanyon observed that 'when it comes down to doing any shooting I expect I will have to do it'.[28] In essence, he set himself up to play Wyndham Lewis to Heron's Bloomsbury, calling for an intellectual and formal rigour against the threat of good taste; he presented himself, as has been said of Lewis, as one of 'the boys who would do "the rough masculine work" of British modernism'.[29] In painting, Lanyon would

insist upon the physical and mental struggle of the artistic process, the social relevance of the artwork and the importance of an external subject. In May 1951, he was one of the artists whom Heron considered for his 'Post-Abstract Group', an unrealized movement for an art that was both modernist and retained a degree of figuration in opposition to the rise of pure abstraction led by Victor Pasmore. For Lanyon, however, the subject was paramount and he emphasized this by his claim to a type of realism; in contrast, Heron judged good painting, even if figurative, purely on the basis of colour and form.

Such differences were manageable, it would seem, until Heron settled permanently in Cornwall in 1956. He had bought the large house Eagles Nest near Zennor in 1955, and shortly afterwards Lanyon purchased Little Park Owles, the house in Carbis Bay that Stokes had occupied during the war. There is a sense in which the two might be seen to fight over Nicholson's role as 'top dog' of the district. Heron believed that Lanyon turned against him soon after Nicholson's departure from Cornwall in 1958, as Nicholson had predicted, and agreed that it was because he had helped him in his career.[30] There were certainly petty professional jealousies between them, as they competed over the promotion of their preferred protégés and for the attention of important visitors to St Ives. Lanyon believed Heron deliberately kept Clement Greenberg from him in the summer of 1959 and, reciprocally, Heron maintained that Lanyon had prevented Rothko from visiting Eagles Nest the following month.[31]

Significantly, however, the main source of friction between the two artists was the Cornish landscape and Lanyon's continued opposition to the intrusion of 'foreigners' into local affairs. In 1961, Heron led a campaign against the proposed opening of a new tin mine at Carnelloe, a headland near Zennor. Raising a petition of nine hundred signatures (many from national rather than local figures), Heron objected to the mine's impact on the landscape and the effect of the invasion of three hundred miners: 'Imagine importing West Indians and building a housing estate at Zennor', he wrote to Nicholson, 'and then the mine going bust'.[32] Lanyon, in contrast, vociferously supported what he saw in terms of its enhancement of local employment opportunities founded upon a romanticized idea of Cornwall's historical identity:

> The opponents of the scheme talk of beauty and the magnificence of scenery as if nature were incapable of wrath that would touch them … When the new arrived see the revenge of time creep up on their door steps, they wail out that we destroy the beauty of their views. What view do they think the Cornishman has, who desires above all to make his own riches, but is barred by some concept of beauty that denies him the honour of his labour.[33]

At the Public Enquiry into the proposal, Lanyon was the only witness
to speak for the mine; the planning application was refused.

This debate illustrates the contrast between Lanyon's attitude
to landscape, as part of a complex understanding of place, and Heron's
conception of it as the beautiful object of an appreciative gaze. As such it
reveals something of their differing views of painting. It also demonstrates
the convergence of Lanyon's artistic position and his feelings towards
Cornwall. His resistance to the interference of 'foreign' artists into the
cultural life of the Cornish was part of a wider dissatisfaction, shared
with many local people, with the area's dependence on tourism.

Lanyon's long-running feud with the 'foreigners' of the Penwith Society
parallels a wider conflict within the cultural and socio-economic life of
post-war Cornwall and its relationship to an increasingly centralized state.
The rapid growth of tourism in Cornwall since the last quarter of the
nineteenth century had been accompanied by a reciprocal decline in its
core industries of mining and fishing. Despite a brief revival of mining
during the war and in 1951 when the Korean War sent tin prices rising,
mining and fishing have been in terminal decline since 1918. Partly as
a consequence of this economic condition, Cornwall was undergoing
significant demographic changes as the outward migration of the young
continued unchecked and the population of retirees from outside the county
swelled.[34] A 1947 survey that charted the drop in the Cornish population
(2.5% between 1931 and 1938, a time when the national population had
risen by 3.2%) revealed that one of the most rapidly declining areas was
around St Just, which had witnessed the departure of 16.6% of its
population.[35] Methodism, a mainstay of Cornish culture since Wesley's
hugely successful visits to the mining districts in the mid-eighteenth
century, was also under attack, it has been argued, as the Welfare State
was 'chipping away at chapel functions'.[36] Against this backdrop of post-
industrial demographic decline was acted out the drama of the rapid growth
of tourism, of which the artists' colony centred upon the Penwith Society
was a part. The process of changing work patterns was accelerated by the
acceptance by local planners of the county's peripheral status and reliance
for any jobs, mostly in service industries, upon tourism.[37] The development
of new forms of touristic activity and experience through the greater
mobility resulting from widening car ownership was reflected by the county
planners' desire for a motorway to better link Cornwall to the rest of
Britain. In such ways, the region's dependency on tourism was seen
to erode its sense of difference and distance.

The dominance of tourism placed particular pressures upon
the land of west Cornwall, which found itself caught between the rock
of development and the hard-place of conservation, motivated in part by
the economic necessity of preserving the countryside as an attraction for

the self-same tourists. This was confused further by the post-industrial, rather than unspoilt, nature of the area. Sylvia Crowe, for instance, singled out the Land's End peninsular as, in its openness, particularly 'vulnerable to sordid intrusions', whilst paradoxically going on to call for the reclamation of industrial land for recreation.[38] It had been such anxieties that had motivated the 1945–51 Labour government to centralize control of land use and to designate National Parks in a bid to return the land to the people. Though it stopped short of the Uthwatt Report's call for the nationalization of land for development, the 1947 Town and Country Planning Act did represent a significant centralization of control over the landscape.[39] This centralization was taken further with Labour's second legislative intervention into the natural environment, the 1949 National Parks and Access to the Countryside Act, which reflected more than anything a view of the landscape from the perspective of the city. The roots of this legislation lay in the pre-war Ramblers Association, the Leavisite values of the Council for the Preservation of Rural England (CPRE) and such writers as Vaughan Cornish, and was influenced by a landscape aesthetic promoted by guide books epitomized in the work of H.V. Morton.[40] The establishment of National Parks was based on the belief that 'the beauty and quietness of unspoilt country' was a necessary 'refreshment' to the four-fifths of the population who 'dwell in urban areas, many of them in the smoke-laden atmosphere and amid the ceaseless traffic and bustle of our industrial towns and larger cities'.[41]

The issue of National Parks had very immediate implications for west Cornwall. The Cornish branch of the CPRE was the first to survey and report on its area, recommending in 1930 that the West Penwith moors should be protected and a National Coastal Park established.[42] In 1945, the Dower Report included the Cornish coast among its ten recommended National Parks, though the later Hobhouse Report, which placed greater emphasis upon the need to have a park easily accessible from each of the major conurbations, rejected such a long strip of land as too hard to administer.[43] West Cornwall was caught in an undefined position between the concept of the landscape as 'a national playground',[44] the touristic construction of the county as 'Riviera'[45] and the nationalist (in the English or British sense) image of an unchanging countryside that was promulgated in such discourses as wartime propaganda and the Festival of Britain. If, as has been suggested, countryside imagery projected 'a modern Britain emerging from the unsightly ravages of Victorianism',[46] what image did a landscape have that was a wilderness and sea coast scarred by Victorian industrialism?

One can see how the Arts Council-sponsored Penwith Society, in Lanyon's view of it, could be thought to parallel Cornwall's dependence on tourism and the subjugation of local culture to an homogeneous national identity. Lanyon's position continued an inter-war Celtic revival that, to counter the construction by S.P.B. Mais and other tourist writers of an

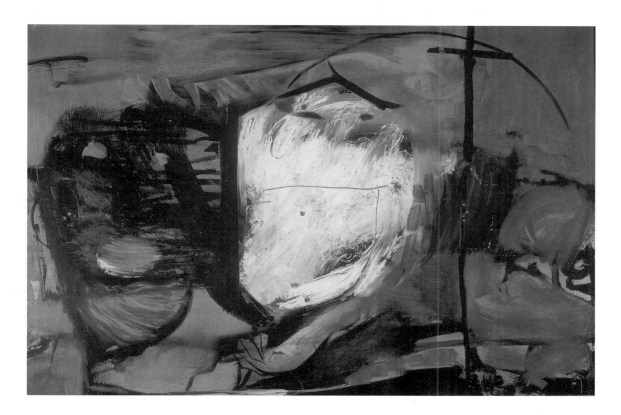

exotic, picturesque, ancient and primitive Cornwall, sought to fuse
pre-industrial and industrial histories in 'a Celto-Victorian synthesis'.[47]
This synthesis was reiterated after the war with the publication of W.G.
Hoskins's *The Making of the English Landscape*, which, along with a
number of popular accounts of Britain's geology and archaeology, such
as Jaquetta Hawkes's *A Land*, for the first time envisioned the landscape
as a palimpsest of its historical human occupation, including the recent
industrial past.[48] Lanyon's work from 1949 to c1953 focused on a
collocation of such historical associations and more subjective experience.

 Just as he railed against the foreign invasion of the area, so
Lanyon disparaged the town of St Ives for what he saw as its cynical
and greedy commercialism. The cultural decline of the town had been a
common cause of local concern since before the war, and, as early as 1940,
Lanyon wrote of 'the fun fairs at St Ives and the eating away like desease
(*sic*) of the fishermen's backbone'.[49] In 1962, he made a painting about
the town in which, from amid the swirling ochres, blues and white, a hand
emerges – that of the hypocrite asking for baksheesh on the way back
from chapel; it was painted on aluminium, which was good for kicking (49).
The decadence of St Ives and the dogma of abstract art coalesced for
Lanyon, as a vacuous abstraction provided an apparently fitting symbol
for the town's cultural vacuum. In his last years he drafted a description
of St Ives and its history in which he noted the migration of the artists
into the former homes of fishermen in the heart of the town and the

49
Untitled (Sunday), 1962
Oil on aluminium
48 × 72
Private Collection

movement of locals to council housing on its periphery, 'their harbour cottages condemned and then redeemed by the very gentry who first came to applaud, admire and exploit their way of life'. Now,

> the native knows he is being exploited and is not any longer the innocent in the game. He is liable to become abstracted himself and to live entirely on the subsidies of philanthropic bodies geared to the preservation of things – a large scale way in which wealth stops life from being awkward and progressing. We shall become a huge museum.[50]

St Ives had become 'a show place', he wrote, in the middle of which was 'abstract Art, a final and inevitable hybrid made out of the minds of people from nothing. It is the art St Ives deserves'. The complete surrender to tourism could prove counter-productive, he warned, as he proposed a typical Hepworth sculptural form as a symbol for the town:

> the artist may not remain detached from the moral illness of what is happening socially today. He may be forced by inner necessity or by economic conditioning to become a part of a more productive community leaving St Ives to the casinos and dance halls of the holiday trade, then perhaps the most appropriate monument to St Ives will be a large stone with a hole through the middle.[51]

A Penwith pilgrimage

'At present I seem to be on a pilgrimage from
inside the ground, as if I were the only one saved
from the Levant disaster ... the unlucky mourner.'

Porthleven was a turning point in Lanyon's career, an end to one type
of work and a new beginning. The enthusiastic reception it received
from different parts of the critical constituency, its purchase by the
Contemporary Art Society and its eventual acquisition by the Tate Gallery
surely marked an important professional juncture. Through the necessity
of repainting the work in a few hours, the artist developed a new, more
physical practice and left behind the gentle, laboured, weathered surfaces
that he had adopted from Nicholson. The change in style can be discerned
from a comparison of the final work on board with photographs of the
original canvas during painting. The multiple layering of densely
interlocking forms truncated by the 'sky' painted around the top has
given way to a thinner, more linear composition with more dynamic
elements. The shift in working method had enabled Lanyon to render
his image on a large scale – eight feet high – to which he would repeatedly
return. In the painting's conception he had formulated a new subject –
or a variation on an old one – with the rendition in two dimensions of
a subjective, physical experience of a specific place rather than the
expression of a vaguer idea of an area as seen in *West Penwith*.

 The bodily experience of movement and the specificity of place
became still more important in his subsequent work. The paintings he
made between 1951 and 1954 – that is to say from *Porthleven* to the worst
interruption to his production since the war when, in 1955, he was unable
to paint for almost a year – can be see as a coherent group. In these he
developed a more complex layering of meaning, to echo the intricate
stratification of paint, that brought together a search for identity through
bodily experience, history and myth, sex, death and fecundity. In relation
to many of the paintings of those four years, he wrote of a journey along
the north coast of Penwith, a pilgrimage, culminating at St Just, which
he schematized in a sketched map. Certainly, most of the paintings are
named for places between St Ives and Land's End, particularly the mining
district from Levant to St Just, but many of the same features – physical
and theoretical – can be seen in the works that derived from Corsham and
from his three-month stay in Italy at the beginning of 1953. It is in the
paintings of these years that his reaction to Nicholson and Hepworth is
most evident – superficially in his rejection of Nicholson's delicate practice
and, more abstrusely, in his engagement, not only with human issues,

but with social and political events.

The paintings from this period take their names from, or refer to, places or events, such as a journey. With the exception of the canvas *St Just* (**59**), Lanyon retained the resistant support of gessoed hardboard, but the paint finish is quite different from the works of the preceding period. He ground his own pigments and mixed his own paints, and the use of stand oil as a medium gave his colours a smooth, slightly glossy finish akin to household paint. The consistency of different colours varies, and texture is achieved more through the accretion of paint than the application of impasto. The illusion of depth, and the variation in the surface, created by the interleaving of successive layers is now achieved through the partial mixing of colours on the surface and the removal of certain sections with rag or knife, as opposed to the gentle scraping of a razor blade. In the first version of *Porthleven* we can see that Lanyon would paint over areas with white before reworking them, but now underlayers were left to intermingle with those over the top. Paint was applied in a variety of ways, in short dabs, long smears, or broad veils cloaking areas beneath. These create illusionistic effects, as certain sections that seem to have been added to the surface, such as the red, white and blue in *St Just*, actually peep through from under subsequent layers. The results are surfaces that swing from a multi-chromatic smoothness, as if the artist has lain paper on the wet paint, to a dry and encrusted pock-marked fragmentation with thin layers of paint just catching the high points of the heavily-worked under-layer. Strong black lines are used to hold the compositions together and these show an ambiguity, as they appear to have been drawn over the paint and, at the same time, to merge into and emerge from it.

These works were determined by a change in Lanyon's perception of landscape as he travelled through it on foot, bicycle, motorcycle or in a car. He described how it shifted in relation to his body:

> Riding along the north west coast of Cornwall I get the sea at my side and the sky over my back. With a motorcycle I make expeditions for the physical experience of the country all around me or in a car I "sit" the bends and slide between walls and open fields, or again walking, the feet are informed.[1]

In place of the '"lumping together" device' of such works as *West Penwith*, the painted sky now described his physical experience. He wrote:

> While I am moving about the country here with all this history under foot I find the sky on my back as I climb the hills and the sea behind me, then at my side and it becomes the same thing in my painting.[2]

So, in such paintings as *Harvest Festival* (1951–2) (**50**),[3] the sea and sky run down the side of the startlingly vertical 'landscape' to highlight the

← **50**
Harvest Festival, 1952
Oil on board
72 × 24
Private Collection

51 →
Corsham Summer, 1952
Oil on board
72 × 24½
Private Collection
Courtesy Bernard Jacobson Gallery, London

experiential narrative of its representation. Describing it as 'a journey in search of "saying" about here', Lanyon wrote that in this work he was 'trying to travel all the way from the (Leach) pottery (in St Ives) to St Buryan'.[4] He also wrote of another painting, possibly *Corsham Summer* (1952) (**51**), in which he 'was stretched from Taunton to Land's End'.[5] The paintings of this period addressed various issues concerned with history, industry, myth and sexuality, but his later work became increasingly dependent upon this corporeally-centred phenomenological experience.[6] The importance of bodily sensation is marked by the number of titles that, like *Harvest Festival*, refer to the harvest – a symbol of natural potency and regeneration, but also an event of which Lanyon, suffering from chronic hayfever, was most aware through his own physical condition.

Again, this complex understanding of the body's relationship to the world around it suggests Lanyon's awareness of current philosophical discourse. In the work of Maurice Merleau-Ponty, the perceptual body and its environment are bound into a single structure, 'every external perception (being) immediately synonymous with a certain perception of my body'.[7] This parallels Karl Jaspers' similar concept of a 'Comprehensive' reality that is neither subject nor object but both sides of that polarity, and Heidegger's idea of 'being-in-the-world'. In particular, for Merleau-Ponty, the body's movement serves to define its own boundaries. As he says, 'If bodily space and external space form a practical system … it is clearly in action that the spatiality of our body is brought into being'.[8] In this concept, the work of art holds a privileged position in that it 'illustrates nothing other than our bodily insertion in being'.[9] That is to say, in painting landscape in this way, with reference to all four dimensions, Lanyon is enacting a process of self-definition.

The artist's use of the experience of space and time as the source for his painting also incorporated the historical experience of the place and its people. This was not just a question of the countryside holding the deposits of earlier occupation but of its contents embodying a human past. 'Rocks and boulders', he said, 'are touched by centuries of work and life. For me they're stones with a human history and meaning'.[10] In a sense, for him landscape forms were invested with a memory, almost, of the human body:

> I'm much more interested in the fact that perhaps this hedge that I'm walking along many other people's shoulders of generations have actually been, they've actually touched these hedges they're man made and they have a physical proportion to man. I know that some of (the fields) are the sort of size that one man can plough with one horse in one day. It's this sort of relationship to man himself.[11]

This is another aspect of the phenomenological idea of the body and its environment being a single entity – landscape and figure becoming one

continuity. Through a process of embodiment – the landscape's embodiment of its human history and its perception in terms of the human body – Lanyon's painting is constructed as a humanist project, a connecting with other human beings, even if – especially if – they are of past generations. This was anticipated in his identification in *Porthleven* of the two archetypal figures of the fisherman and the waiting woman. Through these sorts of allusions the artist addressed the (clearly gendered) socio-economic experience of the population of the places he represented. 'I paint the landscape', he is reported to have said, 'it's all mining country and fishing country and I'm really painting the face of working people'.[12]

It was this aspect that enabled him to claim the label of 'realism', though, of course, he abhorred all such categorization, and that won him plaudits from critics beyond such formalists as Heron. Specifically, Heron's adversary, the socialist John Berger, was able to accommodate Lanyon within his concept of realism, which he defined as the work of those

> artists struggling, in the face of the obscurity and nihilism
> of so much contemporary work, to produce a rational,
> constructive art which can comment on and express
> fairly objectively and with a sense of human purpose,
> the development of the life they witness around them.[13]

In 1956, Lanyon wrote favourably about an exhibition of six young, mostly realist, painters (including John Bratby, Michael Andrews and Derrick Greaves), whose 'concern for the environment and life of people' he contrasted with the 'now academic abstraction' of St Ives.[14] A similar involvement was claimed for his own work. He had described West Penwith as a 'coastline … revealing on its varied faces a sea history and a land history of men within and without and a commerce of man with the weather', and it was the themes of coast, agriculture and mining, of labour, exploitation and death, that dominated his work at this time.[15]

In 1954, Berger recognized the importance of Lanyon's involvement in his environment:

> Lanyon searches for something which includes a sailor's
> knowledge of the coastline, a poacher's knowledge of the
> cover, a miner's knowledge of the seams, a surveyor's
> knowledge of the contours, a native's knowledge of the
> local ghosts, a painter's knowledge of the light.[16]

If the paintings of this period documented, as it were, a westward, coastal journey, then St Just was 'the Jerusalem of this ride'[17] and the large *St Just* (1953) (**59**) is the culmination of this group of paintings. Although the first state was completed at Christmas 1952 (**55**), the image we see today was painted after Lanyon's return from Italy several months later; modifications in technique are consistent with this redating. Although he wrote of a pilgrimage, a sacred journey to St Just, that title was only

applied retrospectively; throughout 1952 he referred to the painting as a Crucifixion.

St Just, a small, grey town, not picturesque enough to attract tourists, was the major tin-mining centre of West Penwith and consequently has been largely devoid of economic activity since the demise of the industry. Lanyon painted the town as a Crucifixion, the central black form representing at once the mine shaft and the cross, the curls of barbed wire around the old shaft forming the crown of thorns at the top, in order to raise a memorial to the dead miners – victims of 'a social system that is absolutely criminal'.[18] He spoke later of the mine owners' lack of concern for the miners' safety, despite their huge profits, and of the accidents that resulted from pushing the tin lodes too far out beneath the sea, and from the deterioration of machinery:

> If you walk along this coast you can't escape this shame …
> there's a great pressure of human suffering that has gone
> on and St Just itself … is like a town waiting.[19]

Lanyon's intention was, then, both realist and political. The problem, which persists, was one of legibility: how were viewers to read and interpret this message? While admiring the works for their pictorial qualities, Berger articulated this conundrum. Relating *St Just* to mining disasters, he wrote:

> London or Venice Biennale gallery-goers will not know that:
> the people of St Just who would, would not understand the
> picture. Is this impasse the result of our lack of any integrated
> attitude to Nature? Does this lack force Lanyon to discover
> his own symbolism which is then inevitably over-vague and
> incomprehensible?[20]

Despite its apparent verdant richness, the land along Penwith's northern coast is inhospitable and unforgiving to farmers, as it sits on a granite bed and huge boulders litter the tiny fields that often rise steeply to moorland that, though it once hosted many small-holdings, is now largely uncultivated. Restricted to the narrow green strip between the moors and the cliffs, the small farms are among the poorest in Europe. Agriculture and its decline was a major theme for Lanyon, most particularly in *Bojewyan Farms* (1952) (**52**), which he saw as embodying images of landscape, life and death – a lament for the derelict farms and a celebration of a down-to-earth, natural fecundity. The artist was inconsistent with the amount of detail he would supply in explaining such paintings. The work was made as an image of farms in general and, he wrote later, he 'only found out that "Bojewyan" fitted my painting as being the place name most appropriate to the concept <u>after</u> I had finished' it.[21] He told the painter Paul Feiler,

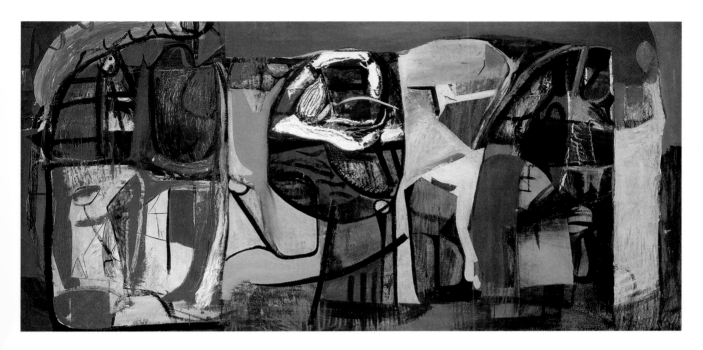

> I paint places but always the Placeness of them. In the
> Farms painting ... there are many meanings but they are
> all meanings of farmness – animals are implied and not
> representational according to photo vision.[22]

When *Bojewyan Farms* was first exhibited in March 1952, it received a
detailed analysis from the poet Roland Bowden who saw it as a triptych,
the left-hand section symbolizing 'Life', the uterine centre 'Birth', and
the right-hand side 'Death'.[23] The artist cautioned that this reading

> tends to particularise something in which nothing is
> really particular, not even I think the three separate
> elements in the triptych. These are really three aspects
> of one thing. I find that you have discovered things I was
> not aware of and that may indicate that really the picture
> is not quite precise enough.[24]

Nevertheless, he would come to employ the same terms to explain
his imagery. Describing it as a painting of 'one of the most ancient
and primitive parts of the district', he identified it as

> a farming picture – a bucolic scene, rather earthy. It's also
> a triptych, with three sections in it. On the left there's the
> sea at the top, and grass and hayricks. The middle is some
> sort of animal, even a head. And on the right the chaff which
> comes from harvesting. In some ways it's a picture about
> birth and life and death.[25]

52
Bojewyan Farms, 1952
Oil on board
48 × 96
British Council, London

Thus, certain literal details, such as the sea curling around the top left-hand corner, sit alongside the abstract imagery of the 'Generation Series' and, specifically, of *The Yellow Runner* (**31**). The central womb is defined in abstract form but is also consonant with the animal – a white bull, perhaps – that Lanyon distinguished. According to James Frazer, the bull is often a symbol of the harvest, but the fact that the beast in *Bojewyan Farms* is white has been linked to Lanyon's later treatment of the Europa theme – a fertility myth – and specifically to the later section of the narrative when Cadmus is led by a white cow to the site where he is to found a new city.[26] If the painting is a lament for the Penwith farms fallen into disrepair, then such a reading offers the possibility of renewal. This will be seen to be a persistent feature: these works are a lament for past losses and exploitation, but also seek to enact some form of restitution. This is articulated as a social and historical act but can also be seen to continue Lanyon's on-going conception of art as an act of personal reparation.

The complexity of Lanyon's metaphorizing of self-renewal through the painting of a symbolic and historical landscape is best shown in those works relating to mining. After the valleys of Camborne and Redruth, the stretch of land between Pendeen Watch and St Just had been the richest mining district in Cornwall. As its heart, the town of St Just had been an important industrial centre: in the eighteenth century, when west Cornwall was one of the most densely populated parts of Britain, it was the same size as Manchester.[27] After several periods of hardship, Cornish mining – not only of tin but also copper, arsenic and, at St Ives Consols, radium – had reached its apogee in 1870–2 and has declined ever since. The First World War had temporarily improved the ailing industry but was immediately followed by a collapse that left only one mine working in 1921. The following decade saw attempts at revival at individual sites, but the cost of extracting minerals from Cornish granite prevented the mines from competing with the cheaper conditions in the Far East and South America, and 1930 saw another crisis exacerbated by the state of the world economy. So, as a child and a young man, Lanyon would have been aware of the high levels of unemployment and consequent poverty and industrial unrest in the area, which led to an offically-backed exodus of miners to Australia and America. After the Second World War, optimistic attempts to revive the industry persisted, but the melancholy sight of the single-chimneyed, empty engine houses that peppered the district, and a knowledge of local history, could only reveal this place to be a post-industrial landscape. Lanyon must have been especially conscious of the decline as his family had been actively involved in tin, his grandfather Alfred Lanyon having been a senior partner in the Cornish Tin Smelting Co, the largest smelting firm in the county, and involved with other concerns around Redruth.[28]

As a Cornishman, Lanyon identified himself with the miners. On returning from the war, he had recognized his ancestral involvement in mining and speculated that his 'own myth was built up over this thing

of miners working under the ground, under the sea, coming up to the
surface … this extraordinary commerce which went on in this small strip
of land'.[29] He used mining as a metaphor for his own working processes –
his involvement with and apprehension of a place, its precipitation within
him and externalization in paint. He wrote in 1952:

> My work contains the whole constructive process which I
> illustrate as follows: The miner extracts inside the earth; his
> trolleyings in the galleries a shuttling within the earth and
> his laborious incisions are eventually brought 'to grass' (a
> miner's term for the surface). Here the change continues by
> controlled processes in the furnaces and eventually the
> product has no resemblance to the rock ore. That is the
> mechanics of it. But the mine is also hollow and men have
> their being therein and the miner also comes up to grass
> and that is what I also hope for in my painting.[30]

As the mineral ore is extracted and fundamentally transformed at the
surface, so Lanyon's image is translated into paint on a flat surface. What's
more, the descent of the miner into the bowels of the earth and his return
'to grass' – a clear symbol of rebirth – once again provide a metaphor for
the process of renewal, or reparation in Kleinian terms, that the artist
hopes to achieve in painting.

As the descendant of mine officers, Lanyon's empathy with the
miners takes on a certain resonance. Indeed, when he talks of 'the shame
that I feel … seeing these ruined tin mines',[31] he perhaps speaks as one
implicated in the exploitation of the miners. It certainly recalls his wartime

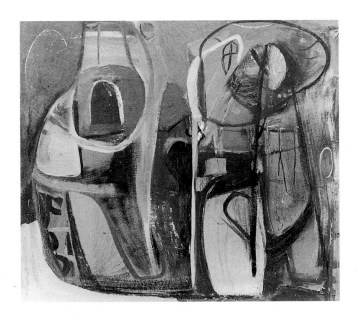

53
Levant Old Mine, 1952
Oil on board
51 × 47
Private Collection

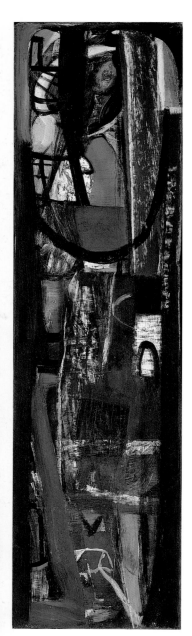

encounters with working-class men and consequent sense of responsibility for his own class's failure to hand over power.[32] His stance is typical of a certain kind of well-to-do masculine hero who, like a comic-book hero, descends from an 'old-money class identity' into a bestial underclass to counter the threat of 'effete, feminized urbanity' with a 'nostalgic mourning for pre-capitalist patriarchy'.[33] He is also cast in the role of existentialist hero as depicted, for instance, by Antoine de Saint-Exupéry, whom Lanyon read.

The first two paintings to deal with mining appear to have been *Levant Old Mine* (**53**) and *Botallack* (**54**), both dated 1952 but probably begun in 1951. The artist recorded that *Bojewyan Farms* was 'before the real journey begins. The painting "Levant Old Mine" is the beginning'.[34] Both that work and *Botallack* take their names from mining villages, and both were sites of disasters. In 1895, the sea had broken into a section of the Wheal Cock mine at Botallack and it was from this tragedy that the painting arose. As Lanyon explained,

> Botallack mine went out to sea a mile under the rollers of the Atlantic and in the swell of the sea the boulders made a cavernous drumming in the galleries under the rock. Now the mine is inundated ...(it) drops away down the face of a cliff from the village and all the back windows are tall and thin and the gates black and the grass as you could imagine is weeping with wet greenness.[35]

Levant, one of the great Cornish mines, had suffered one of the most terrible and most recent accidents. In 1919, the man-engine, a large oscillating ladder-like mechanism for transporting the miners up and down the shaft, collapsed, pitching the men it carried two hundred and sixty-six fathoms into the earth. Lanyon was muted in his explanation of *Levant Old Mine*, but noted that the 'mine had had its death'.[36] However, the Levant disaster seems to have been in his mind when he conceived a painting that would combine the traditional Christian imagery of the Crucifixion with this theme of Cornish mining. After a few months', work on the painting, he wrote that the disaster had 'always remained a part of me as if it had happened to me also'.[37]

He seems to have begun the work that would finally emerge as *St Just* (**59**) in late 1951 or early 1952, as he appended a small note – 'I am painting a crucifixion' – to a letter posted on 10 January 1952.[38] The comments on it that recur in his correspondence for the rest of that year reveal its progress and suggest the importance he attached to it. He believed the painting to be finished in December 1952 (**55**), but on his return from Italy in May 1953 he reworked it so fundamentally that only a few features of that first state remain visible.

Though he said in December 1952 that the apparently completed painting was still untitled, he had associated the work with the town of

54
Botallack 1952
Oil on board
50 × 16
Art Gallery of Ontario, Toronto

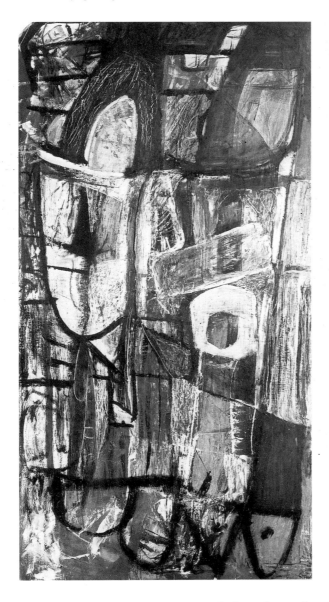

St Just as early as March.[39] By April he had 'three large sketches for a crucifixion ... all eight foot tall' (57),[40] but he soon fell into a depression and wrote of being 'at the bottom of a black pit and climbing slowly out'.[41] At the beginning of June he wrote 'the crucifixion is in cold-storage pro tem,' though he also mentioned another eight-by-four-foot painting, of Pendeen Watch; no record of this work is known and the reference may offer an alternative source for *St Just*.[42] Though he suffered one of his frequent debilitations as a result of a stomach ulcer, he announced in late July, 'I am piling paint on to canvas in an all out attempt to paint this crucifixion'.[43]

In setting out to paint a Crucifixion in 1952, Lanyon followed Graham Sutherland's recent recuperation in Northampton of Grünewald's *Isenheim Altarpiece* and Bacon's various interventions in the genre, including the *Fragment of a Crucifixion* (1950) that Lanyon later used in a lecture on British art.[44] Lanyon explicitly cited Bacon, describing the first state of his own Crucifixion as 'all gossip and mocking and Napalm burning but without the Francis Bacon illustrative obsession'.[45] More importantly, he invoked Bacon's imagery with a description of *St Just* in terms of catastrophe and abomination that resonates with the other painter's statement that 'slaughter-houses and meat … belong very much to the whole thing of the Crucifixion'.[46] Referring to the accident at Levant Mine, Lanyon brought together that tragedy, myth and his own fragmentation and restitution:

> Was it Osiris who got measured for his coffin at a banquet & then slain and placed in it? My heavens how like Levant and Botallack! … those bits of miners, so much meat hanging from the man-engine collected up into shovel-fulls and processed to St Just for the laying in state. … All I can do is arrive there by a pilgrimage on foot and through my feet so that I am broken and made whole again outside the city. St Just is full of dogs, remember the god Anoubis (*sic*) who descended in canine form to be a catalyst at the wedding, welding together the bits of Osiris, that is what my crucifixion is about, the underrated, undisturbed and reviving in the open square of St Just.[47]

Thus, he combined the revival of myth, possibly drawn from Frazer's *Golden Bough*, and a Kleinian idea of reparation.[48] Though this imagery is discernible in neither version of *St Just*, it had been anticipated in a number of linocuts he made on the same theme in 1949 (**56**).[49] In a series of vertical enclosures similar to the structure of *Cape Family*, Lanyon

showed the mine's winding gear, a miner with a Wesleyan chapel and terraced houses that characterize St Just, a bird rising vertically (a symbol of the resilient spirit, perhaps) and a dog.

In the pharaonic myth to which the artist referred, Osiris was murdered and torn into fourteen pieces by his jealous brothers and the limbs were scattered abroad. Isis – both his sister and his wife – journeyed to gather them, and with her sister Nephthys and the jackal-headed Anubis they pieced them together and Osiris was resurrected to rule over the dead in the other world. In his approach to this painting, Lanyon cast himself, like Isis, as the instrument of restitution and reparation, performing an act of personal atonement. At an early stage in its development he wrote:

> At present I seem to be on a pilgrimage from inside the ground, as if I were the only one saved from the Levant disaster and as if I moved, the unlucky mourner, along the gale ridden coast to St Just trying to adjust the bones of the miners shovelled into coffins to represent beings (a last rite of categorisation to make living bearable).[50]

At that time he was working on the large gouache studies for the painting. In one of these, the leg of a skeleton emerges from the ground, suggesting at once the idea of the bones of the landscape and the disinterment of a corpse (57). Through its graphic style, Picasso's *Charnel House* (1944–8) is invoked, but so too are images of the opening of the concentration camps, and, from the aftermath of an earlier war, the lines from T.S. Eliot's *The Waste Land*: '"That corpse you planted last year in your garden, / Has it begun to sprout? Will it bloom this year?"'.[51] Just as Sutherland had drawn on photographs of Belsen for the figure of Christ in his Crucifixion, so Lanyon, conscious of the war in Korea, used the Christian theme as a symbol of contemporary events and anxieties. In the wake of Auschwitz, Hiroshima and the artist's own experience of war, the Cornish miners of the past, exploited and tragically killed, provided symbols for the victims of modern war and genocide. 'I have just constructed and executed Christ', he wrote on the completion of the first version, 'and the result is like the residue of a napalm bomb'.[52]

Contemplating the Crucifixion, Lanyon wrote, 'what a face that body is – nakedness turned inside out!'[53] Yet what is striking about both the original and the final versions of the painting is, as he observed himself, that 'Christ is nowhere'.[54] It would appear that the artist was unable to paint such a nakedness, and a similar reluctance may be reflected in the restricted palette of the first version. He described it himself:

> It is nearly all black and without any colour no greens at all. A new deep purple, black and white. I think it is the beginning of painting Chiaroscuro or light and shade in my own way. ...

57
Untitled (Study for St Just), 1952
Gouache on paper
100 × 30
Gimpel Fils, London

58
Construction for St Just, 1952
Glass, paint and bostik
25¾ × 11¼ × 10
Private Collection

Giotto, Cimabue and the Italian landscape will I hope
restore the colour to me. Here there is a charring of bones,
eisenhowers (*sic*) and Eden[55]

He boasted to Ivon Hitchens, 'I have at last painted a picture with no colour
like glass'.[56] The bleak colouring may have derived from a construction
made in the preparation of the painting (**58**). Made simply of sheets of glass
– mostly clear but with green and pink elements – held precariously with
bostik and painted only with black, it was, as Lanyon described it, a
'crystallisation of the experience of landscape – mostly to do with mining –
the pit head gear of the mine, the shaft itself, the lodes of tin – perhaps
also the telegraph poles around the town'.[57]

A change in Lanyon's psychological state seems evident in the
dramatic alterations he made to the painting on his return from Italy.
Other than some of the heavy black lines visible through the paint at the
bottom, little of the first version can be seen. The painting now has large
areas of the Cornish green that he had often used before, and intermeshed
with this are a variety of greys, whites and a few stronger colours: a rich
blue underlies much of the lower section and ochre plays an important role,
as it so often does in the work of this period. But most obviously, the
composition is now dominated by the black vertical form that rises up the
centre to open at the top into a triangle with a pattern of curling black lines
within and around it. Though the conjunction of the Crucifixion and the
town of St Just seems to have emerged early on in the production of the
painting, Lanyon later claimed that he only 'recognise(d) the image' in
St Just when John Berger wrote about it. 'In the large painting of St Just',
wrote Berger, 'there is a black crucifix shape in the middle. This represents
a mine superstitiously abandoned'.[58] Whether this was true or not, this
reading offered the artist a description of the painting that related the
new imagery to the original theme:

> the central black section is the mineshaft. There are fields all
> round the town, with grass of a harsh, smoky quality, and the
> town seems to be on top of the fields. On the left are houses,
> figures, rocks, maybe the church ... Many people in St Just
> lost their lives in mine disasters, so the mineshaft at the top
> becomes a cross, and the barbed wire round the disused
> mines a crown of thorns. For me this picture is also a
> crucifixion.[59]

The violence of the theme is communicated through the material
of the work rather than through its imagery. Though the colouring and,
in large part, the forms of *St Just* are of landscape, the picture is given a
corporeality, a fleshiness, by the handling of the paint, like the smearing
of an abject substance that is suggestive of Bacon's meat, of the corpse –
'the fundamental pollution'[60] – of defilement and death. As David Sylvester

59
St Just, 1953
Oil on canvas
96 × 48
Private Collection

was to write of Bacon's technique, 'The smearing means disintegration: the face is already "food for worms", the skull seen now beneath the skin'.[61] A similar idea, though more obscured, may be discerned in much of Lanyon's work.

The artist so developed the idea of a Crucifixion that in 1963 he said that he had intended *St Just* as the central panel of a triptych.[62] He identified the wings of this polyptych, 'the mourners' at the Crucifixion, as *Harvest Festival* and *Green Mile*, but in fact the second panel is more likely to have been *Corsham Summer*, which, unlike *Green Mile*, is the same size as *Harvest Festival*; both are the same height and half the width of *St Just*.[63] *Bojewyan Farms* was said to be the predella that would sit at the base of this arrangement and, though the concept clearly post-dates the paintings, the theme of death and rebirth would be appropriate, echoing, as it does, the *Pietá* or *Entombment* that often occupy the predella in Italian altarpieces.

St Just was first exhibited at Patrick Heron's 'Space in Colour' exhibition at the Hanover Gallery, London, in July 1953. Lanyon told Roland Bowden he was disappointed when he saw it there:

> When it left here it was large in form and just holding together ... at the Hanover it was all bits of string and disconnected happenings. So much so that I had to apologise for it to many people. I fear it will do me some harm.[64]

He believed, however, that the problem lay in its display, which exaggerated its symmetry and obscured the top, 'which pushes out the two sides into two wedges so that there is a way out from both but a different way out'. He elaborated on its meaning, or responded to Bowden's own reading of it, identifying the red, white and blue area as both a coronation flag and a signifier of the Virgin. He again alluded to Kleinian ideas of renewal and the reparation of motherhood, suggesting that 'from below it is a pure journey in search of the womb; the hymen is possibly that triangle of rock across the shaft to which the Virgin bows, and the way to the weeping head is restricted.' A little later he wrote that, though 'St Just is the ultimate as far as I am concerned of gloom, duality and bitterness', it had a 'tenderness possibly because of its tendency to expand like an umbrella inside out'.[65]

So, one might view the changes made to *St Just* as a reflection of a new optimism in Lanyon after his time in Italy. If its first state had been devoid of hope, the upward movement of the final composition, and the release offered by the open 'arms' at the top, introduced the possibility of redemption implicit in the Crucifixion theme. Again he wrote of this in terms of local history, sex and maternal reparation, using the miners' labour as a symbol of the condition of man – the coming to terms with existence and personal relationships:

I see the whole private situation now as parallel to the
Levant Geevor Botallack and St Just tragedy. The dipping
down of meaning into the earth ... the tragedy is the presence
of man adjusting to the granite and his impossible task when
it is seen as a spiritual one as well. How indeed he can dig
down into his own thighs and on into his toes and then follow
down beneath the very sea .. for his private joys and yet be
with woman. Perhaps ... he can be the child and go in again
to his mother ...To go down and be lifted up and to go up to
meet the woman coming down with food for the shift. The
imagery is one of sex but more than ever it is the cross that
I see and there again the man who seeing all of his journey
and seeing then that it is impossible would have somewhere
to go (to go and BE at the moment if you get my meaning)
somewhere above grass – to rest in Christ's arms. [66]

The conjunction of landscape or place, sex and death as a means of
exploring the artist's fundamental concern with questions of Being was
one that had emerged during his stay in Italy and was addressed most
forcefully in paintings relating to his time there.

Filth, sex and death

'We have to go beyond the bearable to create …
inadequacy and fear – the unguarded back. It is
no wonder that sex inspires us and makes us
the saddest creators.'

In 1952, Lanyon was awarded an Italian government scholarship for
travel to Italy. He had originally planned to visit in September, prior to a
more extended stay in the early part of the following year. In the event, he
travelled to Rome in early January 1953 and left Italy at the beginning of
May. After two weeks in the capital he settled himself in Anticoli Corrado,
a steeply rising hill town in the Abruzzi mountains, where he took a studio
– Studio Cicarelli – on the track that led to the village of Saracinesco. He
decided to abandon his original intention to visit southern Italy, though he
did plan to go to Perugia and Ravenna, and certainly went to Siena and San
Gimignano when he was visited by Patrick Heron in April.[1] In *Inside Out*,
Adrian Stokes had presented Italy as the site where he was able to find
restitution after disintegration in London, and it held a similar symbolic
value for Lanyon, who described the country as his 'second home'.[2] He
had, of course, spent several years there during the war and had returned
to recover from personal crises in 1948 and 1950. Following his stay in
1953, he would return to Anticoli in 1957.

It is hard to estimate how many paintings Lanyon actually
produced in Italy and how many of the works with Italian associations
were made back in St Ives. When he went there he had decided to paint
the nude and planned to employ a model, but that proved impossible and
at the end of his time in Anticoli he told Terry Frost that he had 'not
painted too well here and life has been rather unsuccessful'.[3] Nevertheless,
he had a number of works shipped back to Britain and the tone of a letter
complaining that one was missing from the shipment suggests that there
were quite a few in this consignment; in addition to the paintings sent to
St Ives, Gimpel Fils had a further three.

Lanyon's response to Anticoli is telling. Rather like St Ives, the
town had a long history as a centre for artistic production. Only forty miles
from Rome, from the late nineteenth century until the Second World War,
it had provided a rural base for many artists, including most recently the
painters Giuseppe Capogrossi, Masimo Campigli and the sculptor Arturo
Martini. Though by the 1950s few artists remained, the town still had a
ready supply of studios and the director of the British School in Rome had
a house there that was used by visiting British artists, such as John Bratby
and Edward Middleditch.[4] Later in the 1950s, several younger British

painters associated with Lanyon stayed there, including Trevor Bell,
Anthony Benjamin and Joe Tilson.

 For Lanyon, however, his stay in the town and exploration of
the surrounding region represented a return to a more primitive way of life,
the recovery of lost traditions and human relations and, as a consequence,
a renewed interest in myth. Ironically, one can see in his idealization of
the simple life of the people, and his yearning for a pre-capitalist society,
a reproduction of the same romantic misconceptions for which he criticized
the 'foreigners' in St Ives. This does raise an important question about
those works derived from his Italian experiences and other pieces related
to places outside Cornwall. If his paintings of Cornwall relied upon an
understanding of place that incorporated the historical and cultural insight
of the native, how could he claim a similar approach to places in which he
was the outsider? To answer that question is, perhaps, to highlight the fact,
fundamental to Lanyon's work, that landscape and place are not only the
subjects of his work but vehicles for much broader issues.

 Other than its square format, one of the major works to emerge
from the Italian experience, *Saracinesco* (1954) (**60**), is not strikingly
different from those of the preceding years; in fact, it has been suggested
that it was probably begun shortly after *St Just* was completed, so such a
continuity may be expected.[5] The main difference is the intrusion of much
stronger colours: a range of reds, blues, ochres are used and, in one place,
gold-leaf hints at the early Italian paintings that Lanyon had hoped would
bring the colour back to his life after his Crucifixion. It displays the greater
degree of smearing of paint and mixing of colours that appeared in *St Just*
following the artist's return to Britain.

 Saracinesco is a walled village in the mountains, 2000 feet above
Anticoli and to the east of Rome. Lanyon noted its similarity to Cornwall.
He later wrote that he saw it as a place 'living on a rich historical past' and
related that to the heraldic form of the painting. He was told by local people
that the place had been the last town of the Saracens, and learnt of its
Etruscan past from the Etruscan Museum in Rome.[6] The main form in
the painting is the shape that Lawrence Alloway identified as 'common
to the Corsham painters', whether in figure or landscape, 'a rectangle with
rounded corners, somewhere between a TV tube and a weathered stone'.[7]
The artist described the work in terms of the appearance of the place. He
said that this softened oblong derived from the wall around the village –
which, he noted, was of limestone, in contrast to Cornish granite – and
above and beyond it were the Abruzzi hills. Lanyon was in the area during
the winter and later recalled that at that time of year Saracinesco was cut
off by snow. He said that mules with baskets slung on their sides were used
to bring food and fodder for the animals, and identified such a creature in
the top left-hand corner of his picture; he had made a plaster sculpture of
a mule while in Italy. As with such works as *Bojewyan Farms* and *St Just*,
these details opened up another level of – probably retrospective –

60
Saracinesco, 1954
Oil on board
50 × 48
Plymouth City Museum and Art Gallery

interpretation. 'The journey to Saracinesco took two hours walking along the valleys', he wrote.

> The track was used by mules carrying wood and by shepherds. It followed mostly a ridge which gave a magnificent view over the Abruzzi mountains to the north. Saracinesco rose like a pyramid above the ridge, the town being built on the summit. I was reminded of the countryside between Bethlehem and Jerusalem. The mules and the mountain ridge and the colour of high places are all suggested in the picture. The underlying 'story' ... is I think the flight into Egypt and the return and eventual journey to Jerusalem on an ass.[8]

So, once again Lanyon combined personal experience of a specific place with mythic religious associations to produce a painting on the theme of pilgrimage, the search for protection (for which the topography of the walled village provided him with a ready symbol) and final restitution.

The theme of renewal had re-emerged the previous year in one of his most festive paintings, *Primavera* (1953) (61), the title invoking both spring and Botticelli's allegorical representation of it. Having come to the mountains in January, Lanyon had been very aware of the arrival of spring, the transformation of the landscape and the attendant rituals,

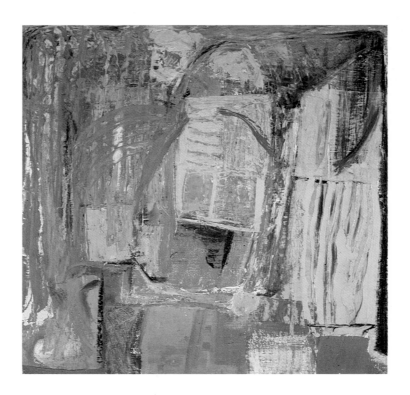

61
Primavera, 1953
Oil on board
28 × 28
Private Collection

which, no doubt, spoke to him of timeless rural traditions and pagan
origins. The theme of germination and rebirth is, once again, signified
by the egg form at the heart of the painting. The work is a riot of colour
as hot reds, pinks and a rich blue peer through the greens and browns on
the left-hand side and the thickly-knifed yellow on the right. Unusually,
the composition seems to have been started with blocks of strong colour
on a white ground and further hues applied over the top.

The application of the yellow on the right recalls a similar
use of ochre in *Farm Backs* (1952) (**4**), which in its colouring and glutinous
consistency has a suggestion of excrement. While consistent with
contemporary painting practice, this can be linked to the artist's
fascination with the abject, which his time in Italy seems to have brought
out: 'One lives very excrementally in a place like anticoli (*sic*)', he wrote.[9]
Lanyon's interest in the primitive life of the place can be seen to have
marked his painting with a stronger accent on the excremental and the
sexual and with a more sensuous use of paint. His time there reinforced
his belief in a masculine, down-to-earth art as opposed to the bourgeois
and genteel. Two hours before leaving the town, he described his feelings
for Anticoli and its effect on him:

> I am developing an aversion for the manners which cloak
> animal intentions and getting a strong taste of the primitive
> tongue which operates bodily and massively mainly by
> instinct. That is anticoli (*sic*) ... The pride is fiercer than
> St Ives because commerce has not shaved the hand marks
> off the stones ... Pat (Heron) has shown me by his reactions
> here just how far I have gone towards a community in my
> feelings with people. ... I have a preference for the coarse
> arts because out of them in their direct joining of sensuous
> with sensibility comes the future refinement and meaning
> which is culture. This preciousness, the dolling up of sweetly
> flavoured pastries is so much chlorophyll. One can only end
> up in being insulted by the cow which farts or being sick in
> ones butlers napkin because a horse has pissed under one's
> window. But here there is dung on the roads and a pig on the
> doorstep and a great glorious weaving of busts and arses
> in and out of the piling houses.[10]

The artist's writings had already shown his engagement with ideas of
abjection: he contrasted the 'rather earthy' *Bojewyan Farms*,[11] for example,
with the sterile purity of Nicholson's and Hepworth's work, telling Rosalie
Mander that the painting 'stinks of dung, old cow, whiskered implements
and stale cats'.[12] Lanyon was similarly 'down-to-earth' when he warned
Peter Gimpel prior to his 1952 exhibition that 'Some of the paintings may
want polishing & treating with a little deodorant. I am bringing a little
concentrated essence of farmyard to sprinkle at the show'.[13]

In this elevation of primitive life over the bourgeois, the artist sought an image of himself as an outsider – beyond the limits of conventional society and culture – in order to reinforce his artistic individualism. This was related to his desire to establish the source of his painting as the external environment rather than other art, and that need was reflected in his inclusion in a biographical note of the detail, 'Considers Italy to be a second home. Has visited Paris for one day'.[14] Thus, Italy symbolized authentic experience as opposed to the conventions of high culture epitomized by Paris. He also recognized a need to escape from his own background. 'For me', he told Frost, 'it has been necessary to go out of a well nursed living into the streets which were removed from me by the wrappings of a wealthy family'.[15] Though described by his son as 'a concert pianist and composer', Lanyon's father was an amateur musician and photographer and it has been suggested that the artist's desire to establish his authenticity was motivated by anxieties of a similar dilettantism.[16]

The abject is that which we expel, socially and bodily – excrement, mucus, semen – and in so doing, it has been proposed, we both define ourselves, through the emptying out of that which is unclean, and threaten our identity with that expulsion.[17] The process of abjection is one by means of which one reassures oneself of one's 'own and clean self'.[18] However, neither subject nor object, the abject is that which blurs the boundary between ourselves and the external world and, as such, is associated especially with liminal zones, points of contact, edges, and most particularly with skin. This blurring of boundaries poses a threat to identity and so the abject has been associated with the sublime and with death – the corpse being the ultimate abject matter. So, Lanyon's invocation of the abject is not simply a nostalgia for lost, pre-capitalist society and a re-engagement with 'authentic' culture, but also continues his attempts to define the self through art and to address the themes of life and death. In his letter to Frost we can see how the artist brought into conjunction his scatological fascination, a sensuous mode of painting and the erotic – the 'great glorious weaving of busts and arses'. This was reflected in the development of his technique and in the advent, or greater prominence, in his work of the female body.

As we have seen, with the works of 1952, and even more so in 1953, Lanyon's painting technique had become significantly more sensuous and loose, the paint being smeared on as well as applied with large brushes in fast, violent strokes. In seeking a different finish, the artist was setting himself apart from Nicholson, in whose work he saw a division of idea and practice resulting in 'a complete blindness to values of touch or the sensuous'.[19] He was also indulging a long-held passion. One of his earliest memories of painting, he said, was of visiting the studio of Lamorna Birch as a boy and seeing a painting of bluebells: 'I was so excited with the quality of the thick paint that I went up and smelled it'.[20] Similarly, paint is eroticized in David Lewis's account of his conversations with Lanyon

'about the tactility of colour, a dry powdery yellow, a slimy green lapping against a succulent red you could run your tongue over'.[21] A sensuous use of paint indicated the sincerity of the artist's engagement with his subject and translation of it into a work of art. It also provided a surface at which the viewer could engage more fully with that object: 'paint is familiar as long as it is sensuous', Lanyon maintained, 'and at the same time it can imply a remoteness. Paint in itself is a universal language because it is sensuous'.[22]

Sources for Lanyon's desire for a more painterly finish were, of course, manifold at that moment. At the 1950 Venice Biennale he could for the first time have encountered works by the American Abstract Expressionists. And in 1952, with Patrick Heron and William Scott, Lanyon had admired the sensual abstractions of Nicolas de Stäel on show at the Matthiesen Gallery, though he warned against the conscious adoption of another's technique rather than the development of such a practice 'out of living'.[23] Similarly, despite his stated lack of interest in Paris, he would have been aware, through his dealers Gimpels Fils, of the contemporary painters in France, such as Hans Hartung, Georges Matthieu, Pierre Soulages and Jean-Paul Riopelle. Perhaps most significant was his encounter with Marie-Christine Treinen, a French student at Corsham from 1950 to 1952, who introduced a 'brutal' painterly surface quality that suggested a knowledge of Dubuffet and, in 1951, had 'started to attack the surfaces of her work with gouges and scratched lines'.[24] Lanyon was, in any case, a great admirer of Expressionism, of Kokoschka (who had stayed in Cornwall for a time) in particular, and he would undoubtedly have been interested in Gimpel Fils' 1947 exhibition of Soutine, with whom he had been compared by Heron.[25] The artist later described how, on looking at a Soutine, he was 'taken into the painting, to the actual making of the paint'.[26] Also, Lanyon's new painting style brought his work closer to Robert Melville's characterization of Francis Bacon's painting of 'phantasmal tissue',[27] Bacon being one of the contemporary British artists Lanyon most admired. In Melville's conception of Bacon's painting, the matière embodies elements that were central to Lanyon's work: paint is given a liminal corporeality and, as such, a humanizing function; in it, he wrote, 'modernism has found its skin'. As in the work of Cézanne and van Gogh, it creates a vertiginous effect – it 'is the sacred substance of the tunnel'.[28] Similarly, in Lanyon's work the quality and the handling of the paint might be thought to act as a signifier of the body's limits in its mimicry of the abject matter, and so to mark, once again, a process of self-definition.

The sensuousness in Lanyon's work also manifested itself in his painting of the body. He had been unable to paint nudes in Anticoli as he had planned, but made up for it on his return to Corsham in June 1953

by taking a model. The result was a significant number of drawings and gouaches of nudes (**62**), some of which have been related to his first treatment of the subject in paint, *Europa* (1954) (**66**). The title alludes to the rape of Europa, in which Zeus assumed the form of a beautiful white bull that, having been befriended by Europa, carries the girl out to sea never to return. Lanyon, however, compounded it with the story of Minos – one of the offspring of their coupling – whose wife Pasiphäe fell in love with another white bull and, having satisfied her desire for it, gave birth to the Minotaur, half man, half bull. Once again, Lanyon united classical myth with his own experience of Anticoli as he explained the origins of the painting:

> For me this is a story about primitive life, about living among the animals. The God comes to Europa in the form of a beautiful white bull, and from their union the Minotaur is born. This seemed to me the most appropriate myth for this district where people sometimes sleep near the animals for warmth in winter. I was fascinated by this strange human-animal relationship – it's something very basic that we've lost because we've become too sophisticated.

> In the painting the scene is set in the landscape, and the figures could be rocky boulders. The forms of girl and bull are all mixed up with the heads on the left side. The red colour comes from the primitive habit of hanging out a red blanket after the nuptials.[29]

Again the theme of birth and renewal is articulated through the procreative aspect of the story of Europa and its traditional identification as a seasonal myth. Similarly, the motif of the bloodied blanket of the marriage bed continues the artist's interest in primitive culture as mediated through the abject, serving, as it does, as a signifier of both cultural tradition and of sexual congress and loss of virginity.

The narrative of Europa's abduction, and traditional representations of it, also allowed the artist to draw a parallel between sexual union and the gendered encounter of sea and land. As he noted, 'the white bull refer(s) to the animals of Anticoli and the girl to the shore of Cornwall. Since this painting my work has returned frequently to the shore as female and the sea as male.'[30] This gendering of the natural environment, which had informed his work as early as *The Yellow Runner* (1946), was reflected in his recurrent treatment of those places where the sea might be thought to forcefully penetrate the land. He based several paintings on places built around long thin estuaries (Portreath and Porthleven, for example), made a number of drawings and paintings of Gunwalloe, a cove where the sea rushes up to a small church on the beach, and he was fascinated by the zawns of Penwith's north coast – narrow intrusions into the granite cliffs where the sea has eroded the softer

62
Nude (study for Europa), 1954
Charcoal on paper
30 × 22
Private Collection

tin-bearing rock. He returned to the combined theme of the erotic figure and the sea in 1961 with *Beach Girl* (1961) (**63**), which he described as 'a picture about blonde girls on sandy beaches' and, more specifically, 'a gorgeous norwegian (*sic*). Like a Viking in a Bikini'.[31]

Beyond the conception of the landscape as gendered, prior to *Europa* Lanyon had produced paintings in which the human body was projected on to, or read into, the landscape. We have seen how *Harvest Festival* and *Corsham Summer* were interpreted as 'mourners' at the Crucifixion, and he had previously described a long thin painting – probably the latter of that pair – as a 'portrait of Anne', adding that calling it 'the anness is not particular enough, it remains the annescape'.[32] Later he had written to Roland Bowden, 'You ask about developments since the portrait landscapes … I think they are still person landscapes'.[33] That he described the country around Corsham as a 'feminine landscape' thus takes on a new significance.[34]

There were, of course, many precedents for an art that fused landscape and body, and, at that time, the sculpture of Henry Moore established such an ambiguity as a major artistic form. In the 1930s, Pavel Tchelitchev had produced images of landscapes that metamorphose into recumbent female bodies, and similar works by Michael Ayrton displayed a still greater sexual charge. During the 1940s, Graham Sutherland's depictions of tree forms had resonated with a barely hidden erotic anthropomorphism, while, conversely, John Piper's erotic drawings of the nude implied a continuity between the expansive body and the landscape

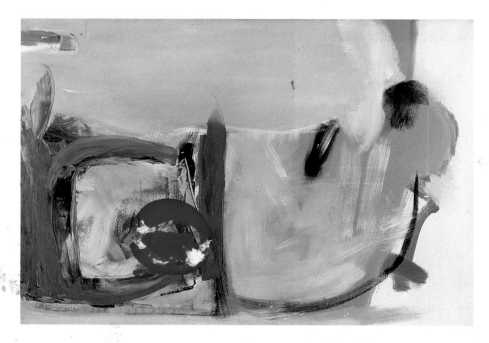

63
Beach Girl, 1961
Oil on canvas
42 × 60
Bernard Jacobson Gallery
and Gimpel Fils, London

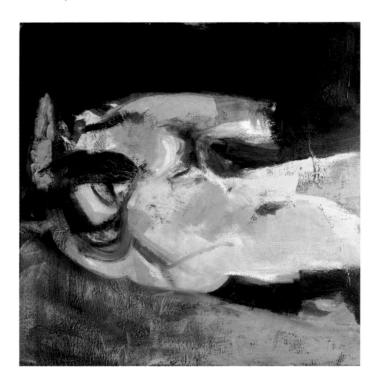

within which it lay. There is, however, a fundamental difference in Lanyon's treatment of this familiar ambiguity. For these other artists, both land and body were objectified and contained by the gaze. In contrast, Lanyon's 'nudes' interpreted the body through touch, and the claustrophobic merger of forms in *Europa* epitomizes this concentration on points of contact. Even in the elongated landscapes that the artist read as figures – or in some way figural – haptic experience echoed the phenomenological experience of place. A work such as *Corsham Summer* described a journey through the countryside and Lanyon drew a parallel between that and the conception of the nude as a journey across the desired female body:

> Having experienced this long line say from the armpit down over the ribcage down to the pelvis, across the long thigh and down to the feet that line might take me out in the car to the landscape and I might experience this again. By having drawn this nude I experience it sensuously, the sort of experience one would have perhaps by some sexual contact with the female. But in this case transformed to an understanding of the landscape.[35]

Just as his approach to landscape replaced its objectification by the gaze with his bodily experience of its spaces, so touch came to take a position alongside vision in his approach to the body.

64
Susan, 1958
Oil on board
47½ × 46
Private Collection

Lanyon later recalled that *Europa* was one of four nudes that he had painted.[36] Though he did not name the other three, one was clearly *Susan* (1958) (64), which he described as 'a straight painting of a model turning over on a bed ... there's no reference to any specific part of the body – I wanted to paint the movement of the girl rolling over'.[37] Interestingly, the generalized features and the sense of erotic exposure that result from the depiction of the moving body anticipated Bacon's treatment of the naked female form after 1959.

If 'nudes' were rare in Lanyon's production, sexual encounters became a major theme, as many of his experiences of place were shared with his mistress. Its distance from home ensured that for many artists Corsham represented an escape from domesticity and, like others, Lanyon enjoyed relationships with several of the students. These were not especially secret and an early partner, Judy Jackson, was featured in the painting *Judy* (1953).[38] Though he would have a number of minor encounters, the artist's relationship with a girl called Susan would prove to be longer lasting and he noted that she 'appeared' in a number of paintings after 1956.[39] This situation does not signify a denigration of the importance of Lanyon's wife and family, for that domestic core continued to provide a vital support structure and source for the artist. Nevertheless, the complications and emotional conflicts of such a situation were incorporated into his conception of a life of sacrifice and suffering.

That Lulworth, on the Dorset coast, should appeal to Lanyon was inevitable as its almost circular cove, so nearly enclosed as to become a lagoon, provides an obvious symbol of a maternal, protective space, and the soft chalk cliffs' geological strata dramatically reveal their historical make-up. However, he identified the painting *Lulworth* (1956) (65) as one derived from a visit to a place in the company of his lover. He described it as a

> story painting ... I've painted not only the shape of the cove itself and the shape of the beach, but also two lovers standing up hugging one another waiting to have their photographs taken by a rather old-fashioned photographer who's on the left hand side of the picture.[40]

He specifically told one friend, '*Lulworth* is a portrait of Susan. So is *Tamarisk*'.[41] It seems likely that the artist read the narrative of a posed photograph into the painting after it was completed. It is noteworthy that he described the 'towering form' on the left as an echo of the clock tower in *Porthleven* and that, in describing it as 'the guardian (the photographer)', he introduced the idea of a father figure. Such a conjunction of two forms became a recurring feature of his work, and, while this inevitably invites a sexual reading, it is always ambiguous and can be seen in purely formal terms, or read as elemental, alluding to the confrontation of the elements or of two air masses.

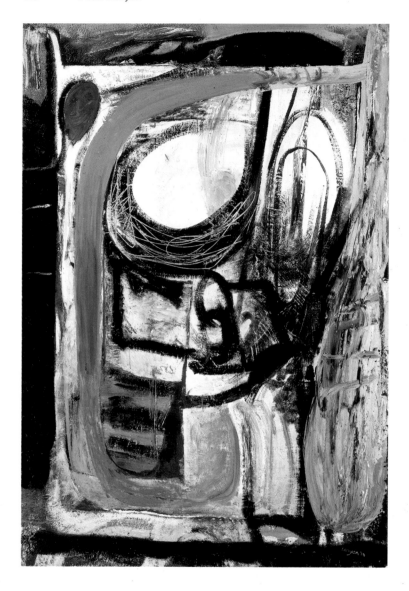

Lanyon's paintings were increasingly predicated on such an encounter between two forms, and in considering his use of the sexual theme it is worth focusing on his fascination with the point of contact, the liminal zone. It was around the time that he painted *Europa* that he told Roland Bowden,

> I would not be surprised if all my painting now will be done on an edge – where the land meets the sea where flesh touches at the lips – a point of thinness which adds up all of preparation before committing the nearest thing I believe to death.[42]

This reveals the crux of much of his work, the focus on those sites where one's identity is both challenged and, therefore, established. It is here, as the artist's comment indicates, that place, sex and death come together in the definition of the self. This is the significance of Lanyon's fascination with abjection, because it is the abject that blurs the distinction between subject and object, that resides in those bodily regions of transition: the mouth, the skin, the genitalia.

This concern seems to be central to *Europa* (**66**), which in its stated theme addresses what Gilles Deleuze, in reference to Bacon's paintings, called 'the zone of indiscernibility, of the undecidable between man and animal'.[43] The suggestion of sexual transgression, of bestiality, injects an element of taboo and of the grotesque, to which the virginal blood also alludes, and one might argue that the various levels of meaning in the painting revolve around the concept of liminality, of sites of fluidity, interface and exchange. Though the individual elements and actors of the myth are indiscernible in the painting, one can say that, in their union, both the bull and Europa are subsumed into a single mass. The artist had explored this in several massive plaster sculptures made, he said, in preparation for the painting. The most dramatic is in two sections and Lanyon wrote that the female part, which was to have been cast in aluminium, was enfolded by the bull, to be bronze (**67**). In another, *Europa Shore* (**68**), a white form is similarly engulfed by a darker mass that is both bull and sea, and the concept of a fragile identity is enhanced by the attachment of the sculpture to an inverted lens that allows it to revolve and to rock precariously on a mirrored base. It is worthy of note that Jackson Pollock had addressed the theme of *Europa* in one of his rare

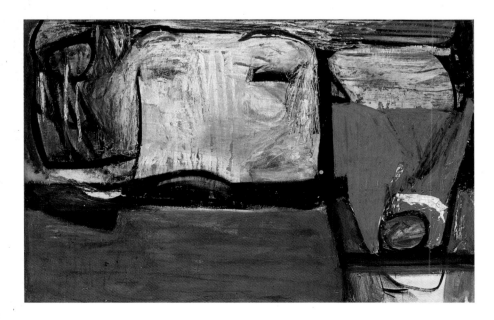

66
Europa, 1954
Oil on board
48 × 72
Private Collection

ventures into sculpture, and Arturo Martini, who had lived in Anticoli, made at least one plaster bull, which, in its compact massiveness, is similar to Lanyon's modelled and painted representations of the myth.

The ultimate abjection, the final line of transition, is death. In *Europa* its presence is implied in the colouring: the red of the blanket and the white-grey of the lovers' bodies, the colours – reminiscent of Rembrandt's *Flayed Ox* or, especially, of Soutine's reworking of that theme – of meat, flesh, death. The fusion of love and death became a recurrent theme in Lanyon's work. While *Orpheus* (1961) recalls the poet's descent into Hades to resurrect his dead lover Eurydice, *Salome*, from the same year, alludes to the death of the male through the female.[44] Both myths, the artist noted, are concerned 'with love and death', while the latter tells the story of a man who 'fell by the scheming of woman'.[45]

In classic fashion, the female appears in Lanyon's work as both a symbol of life and renewal and, as the desired other, as a threat to identity and to life. In 1954, the artist related *Europa* to a photograph of a nuclear test explosion in the Nevada desert, and its symbolic red to the need for 'a new virgin', a symbol of generation – new blood – as opposed to the perpetual threat of destruction.[46] As we have seen, the Virgin, as the archetypal mother and intercessor for restitution, had appeared in his paintings before, and there are a number of other works that refer in their titles to women associated with reparation of the male. Around the time of the 'Generation Series', he had made at least two small pictures on the theme of Isis, and in 1962 he produced *Antigone* (69), which, echoing the earlier 'mourner' landscapes of 1951–2 in its suggestion of a shrouded figure, refers to the loyal daughter who accompanied her banished father Oedipus, and was sentenced to death for performing her brother's funeral rites.

Thus, the reparative female, epitomized by the mother, was a recurrent motif. But the mother can be both nurturing and threatening: Julia Kristeva has shown a double threat to the subject 'from the possessive maternal body as from his separation from it', and Jung described the dualism of the maternal archetype:

← **67**
Europa, 1953
Painted plaster
20 × 27 × 20
Private Collection

68 →
Europa Shore, 1954
Painted plaster, glass lens and mirror
9 × 16 × 9
Private Collection

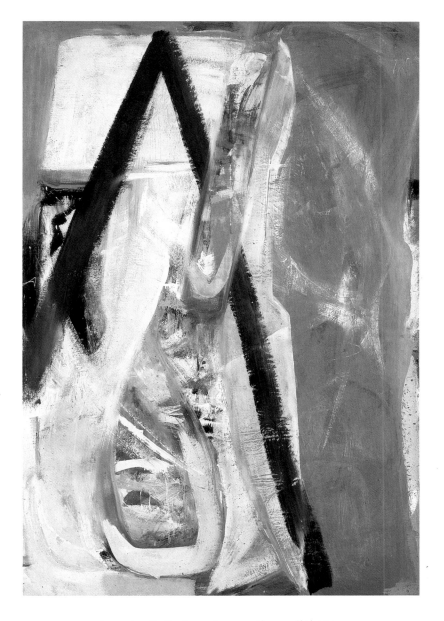

maternal solicitude and sympathy … all that is
benign, all that cherishes, that fosters growth
and fertility … (but also) anything secret, hidden,
dark, the abyss, the world of the dead, anything
that devours, seduces and poisons.[47]

If sex is a return to the womb, if the desire for the
female other is a desire for the mother, then that desire can be
threatening to the male self, and this may be implicit in *Europa*

69
Antigone, 1962
Oil on canvas
72 × 48
Bernard Jacobson Gallery
and Gimpel Fils, London

as, in Ovid's account, Zeus' adoption of the form of the bull is depicted as a loss of dignity, the debasement of the god for love.[48] It was in this spirit that Lanyon, borrowing a term from Stokes, drew a comparison between sex and artistic production, describing both as the restabilizing of the unbalanced self in 'a sensuous immersion … the making of a plastic "otherness"'.[49] The desire for another is an act of self-definition even as the surrender to that desire endangers one's separate identity. So, in his conception, love and sex, like certain places and events, represented similar situations of threat and disequilibrium that were necessary for creative work, and its eventual resolution.

 Lanyon spoke of his nudes as 'more concerned with nakedness … than nude', a quality that he found in Bacon's figures, and this was how he felt in the act of painting.[50] In his conception of artistic work, he maintained the artist's need to risk his security in order to achieve his ends: 'the process of making outward of true construction requires a birth and that means … a willingness to discard and be naked'.[51] He wrote that 'an openness representing nakedness is what I aim for because in this way I think of revelation'.[52] Repeatedly, a comparison was made between artistic production and sex: 'Real love', he told Terry Frost, 'is … like the Arts, in which copulation is a consummation and not only an emptying'.[53] Similarly, he wrote, 'We have to go beyond the bearable to create … inadequacy and fear – the unguarded back. It is no wonder that sex inspires us and makes us the saddest creators'.[54] 'The unguarded back': how resonant a phrase, a powerful evocation of vulnerability to and through the female other and an associated submission to natural instinct.

 So, Lanyon's paintings of the nude, or of romantic or sexual union, paralleled his treatment of landscape and place in their bid to establish a solid identity through posing a threat to the self. The engagement with abject matter reflected a similarly double-edged situation, in which the boundaries of the subject are threatened even as he is redefined. In addressing a body that is fluid, that exceeds its boundaries, Lanyon joined the Bakhtinian tradition of the grotesque evident in contemporary representations of the body in the work of such artists as Bacon, de Kooning, Jean Dubuffet, Germaine Richier and in Jean Fautrier's *Otage* series of paintings.[55] With the body, as with the external environment, Lanyon sought those sites where identity was threatened to create an artwork that restored equilibrium. Increasingly, this reinforced subjectivity in painting would take precedence over the historical and social concerns that had predominated in the paintings of 1949–54.

Lanyon's doubt

'I have had to fight in the dark with things I know
nothing about with nothing and with no hope …
I know nothing about painting.'

The year 1954 proved to be a good one for Lanyon, as he was awarded
the Critics' Prize shortly before his successful second exhibition at Gimpel
Fils in March. His work was regularly included in group exhibitions across
Britain and was shown by the British Council abroad, while the artist
himself enjoyed public exposure with a number of broadcasts on radio
and television. Towards the end of the year he was asked to show a
retrospective exhibition of his work at Plymouth City Art Gallery in 1955,
which eventually toured to Nottingham as well; the opportunity this
offered to review his output fits with a sense that the middle of the 1950s
marked a turning point for him. Just as Lanyon's reputation seemed to be
secured, however, his work almost ground to a halt and he produced few
paintings during 1955. There may have been private reasons for this: the
birth of twins in January 1954 meant the Lanyons now had five children,
and an inheritance enabled them to buy a larger house in time for
Christmas 1955. However, there were clearly changes occurring in his
painting that suggested both progress and doubt.

 The developments in his technique that had emerged after his
trip to Italy in such paintings as *Saracinesco* and the reworked *St Just*
were taken further in a few works exhibited in 1954, such as *Moor Cliff*,
Kynance (**71**) and *Mullion Bay*.[1] In *Moor Cliff*, the long, smeared paint
marks that had characterized such works as *Farm Backs* and *Inshore
Fishing* (**72**), both from 1952, contrasted with a new, shorter gesture,
so that surface texture now played a more important role than it had in
the preceding works. This adjustment to his practice was echoed by the
introduction, in *Europa*, of a new subject and of a more compact, more
abstract compositional style. That Lanyon was uncertain of the direction
in which these departures should take him is suggested by an uneasy
tension in *Mullion Bay* and, even more so, in *Blue Boat and Rainstorm*
(1954) (**70**) between abstraction and representation. While the interlocking
forms of the former maintained his use of shallow space, the literalness of
the depictions of boat, harbour-mouth, cloud and, most strikingly, horizon
in *Blue Boat and Rainstorm* produced a rather trite narrative.

 When Lanyon's production revived in 1956, he had established
a manner of painting that was still clearly related to that of his earlier
work, and yet a significant development from it. In *Highground* (1956)
(**73**), for example, a mass of multi-directional thick strokes of paint served

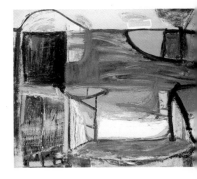

70
Blue Boat and Rainstorm, 1954
Oil on board
48 × 56
Whereabouts unknown

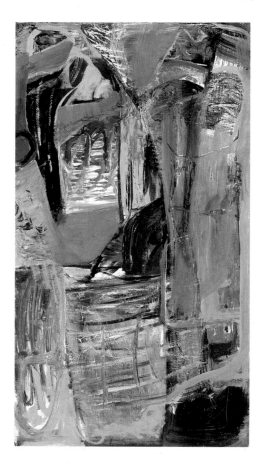

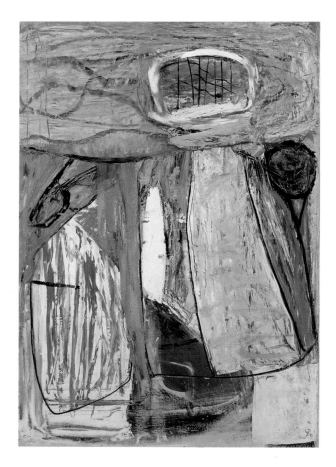

both to create an active, sensuous surface and to signify the work's subject: the artist described it as a 'harvesting picture … it's a picture of tall dry grass blown by the wind'.[2] Lanyon's work became generally more expansive, with larger areas of paint and broader, apparently quicker, gestures, so that it appeared looser and more confident. While he continued to relate the handling of the medium to its representational, or allusive, function, this development brought the appearance of the paintings in line with a wider art practice that was inevitably compared to the works of the American Abstract Expressionists. Specifically, the conjunction in a work such as *Highground* of interwoven flicks of paint over a larger, tighter compositional structure – anchored by the diagonal that rises from the bottom left-hand corner – recalled the work of Willem de Kooning.

In January 1956, the Tate Gallery hosted an international touring exhibition from the Museum of Modern Art, New York, 'Modern Art in the United States', which included a small selection of 'Contemporary Abstract Art'. It is surprisingly difficult to judge just how much of a revelation this exhibition was for painters in Britain. Hitherto, it has been portrayed as virtually the first sight British artists and critics

had of works whose reputations had preceded them by several years. In fact, the advent of Jackson Pollock had been announced by Clement Greenberg in *Horizon* in October 1947 and Herbert Read had made several visits to New York and America between 1946 and 1950. Though none of Pollock's seminal 'drip paintings' were shown in Britain until 1953, the British painter Alan Davie had drawn extensively on his knowledge of earlier works by the American, which he saw at the Venice Biennale in 1948. Lanyon had also been to that Biennale, where he briefly visited the display of Peggy Guggenheim's collection in the Greek pavilion, seeing the early work of Pollock, Mark Rothko, Clyfford Still and others.[3]

While Guggenheim's exhibition demonstrated the new confidence in American art, the works she showed largely pre-dated the establishment of the individual artists' signature styles. It now seems clear, however, that Lanyon was also one of several Britons (including Hepworth, Nicholson and Read) to visit the 1950 Biennale. There he could have seen, amongst others, Pollock's *Number One* (1948) and, more significantly, several recent, major works by de Kooning, including the black and white *Light in August* (c1946, but in the Biennale catalogue as 1948) and *Dark Pond* (1948), the predominantly white *Mailbox* (1948) and the large *Excavation* (1950)(75).[4] One can easily find parallels between de Kooning's work of 1948–50 and Lanyon's of 1950–3. In *St Just*, for example, the strong linear structure, the interleaving of successive layers of colour, and a varied paint surface, ranging from loose, vigorous strokes to markedly smooth areas, are comparable to such paintings as *Excavation*. In the work of both artists the linear elements create a sinuous effect whilst also defining a conglomeration of organically-shaped compartments, which look as if

73
Highground, 1956
Oil on board
47 × 72
Private Collection

the paintings' subjects had been compacted into a small space. While Pollock's paintings derived from a fundamental shift in studio practice, both Lanyon's and de Kooning's were clearly located within a post-Cubist tradition, and retained references and allusions to original sources that are hinted at but subsumed by the matter of the paint.

De Kooning's series of *Women*,[5] begun in 1950, displayed a degree of literal representation that distinguished his work from Lanyon's at that time. However, in the works of the mid 1950s, including, for example, *Woman VI* (1953), the figure was so fragmented and, apparently, assailed by violent brushstrokes that, once again, the two artists' approaches, seemed similar. Most significantly, this new degree of expressive abstraction, in de Kooning's case, appears to have come from his adoption of the convention of the woman-landscape duality. *Woman as Landscape* (1955), for instance, shows a slashing and swirling of violent brush-marks over an underlying structure that is comparable to a work such as *St Ives Bay* (1957) (**74**). *Woman I* (1950–2) was the most recent of de Kooning's paintings to be shown at the Tate in 1956, and so it seems unlikely that Lanyon could have seen such later works before his first visit to New York in January 1957.

Conversely, in 1953 he had been one of three British painters shown at the Passedoit Gallery in New York, when *Corsham Summer* was reproduced in the major American periodical *Artnews*; *Farm Backs* and

74
St Ives Bay, 1957
Oil on board
48 × 72
Private Collection

Inshore Fishing were also shown.[6] In that same year William Scott visited
most of the major practitioners of Abstract Expressionism and described
their work to British colleagues. Later, in a major polemic against American
influence, Patrick Heron recalled that at that time Scott had remarked
upon the coincidental similarity between Lanyon's work and that of the
Americans, and had commented 'that Lanyon was "without knowing it,
already an American painter!"'.[7] It is clear that in his correspondence with
Clement Greenberg, which followed their first meeting in 1954, Heron
particularly advocated Lanyon's work.[8] Though Lanyon's painting was
considerably looser after 1956, Heron later proposed that it was the British
artist who exerted an influence on de Kooning, who, he argued, had started
to make paintings explicitly associated with landscape shortly after
Lanyon's first solo exhibition in New York in January 1957.

 There are many problems with Heron's argument, several
of which have been published, but the most important seems to be the
question, so what? In an analysis of Lanyon's work, or of de Kooning's,
or of painting, art or culture of the period, what is the significance of
influence? More important is the question why a particular practice or
motif was selected by one or several artists at a certain time. Parallels
can certainly be found between Lanyon's painting and the work of the
Americans, whether in the technology of the painting or in the content.
Though artists inevitably adopt forms and ideas from each other, the
important issue is why those elements are considered to be apposite. So,
for example, the fact that Barnett Newman had produced a series of works
on the theme of *The Slaying of Osiris* in 1944–5 may suggest a particular
historical pertinency in Lanyon's references to the same theme.[9]

75
Willem de Kooning
Excavation, 1950
Oil and enamel on canvas
81⅛ × 101¼
©The Art Institute of Chicago

The problem for Heron in his critique of Greenberg's promotion of American painting was always that the two critics shared the same terms of reference. That is to say, the criteria for their judgements of art were always formal, so that they might disagree over the question of whether a composition should be centralized or reach to the edges, yet would confirm for each other the belief that such purely technical questions were all that mattered. It is this formalist doctrine that promotes claims and counter-claims for precedence, while obscuring other considerations. Thinking of Harold Rosenberg's alternative construction of what he termed 'Action Painting', one might like to consider Lanyon's studio practice in terms of the actual process rather than the appearance of the end product. Or, drawing on more recent accounts of Abstract Expressionism, we might wonder why Lanyon, in common with painters elsewhere in Britain, Europe and America, chose to use and address such themes as myth, Jungian analytical psychology and, of course, place. In doing so, we might come closer to the artist's own attitude of disdain for formal critiques whilst positioning him in relation to his contemporaries in contrast to his own claims to an ahistorical individualism.

In the early 1950s, Lanyon's work fitted Heron's attempts to define a modern form of painting centred on the creation of shallow pictorial space. This shallow space and an all-over compositional coherence were the criteria that Heron used to judge contemporary work, and, as a consequence, he wrote approvingly of such Parisian artists as Hans Hartung, Maurice Estève, Alfred Mannesier, Roger Bissière and, most especially, Pierre Soulages. He collected British artists under a similar rubric in his 1953 exhibition 'Space in Colour', in which *St Just* was first shown. But Heron's was only one position in the flux of British art criticism of the period, and Lanyon's work was seen to have a pertinence both to John Berger's attempts to define an art concerned with contemporary social realities and to the position adopted by David Sylvester following his exposure to Parisian existentialism in the late 1940s.

Lanyon might equally be allied to the increasing concern with matière – the actual stuff of painting – which was especially associated with Dubuffet's *Art Brut* and had been a major theme in Michel Tapié's anthology of contemporary painting in Paris, *L'Art Autre* of 1953. The quality of Lanyon's paint, and his concern with a fluid body that seems to metamorphose into landscape, echoes much of Dubuffet's work, but, once again, we might follow the artist in associating his use of paint with the subjects of his work rather than viewing such technical aspects of painting in isolation.

From 1957, he was friends with several prominent New York artists, notably Robert Motherwell and Mark Rothko. To mark Lanyon's second visit in February 1959, Motherwell hosted a party in his honour for about fifty 'friends', including Rothko, Philip Guston, Adolph Gottlieb and David Smith, and, though the Motherwells' planned visit to Cornwall was

never realized, the Rothko family stayed at Little Park Owles for a
long weekend in August 1959.[10] Lanyon was glad to claim an association
with New York whilst still refuting the new academicism of Abstract
Expressionism. The crucial thing for him remained the association
of technique with content, signifier with signified:

> To achieve an art which is in time and space ... it is
> necessary to go beyond the immediate gesture. As soon as
> this is done the artist enters a human condition ... The final
> act is once more a completely integrated gesture and a
> certainty, but this should not be confused with a merely
> talented gesture imposing of the frozen mark. To confuse it is
> to mistake for art that which is a mark of human pride, greed
> and ambition.[11]

The various developments in modernist painting after the war – *Tachisme*,
Art Brut, Abstract Expressionism/American Action Painting, and so on –
coalesced in Britain into a series of vaguely defined groups and exhibitions
that, more than anything, revealed the absence of a critical voice to
rationalize the diversity. In 1957, Lawrence Alloway tried to historicize the
development of such an art in Britain and to discern nuances within it in
two exhibitions: 'Statements' at the Institute of Contemporary Arts, and
'Dimensions' at the O'Hana Gallery. The ubiquity of such work and the
critical confusion around it were demonstrated by the Redfern Gallery's
'Metavisual Tachiste Abstract', in the catalogue for which Action Painting
was described as 'the hybrid child of the Frenchman Dubuffet, the German
Ernst, and the American Jackson Pollock'.[12] Six works by Lanyon were
included under the titles *Painting 1* to *Painting 6*. His use of the landscape
theme also ensured Lanyon's inclusion in the 1958 exhibition 'Abstract
Impressionism', with the painting *Gull Shore* (1957). There Alloway
adopted Elaine de Kooning's phrase in an attempt to define a group
style that was determined by the common use of a uniform pattern of
brushstrokes and an interest in optical effect, which, drawing on such
models as Bonnard, Cézanne and Monet's late work, 'recast abstraction
into something more concerned with the qualities of perception of light,
space and air than the surface of the painting'.[13] In its acknowledgement
of nature as a point of reference and its concern with space as a substance,
such a group might have appealed more to Lanyon.

 One can, of course, find formal parallels between his work and
that of the Americans. As well as the similarity of his brushwork to that of
de Kooning's, some of his sparer paintings, with broad expansive gestures,
are comparable with the black and white works of Franz Kline. One might
relate the flat expanses of a few works of the late 1950s and early 1960s –
Two Birds (1961) (76), for example – to the colour-fields of Rothko or
Newman or, indeed, to the staining of Helen Frankenthaler – Motherwell's
wife – whose studio Lanyon visited in 1962. Lanyon, however, retained the

desire for an engaging, sensuous surface, as was demonstrated by his rejection of acrylic paints as 'dead'.[14] He was especially appreciative of Rothko's work, admiring its humanity and 'incredible "facing" quality', which he compared to the work of Cézanne.[15] The frequent association of Rothko's canvases with the notion of a new sublime is concordant with the engagement with the weather and the expanses of sea and sky that came to the fore in Lanyon's painting of the later 1950s.

Perhaps the most important link between Lanyon and the American artists was a common interest in myth, psychological explanations of painting, and the persistent question and definition of one's place in the world. Lanyon's interest in the primitive, in Jungian theory, in James Frazer's anthropological writings on myth were all shared with American artists. Parallels to Lanyon's titles may be found amongst those of the Abstract Expressionists and, specifically, certain themes recur. So, his use of the Europa myth is echoed in Pollock's sculpture of the same name (c1949–50) and his painting *Pasiphäe* (1943), and the story of Oedipus is referred to in both Lanyon's *Antigone* (1962) (**69**) and Rothko's *Tiresias* (1944). Less directly, one might compare the reparative intention behind the memorial-like *St Just* to Motherwell's series of *Elegies to the Spanish Republic*.

Greenberg proposed a theory of Modernism based on the notion of the progressive reduction of each form of artistic expression to those qualities that were uniquely its own. In the case of painting, the flatness of the picture was the element to which that art form was progressively reduced.[16] The dominance of this account of Abstract Expressionism's

76
Two Birds, 1961
Oil on canvas
48 × 60
Gimpel Fils, London

evolution, and the rise of a Post-Painterly Abstraction informed by Greenberg's theory, obscured for a long time the fact that the Americans' work was first received in Europe under Harold Rosenberg's label 'Action Painting'. Rosenberg's emphasis on the physicality of the painting process could be said to have made even bolder claims for the radicalism of the Abstract Expressionists. In his essay 'The American Action Painters', which was known to British artists, he described an art that was the product of an event enacted on the canvas, rather than a preconceived object, and so placed the artist's subjectivity at the centre of the production process.[17] While Lanyon would emphasize the role of conscious thought, and his deliberate translation of an experience into paint, this existential account of painting comes closer to his own studio practice.

Through his insistence on the relationship of the painted mark to actual experience, Lanyon rejected the idea of an art concerned purely with paint and with the act of painting. In 1962, he explained how a process of 'precipitation' was carried through into the production of a work.

> A specific sight or occurrence may cause an apprehensive reaction, answers are expected. A continuous process is fed by sensation. This is 'informing'. It is the process of collecting and sifting information which is being fed to the artist. He trains himself to select information which is relevant ...The artist proceeds to make marks in an apparently automatic fashion. Considerable training is required to precipitate marks which relate to information received. The artist must proceed beyond the inspired guess to certainty. The surest way to inhibit development of a painting is to remain at the guess. Here the mark itself becomes important (it is in fact the small change of aesthetics) and not that which is signified. This significance begins to show when the informing process or gathering is complete and the forming process begins.[18]

Despite the clarity with which he could conceptualize his 'informing' process, its translation into paint was far from easy. The image we receive of Lanyon in the studio is one of existential crisis, self-loathing, doubt and of confrontation between him and the picture. He suffered from bouts of depression for much of his adult life, and his correspondence is peppered with Cézanne-like declarations of despair. In 1949, for example, he told how he had 'reached an all time low ... really scraped the bottom of Hell and brought up a stinker of a picture';[19] four years later he suffered three months of 'black depression ... the last scraping of the bucket', hoping that 'in its polished surface (he would) see the awful me'.[20] For Lanyon, the working procedure was 'harassing and painful', and he approached his painting with 'dread', because he knew 'there may be a struggle, disillusionment, distress and disgust lasting for years over one

painting'.[21] Writing about *Lulworth* (65) in 1956, he explained, again with echoes of Cézanne, that it was his search for a new means of making the image that caused these problems:

> I have been reduced to more misery and distress by such paintings than any human being can make for me, because I have had to fight in the dark with things I know nothing about with nothing and with no hope ... I know nothing about painting. I don't see it from outside and I have no facility for producing paintings because I have deliberately rejected all such things. I have to find both the means and the subject.[22]

The picture thus became an object of disgust and of attack, as intimated by the rapid, gestural strokes and the repeated use of different means of erasure. Lanyon did not merely rework areas of paint but, in a sort of parody of the scraping of Nicholson's 'St Ives' followers, he scratched through, sanded down and even he claimed, took a blow-torch to the layers of colour.[23]

In claiming not to see painting 'from the outside', Lanyon established a parallel between the phenomenological continuity of the perceptive body and its environment, and the painter and his painting. The work was the final product of a bodily process, as the artist spoke of physically absorbing an environment, so that its 'image' would precipitate within him, and of then expelling that image in paint. If the work of art and the artist's body are one continuous whole, painting for Lanyon was a series of attacks upon the self: 'I *hate* Art, I *hate* Lanyon and I hate hate', he wrote in 1952.[24] His close friend Michael Canney recalled how

> The studio was very much bespattered with paint because he worked with great frenzy at times ... after a long bout of painting of possibly two or three weeks, or two or three months, he would emerge as a public figure again but looking pale and really ill ... painting took a tremendous amount out of him.[25]

As early as 1949, Lanyon had recognized the importance of the experience of depression and dejection to his working practice, when he told Gabo that 'the periods of complete negation and hopelessness in my work are now bearable because I feel them as part of a whole which is the particular image I am making'.[26] Thus, painting was cathartic, the only means, he said, for his 'interior darkness' to be 'revealed'; his 'real' identity was 'locked in a private anguish somewhere and ... only manifest in paint'.[27] On occasion this purgatorial engagement would be openly reflected in the emergent work, the form and colour of which would invoke a darkness reinforced by the title. In *Witness* (1961) (78), a dark blue-black form is painted over a typical flurry of whites and blues, through which flashes of bright greens, reds and ultramarine are discernible. The form suggests an observant body, perhaps bearing witness to historical events, though

77
Lanyon working on 'The Conflict of Man with Tides and Sands', 1960

78 →
Witness, 1961
Oil on canvas
72 × 48
Collection David Bowie

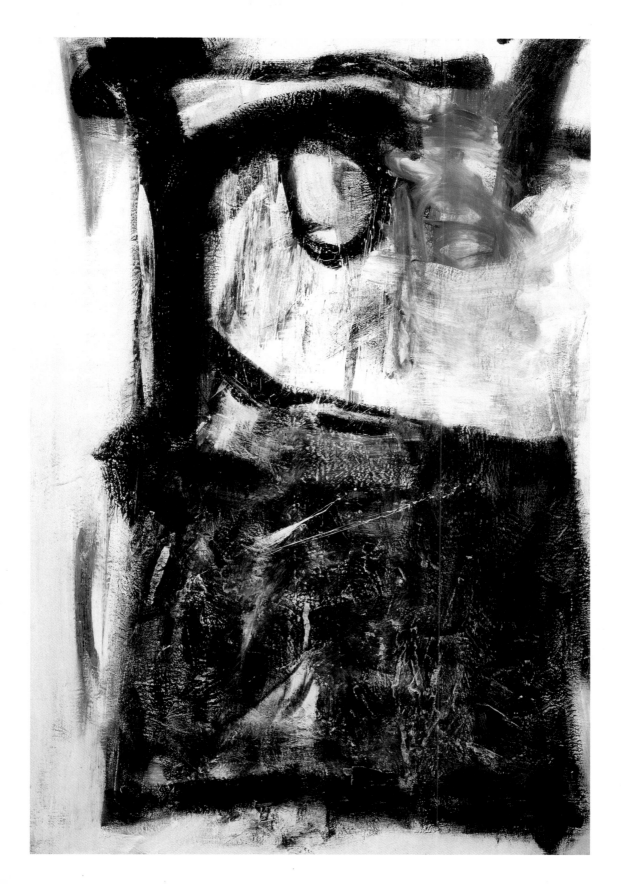

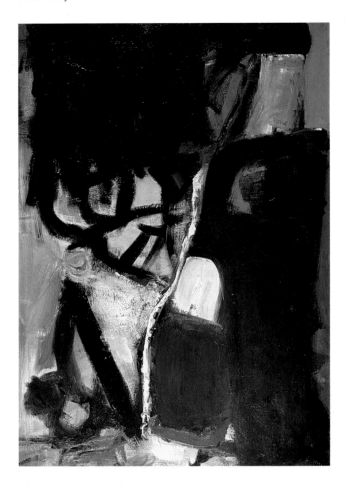

it also recalls the shape of a harbour and extended pier, and could refer
to Lanyon's witnessing of the events in St Ives that he so despised; the
title also suggests that the painting itself is witness to the artist's struggle,
which is encoded in the heavily built-up texture of the surface and the
splattering and dribbling of paint across its top. *Calvary* (**79**) is another,
especially brooding, example produced for the Contemporary Art Society's
'Religious Theme' exhibition in 1958. The colouring recalls Lanyon's
description of the first state of *St Just*, at the time of which he had said that
he felt himself 'lain across the arms' of the Crucifixion; a similar personal
suffering is commemorated here.[28] 'Mine is also a Calvery (*sic*)', he told
Paul Feiler,

> I realise that's what it is ... I have also had a very grim time
> painting it and trying to avoid self pity or any type of pity.
> In the end it arrived out of hopelessness and I have a new sort
> of dislike for it ... for the inadequacy of what it says. However,
> I suspect it will be too big to hang – like sorrow itself.[29]

79
Calvary, 1958
Oil on board
72 × 48
Gimpel Fils, London

In this interdependence of production and self-destruction, Lanyon echoes
Merleau-Ponty's seminal reading of Cézanne as a self-doubting obsessive,
the epitome of the 'authentic' artist struggling to work his way out of
depression through the reconstruction of the external world that brought
subjective and objective experience into unity: 'a paradigm of the
"existential" artist'.[30]

Merleau-Ponty described the paradox of Cézanne's art:

> he was pursuing reality without giving up the sensuous
> surface, with no other guide than the immediate impression
> of nature, without following the contours, with no outline
> to enclose the colour, with no perspectival or pictorial
> arrangement. This is what Bernard called Cézanne's
> suicide: aiming for reality while denying himself the means
> to attain it.[31]

The problem that Lanyon consciously set himself was similar: to find a new
means of expressing lived experience through what he continued to see as
a constructive art. Within a Stokesian-Kleinian idea of art as a reparative
act, in the studio he reached the same condition of disequilibrium that he
sought in the landscape, took himself to the abyss, as it were, in order to
pull himself back from it. His visual vocabulary may have been comparable
to that of other artists, but it is more useful to recognize how that
similarity came out of a shared artistic genealogy and a common attempt
at an expression of subjective experience than to dissect lines of influence,
conscious or not.

The threatened body and the new sublime

'A lonely impulse of delight
Drove to this tumult in the clouds'

W.B. Yeats

The paintings that Lanyon produced from 1956 confirmed his 1954 prediction that his work would increasingly be 'done on an edge'.[1] Though most of his work had been based on places, he had noticed in 1952 that there were a number that were also 'about' events – journeys, natural phenomena and agricultural activities, for example. In the second half of the 1950s, the emphasis in the majority of paintings shifted from places to these more temporal events, in particular the weather. As ever, they derived from actual, subjective experience in a place, almost always on the coast or the high ground where land and sky seem to meet. Thus, storms out at sea, the surf on the beach, the movements of the tides, the flight of gulls over cliffs, the blowing seeds of grasses in the late summer wind and the flow and counter-flow of air currents became themes alongside the more overt allusions to specific places. Though Lanyon's concern with the exploitation of mining informed such works as *Wheal Owles* (1958) and *Lost Mine* (1960) (**80**) – both based on inundated mine shafts – the historical and cultural associations of the places he represented became less important and his own physical experience came to the fore once more.[2]

The new emphasis introduced a greater mimetic function in the manner of Lanyon's working, as strokes of blue and white came to signify gusts of wind, rolling waves or foaming surf. *St Ives Bay* (1957) (**74**), for example, is easily readable as a painting of crashing waves amid skirmishing winds swirling around what might be the harbour in the 'quieter' bottom right-hand corner. The paint-handling seems to preserve the physical action of the artist while evoking the buffeting forces of the sea. Similarly, in *Zennor Storm* (1958) (**82**) a green landscape, marked with the orange of the iron in its rock, peers through the blues and whites of wind and lashing waves that cross the canvas. In *Lost Mine*, a peaceful area on the left-hand side disturbingly offsets the vigorous blues and black on the right that signify the torrent of water bursting into the mine shaft and drowning those within, who may be symbolized by the vibrant red of life and danger. By contrast, in *Silent Coast* (1957) (**81**) Lanyon used large flat areas of paint to instil a sense of peace, and pushed the forms to the edge to reproduce the original experience:

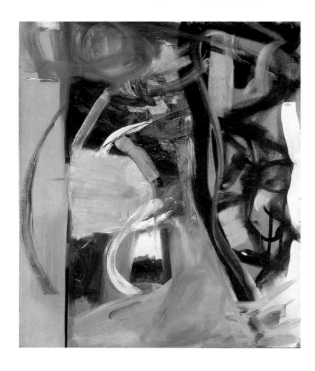

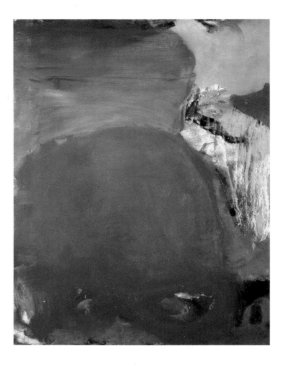

I painted it from very high up, looking down on a broad expanse
of coast. Everything was still and slow-moving, as on those
days when after stormy weather one gets an extreme silence
and restfulness round the coast of West Penwith.[3]

The two swollen blue forms possess an ambiguity: they could be sea and
sky, but the sense of pressure between them as they seem to squeeze together
suggests they might have been conceived as different bodies of air. In this
aspect, and in the painting's economy of form, *Silent Coast* anticipated the
work of the early 1960s.

Lanyon continued to produce paintings that were heavily worked
and involved a considerable degree of erasure – wiping off, rubbing down,
scraping away – and over-painting. Nevertheless, the paintings of the late
1950s and early 1960s generally showed a new openness and fluency. This
apparent facility of facture was encouraged by his use of canvas from 1959,
as opposed to the harder, crisper masonite board that he had employed since
the end of the war. This change in support was apparently requested by his
New York dealer, Catherine Viviano, with whom he had five exhibitions
between 1957 and his death in 1964, as the boards were said to warp in the
central heating of her clients' New York apartments. The change caused the
artist some anxiety – 'a terrible job' – as a pliable canvas risked the ground
coming away from the glue size, while a stiffer one could be damaged if
rolled. 'I <u>hate</u> to think I am painting on a ground which won't last', he wrote,
'because I don't like making a "temporary" thing'.[4] Nevertheless, we can

← 80
Lost Mine, 1960
Oil on canvas
72 × 60
Tate Gallery, London

81 →
Silent Coast, 1957
Oil on board
48 × 36
© Manchester City Art Galleries

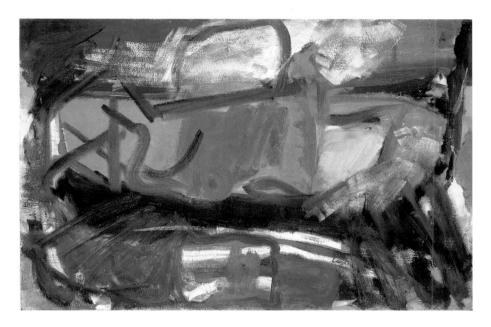

see the new material and the new technique as complementary, and by
the early 1960s he was making pictures – such as *Two Birds* (1961) (**76**)
and *Inshore Wind* (1962) (**83**) – with such an economy of means that much
of the surface is only a single layer of paint through which the weave of
the canvas is clearly visible.

 The concentration on those places where opposites meet produced
a considerable number of works in which a sort of boundary, a line of
encounter, dominates the composition. This introduces a formal tension,
a certain awkwardness, which marks Lanyon's distance from American
painting in its contrast to the all-over harmony that dominated the work
of such artists as Pollock and Rothko. While these lines of interface usually
derived from such natural phenomena as the conjunction of surf and beach,
sea and cliff, or hill and sky, they also imply the human presence that he
had addressed in *Europa* (**66**). Thus, *Long Sea Surf* (1958) (**85**) indicated
one element of its source in its title but was also said to have 'a figure inside
the landscape'. The artist spoke of the 'long sea surf' as a metaphor for
myth, saying that it was again

> connected with the story of Europa – this time the moment
> when the God disguised as a bull appears out of the sea and
> captures the girl … This is a picture about a girl on a long
> beach near Land's End where the waves come in directly
> from the Atlantic. She is very close to the sea, right at the
> edge of the surf which runs up the left hand side of the
> picture, squashing the figure against it.[5]

82
Zennor Storm, 1958
Oil on board
48 × 72
Tate Gallery, London

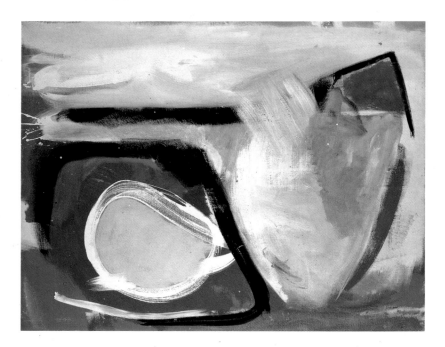

A similar combination of surf and body was identified in *Low Tide* (1959)
(**84**): 'a still figure at the calm edge of a silent day'.[6]

 In 1957, Lanyon travelled to the Derbyshire dales with the
landscape painter Anthony Fry to contrast their different methods for a
BBC radio programme. He described his process of familiarization: looking
at a map of the area and remarking on the ancient place names, talking to
local people about nearby lead mines, visiting churches where a Celtic cross
provided a vertical element and ancient associations, and the figure of a
recumbent crusader on a tomb introduced the horizontal and the idea of
travel beyond the region. He began to conceive of a vertical painting that
derived its format from the cross and from his experience of climbing a cliff
in which geological history was made evident. Finally, he returned to the
studio with a collection of objects – stones, perhaps, or fossils – along with
his collection of ideas and associations. These, then, provided the raw
materials for an 'image' – an idea of the place or experience from which
a painting would evolve.[7]

 Increasingly, however, such historical concerns gave way to more
immediate, physical experience. The artist's fascination with his image-
forming process – which was physical, sensory and cerebral – is indicated
by the fact that two years later he recorded the development of the painting
Offshore (1959) (**86**) from his visit to the village of Portreath on which it
was based, through different stages of its development, to its eventual
resolution. It is, he said, 'a weather painting', explaining that the form at
the top of the picture is 'a gale of wind circling offshore'.[8] His recording
begins with a description of the weather on the day he went to Portreath:

To approach the Western Hill I went along the beach –
the wind was blowing then from the north-easterly. It was
blowing about half a gale. There was a small gig offshore
about two miles out and it could very rarely be seen,
occasionally it was bobbing up and down out there apparently
fishing. It seemed very dangerous weather to be fishing in.
The sea was piling in on the shore ... I walked along the beach
and this was on my right hand side ... Then I climbed up onto
the Western Hill by the rocks, so that the sea descended to
my right. Then I went up the side of the Western Hill beside
the rocks. The sea then became something which was down
towards the side of my feet ... I then walked over the Western
Hill and the gale struck me straight on ... I lay down and,
looked over the edge and watched the sea coming in, striking
on the shore ... Then I came back ... southerly and down under
the lea in the shelter, and there I sat down.[9]

← **84**
Low Tide, 1959
Oil on board
60 × 31
British Council, London

85 →
Long Sea Surf, 1958
Oil on board
72 × 48
Hirshhorn Museum and Sculpture Garden,
Smithsonian Institution, Washington, DC

The painting was initially vertical and was started with a general blue section, green-grey in the middle and a 'rather indefinite area' on the left. The artist described driving in the countryside near his home to 'get a sense of the greenness' for the painting. A process of elimination brought the work to the first state of completion, but Lanyon revised his judgement and resumed work, painting quickly to reach another point of resolution within a few hours. However, he felt that 'the image was lost behind a mess of painting' and sought to reach a balance between the 'masculine' sea and 'feminine' land, seeming at various moments to have ruined the whole thing before reaching the third and penultimate state. Finally, he described how, with the canvas still vertical, he pulled a lot of white over the blue, painted black around the green and extended it up the left-hand side until painting white with two red marks across the bottom 'turned the painting over on its side. It was then completed very, very quickly and I turned my back on it … knowing in fact that it was finished'. The account gives some insight into the relationship between the artist's temporal, bodily experience and a final painting made up of successive, overlaid compositions.

The theme of violent weather was typical of Lanyon's fascination with meteorological confrontations: the clash of natural phenomena or the threat to man, fragile before the elements. It was addressed most ambitiously in the first of three large-scale commissions, which he described as 'the culmination of all the sea and weather paintings'.[10] In September 1959, Lanyon was commissioned by the architect Maxwell Fry to produce a mural for the entrance lobby of the Civil Engineering Building at Liverpool University. The subject was to be 'the work of research organisations concerned with loose boundary hydraulics' and was given the title *The Conflict of Man with Tides and Sands*. As the mural was to occupy a busy site, it was decided to make it in enamel paints on seven hundred and fifty six-inch ceramic tiles. To complete the work, Lanyon had to borrow a barn in the country where he rigged-up a cradle at an angle of thirty degrees in which to make the twenty-three-foot-long and nine-foot-high panel (**77**); the painted tiles were fired in a small kiln by William Redgrave's wife Mary. Six full-size sketches were made, which the artist described as 'exercises, practice runs' rather than studies for the final image.[11] Lanyon researched hydraulics and visited a laboratory in Wallingford before deciding that he should concern himself with 'a general background alluding to but not representing the problems of the science'. The mural was completed in May 1960 (**87**).

With the title given, the artist, naturally, rejected the idea of representing a human figure, seeking instead the quality of 'celebration' that he found in opera and the paintings of Tintoretto, Rubens and Delacroix. Such 'Romantic' precedents provided models for the elaborate movement in the mural. The artist described the imagery: on the left is a generator, derived from the paddles used to produce waves, from which

a threatening mood stretches across the top to be dispersed into 'a lyrical white section' towards the top right-hand corner. A translucent, dark blue part-triangle towards the left acts as a breakwater, while the middle section, defined by an inverted triangle, has at the bottom 'a gentle beach-and-blue sea-landscape of considerable tenderness'. To the right of that is the swirling pattern of mud and sand leading to the red-lead references to bridge and harbour that draw the eye down the small staircase beside the mural.[12]

The concentration on the weather locates sensory experience at the heart of Lanyon's process of 'informing', and centres the body as both the subject of that experience and the catalyst to the evolution of the painting. Here is an image of the artist that recalls Turner lashed to the mast of a ship in order to fully experience a storm at sea, or the mad Lear raving at the elements. A friend, Warren Mackenzie, remembered going

86
Offshore, 1959
Oil on canvas
60 × 72
Birmingham Museums and Art Gallery

into St Ives during a magnificent storm and finding the streets empty save the flying roof-slates and Lanyon, encouraging the storm and crying, 'It's great, it's going to tear the town down, isn't it wonderful'.[13] In the paintings of the late 1950s and early 1960s, the historical and cultural references of the earlier work have been stripped away to focus on the basic fact of human existence, of the body facing the world.

Lanyon had written as early as 1948 that it was in such situations as looking down from a cliff at the crashing, swirling sea hundreds of feet below that a person 'realises he is seeing an image of his own existence'.[14] For this reason he had long sought out extreme situations where his own mind and body were challenged: driving fast; helping with the harvest though suffering chronic hayfever; visiting tin mines in defiance of his claustrophobia; and, despite a fear of heights and the boyhood trauma of being held out over the Clifton Bridge as an attempted cure, he climbed cliffs and would lie at their edge looking straight down to the sea below. Finally, he took up gliding.

Lanyon was a great admirer of the aviator and writer Antoine de Saint-Exupéry, and there were echoes of the Frenchman's existentialist rhetoric when he wrote of failure forcing him to a desperation that led him

> to explore the region of vertigo and of all possible edges where equilibrium is upset and I am made responsible by my own efforts for my own survival. Without the urgency of the cliff-face or of the air which I meet alone, I am impotent. I think this is why I paint the weather and high places and places where solids and fluids meet. The junction of sea and cliff, wind and cliff, the human body and places all contribute.[15]

Lanyon defined vertigo as 'a sort of Angst applied to landscape', which becomes understandable when seen in these terms of liminality, of edges and boundaries – the locus for the abject.[16] He spoke of the need to jump 'through the edge (the naked barrier)' in order to produce a new painting,[17] and wrote that at these marginal zones he could identify three key elements: 'The landscape, distance and life – The body, sex, generation, the animal – and death'.[18] In seeking out these anxious sites or states, Lanyon continued his search for self-definition, exploring the possibilities of an art that defined the individual's place in the world. As Heidegger wrote, anxiety is the state in which one is compelled to face the fact of one's existence: 'That in the face of which one has anxiety is being-in-the-world as such'.[19] So, though the paintings concern themselves with landscape, nature, place and space, the body is always alluded to in Lanyon's work.

Just as the Romantics' human figure was implied rather than represented in his Liverpool mural, so it recurs as an unstated presence in many of the paintings of this period. The fascination with those liminal zones where the sea meets the land, the hill the sky, implies a human presence, a perceptive body, at that site, as the artist had identified in

Long Sea Surf. The confrontation of the fragile human body with the elemental forces of the weather and the sea inevitably associated these works with concepts of the Sublime that had been a key component in the Romantic landscape tradition and was undergoing a recovery in the work of American artists such as Rothko and Newman. In painting the human being's encounter with nature, Lanyon implies the presence of a modern-day equivalent to Richard Wilson's minuscule figures who contemplate the vastness of Snowdonia.

The expansive canvases of Rothko and Newman have often been compared with the Romantics' fascination with the expansiveness of the natural world, most famously in the comparison between Caspar David Friedrich's *Monk by the Sea* (1809) – a depiction of man contemplating infinity and his own existence – and a viewer standing in front of one of their works. This aspect of Abstract Expressionism had been articulated by Newman in his 1948 essay 'The Sublime is Now' in *Tiger's Eye*, a New York journal known in Europe, and a little earlier by Rothko who, in his essay 'The Romantics were Prompted', wrote approvingly of 'the pictures of the single human figure – alone in a moment of utter immobility'.[20] The idea was reiterated by various artists and by Robert Rosenblum, who first associated Newman, Rothko, Clyfford Still and Pollock with Romantic painting in 1961, when he drew the comparison with Friedrich, and with the work of British artists: John Martin – who was 'haunted by apocalyptic visions that turned matter and the works of man into swirling, cosmic upheavals' – and, most especially, Turner who was akin to Pollock in his attempt 'to achieve a pictorial means that would transcend the relatively

87
The Conflict of Man
with Tides and Sands, 1960
Enamel colour on ceramic tile
105 × 276
Civil Engineering Building, Liverpool University

literal description of unleashed, destructive nature'.[21] We can make the same claims for Lanyon's work, or at least his intentions, for, like these artists of the Sublime, he sought to represent in paint those places where the body is confronted by an all-powerful nature, and to invoke the recognition of one's existence that the awesome thrill of the Sublime stimulates.

In the context of the West after the Second World War, and within the tensions of the Cold War and the threat of nuclear devastation, Lanyon's representation of the threatened figure before nature took on a broader metaphorical significance. In August 1945, the cover of the popular magazine *Picture Post* had mimicked Romantic imagery with a photograph of a child silhouetted against a broad horizon over the headline 'Man Enters the Atom Age', the innocent contemplation of a nuclear future. Lanyon too was haunted by photographs of nuclear explosions in the Nevada desert, and the anxieties that those images inspired were a factor in his concentration upon those places where identity is both challenged and established. In the mid 1950s, he wrote about 'edges of experience' – moments of departure, escaping the city for the country – and found in the formality of Capability Brown's landscape at Corsham Court a ready symbol for existence in the face of modern history and modern anxiety:

> At Corsham Court there is a device called the ha ha, it is a ditch which divides the foreground from the distance between an avenue of trees. This is artificial, a part of landscape gardening. It is also the edge of the plateau which at other times supported the Pietas and Annunciations of renaissance painters and also made a platform for the partners in Giorgione's 'Fete Champetre'. Today standing on the edge of the ha ha … with back to the foreground, modern man is less aware of gentle perambulations than of apprehension, a feeling that the back is not guarded. His is the situation of the condemned man who like millions in the last twenty years have faced similar ditches.[22]

So, in reference to the murders of the Holocaust and other genocides, the naked back that Lanyon had felt exposed by sex and, by association, by artistic work is reiterated as a literal symbol of modern man's frailty. The edge of landscape – one of those places of interface – becomes an anxious site for both the individual and for a broader humanity.

Lanyon's notions of these edgy sites of danger and definition are classic expressions of existential thought. The concept of the absurdity of existence, as articulated by Albert Camus for instance, is invoked by the suggestion that 'This is the inelegant situation which faces the man at the edge. He sees himself as ridiculous'.[23] Similarly, the solitary exposure of oneself to risk, the facing up to the challenge of responsibility and

existence, is the classic situation of the existential hero and none more
so than the pilots heroized in the fictional and autobiographical writings
of Saint-Exupéry.[24] The author, who had served as a pilot in the Great War,
had flown the mail in Europe, North Africa and South America and had
died, with a bitter irony, flying in World War Two, was a favourite of
Lanyon's. His narratives of wartime flight and of the equally perilous
pioneering mail service were published in English during the 1930s, and
several recurring themes are echoed in Lanyon's work and attitudes.

The loneliness of responsibility comes through in several of Saint-
Exupéry's books: both the solitude of good, strong leadership that alienates
the patriarchal figure as he pushes his charges to achieve their best, and
the pilots' recognition of their responsibility for their own existence alone
among the clouds. The extreme solitude of the sky is deployed as a powerful
symbol of the existential state, becoming at once a sea in which one might
drown and the Other that defines the edges of the Self. 'You want to
remember that below the sea of clouds lies eternity', the young narrator
is advised in *Wind, Sand and Stars*,

> And suddenly that tranquil cloud-world, that world so
> harmless and simple ... took on in my eyes a new quality.
> ... Below it reigned ... a silence even more absolute than
> in the clouds, a peace even more final. This viscous
> whiteness became in my mind the frontier between
> the real and the unreal, between the known and the
> unknowable.[25]

Flying and its attendant dangers were the vehicle for Saint-Exupéry's
vision of existence – the edge to which his characters were pushed. He
expressed it in appropriately vitalistic and corporeal terms: he describes
how the pilot feels the metal of the plane, 'the life coursing through it; the
metal was not vibrant but alive ... the pilot in flight felt neither giddiness
nor intoxicating thrill, but only the mysterious travail of living flesh'.[26]
In these texts the human body is base, but through the loneliness of
responsibility there is the potential for transcendence. Man's obligation,
Saint-Exupéry wrote, is 'to endure, to create, to barter this vile body';
like the cedar tree, he 'thrives on mud, but transforms it into a crown of
leafage, fed by sunlight. Thus mud is transmuted into virtue'.[27]

Lanyon had managed to fly a little towards the end of the war
and wrote then that it was 'getting in my blood'.[28] In 1959, he decided to
try a different form of flight and started lessons at the Cornish Gliding Club
at Perranporth. Gliding became a passion and a major force in his life and
in his painting. The artist said that 'the whole purpose of gliding was to get
to a more complete knowledge of the landscape', and he related this new
adventure to other means of moving within his environment – walking,
cycling, driving – and said he was now able 'to extend my physical
participation into more dimensions'.[29] He saw it in pictorial terms as

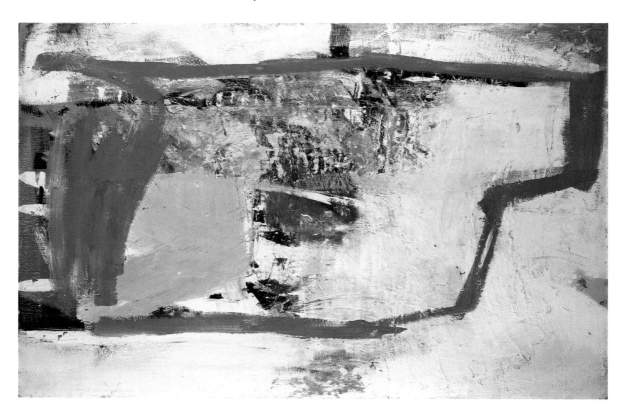

a development of the use by Turner and Richard Wilson of a compositional spiral to define landscape space:

> This is why I do gliding myself, to get actually into the air itself and get a further sense of depth and space into yourself, as it were, into your own body, and then carry it through into a painting. I think this is a further extension of what Turner was doing.[30]

However, gliding also represented a major departure in his involvement with the landscape in that, while he had always conceived of himself as immersed within a place, he was now able to view it from a position of elevated detachment. As he put it, 'For the first time I was able … to experience my county from outside returning <u>to</u> land rather than emerging from inside'.[31] The advent of gliding and paintings deriving from it may, therefore, be seen as a major adjustment: the focus was now even more on the body as the centre of subjective experience. Lanyon said that his work had come to 'combine the elements of land, sea and sky – earth, air and water', but, if specific places had hitherto been represented as experienced by the artist, the paintings were now far more concerned with fixing the body's position in space. Previously, Lanyon's idea of physical involution had shown how he believed his identity to be determined in relation to

Cornwall, the painter and the Cornish landscape being a single continuum; now, his paintings reflected the establishment of a detached self defined by its immediate environment, by all that it is not. In this repositioning, Lanyon moved away from the politics of cultural identity towards a phenomenological concept of individual identity. The gliding paintings of the late 1950s and early 1960s may be seen to represent, therefore, the artist's major statement about being-in-the-world.

No works better reflect Lanyon's desire to locate himself than his first gliding paintings: *Solo Flight* (88) and *Soaring Flight* (7), both from 1960. In the former, through the earthy browns, the blues and chalky white impasto, a red line, quickly applied and simple in form, signifies the journey of the artist's body through the air and over land and sea, the hot colour symbolizing danger and vitality. In this centring of subjective, bodily experience, Lanyon developed the romantic trope of the threatened male body, seeking, perhaps, like Rothko and Newman, a synthesis of the Sublime of Romanticism and the isolated individualism of the post-war period. Similarly, in *Soaring Flight* the experience of silent passage through the air is suggested with diaphanous layers of blue, while once again the vital centre of this experience, the artist in his red glider, is marked with a line that traces his movement and tries to conjure up a sense of his shifting speed as it rises gently and plummets through the composition.

The attempt to paint amorphous space provided Lanyon's paintings with an unprecedented lightness and sensitivity, and it was this that delighted critics when the first gliding paintings were exhibited. While established supporters tended to discuss Lanyon's work in the same terms as before, the stylistic developments won new admirers who saw a radical change. The critic Lawrence Alloway had long been suspicious of St Ives artists' retention of landscape references, but, reviewing Lanyon's Gimpel Fils exhibition in October 1960, he found a new open and light richness:

89
Lanyon coming in to land, 1963

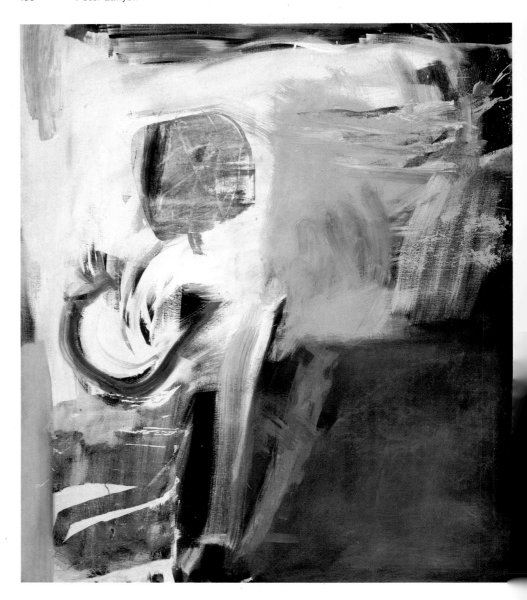

The exhibition includes a few of the impasted monolithic landscapes of his earlier style, but these are like puddings compared to the dominant moist and swinging blues. ... Soft and amorphous veils of colour are a painterly code for the ways in which light models insubstantial cloud layers or catches the movement of tides and winds in water seen from above. He paints with an attack which is rare in England ... and the élan of his technique becomes a metaphor of the light-filled space which is his subject.[32]

90
Thermal, 1960
Oil on canvas
72 × 60
Tate Gallery, London

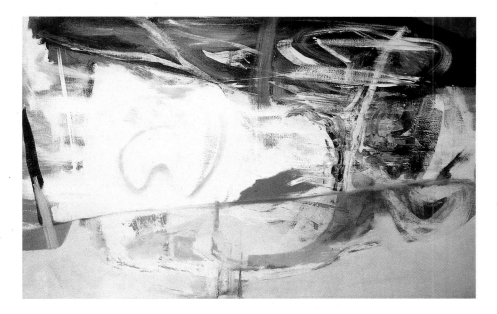

Gliding informed Lanyon's understanding of weather and the elements, and he described *Thermal* (1960) (**90**) as 'essentially a weather painting, and of the sky which is all round one in a glider'. The painted gestures seem to mimic the movement of air currents that he is describing:

> Terrific turbulent action going up on the left hand side, then slowing down completely into the deep blue below, which is almost completely static, like a threatening thunder cloud. A glider pilot needs a thermal to gain height. The rising hot air lifts him up in a great spiral, sometimes meeting the cold layers of air with an impact as sharp as being hit by a stone.[33]

So, as is even clearer in *Cloud Base* (1962) (**91**), gliding provided new instances – anticipated in the bulbous masses of *Silent Coast* (**81**) – of opposing forces meeting.

Flight had been an established symbol of modernity since Robert Delaunay's fractured bi-planes spiralled around a tilting Eiffel Tower, and in the 1930s the experience of flying had provided Ben Nicholson with an optimistic vision of the future. For Saint-Exupéry the aero-engine was part of a mechanistic future that need not be feared; but gliding, flying with no source of power other than natural air currents, is a far more elemental experience. It entails a great knowledge of natural phenomena, the movement of the air over different types of land and sea, and it is an experience that is largely silent and, in the tiny cockpit, without encumbrance: the glider pilot becomes the solitary body in space responsible for its own survival. Lanyon had long been fascinated by the flight of birds, and in gliding, he said, he was able to move as they did.

91
Cloud Base, 1962
Oil on canvas
48 × 72
Private Collection

The painting *Two Birds* (**76**), in which the simplified black forms of the birds seem suspended between two zones, hovering, poised at the point where two air currents meet, was surely informed by the artist's own experience of flight, and we might see those isolated forms as metaphoric signifiers of solitary man teetering at the edge.

In Merleau-Ponty's philosophy, the perceptive body and its environment are bound into a single structure, 'every external perception (being) immediately synonymous with a certain perception of my body'.[34] The relationship of a body with its environment, its Other, defines the boundaries of that body, so that in representing his position in space Lanyon can be seen to be defining his own Self. It is motility that defines one's body-image, in that the body is not just one of a range of objects, it is the only thing that is self-contained, it is defined, as it were, by what it is not. In seeking to represent his own vital movement through the extreme abstraction of air, Lanyon extended his attempts at self-definition through painting. In his gliding paintings, he stripped away all incidental, cultural, historical, anecdotal accoutrements to paint his being-in-the-world in his passage through the clouds.

Widening horizons

'Beachcombing is a favourite activity of mine,
and for me the painter is a kind of beachcomber.'

The last years of Lanyon's short life witnessed a consolidation of his career
and new departures in his artistic production that leave one to speculate
on how and where his work would have progressed had he lived longer.
His status as one of the leading figures in British art was reflected by his
inclusion in the second 'Documenta' exhibition at Kassel in West Germany
in 1959, in a North American tour of 'European Painting and Sculpture
Today' from 1959 to 1960, and in a number of selections of British art that
were sent to locations as diverse as the Soviet Union, Portugal and the
southern states of America. In 1959, *Offshore* won second prize at the '2nd
John Moores Liverpool Exhibition' and in 1963 Lanyon sat on the panel of
judges of the same competition. In 1962, he won the Premio Marzotto in
Valdagno, near Vicenza, with *Orpheus* (1961). In 1960, plans were already
in place for a retrospective at the Whitechapel Gallery in 1962, but for
reasons that are not clear they did not reach fruition.

Despite the tensions the arrangement caused, he continued to
show with Gimpel Fils in London and with Catherine Viviano in New York.
Nevertheless, he was disappointed by low sales and concerned about
money. Lanyon had enjoyed an independent income since he inherited a
third of his father's estate on his twenty-first birthday and benefited from
other family business interests in Britain and South Africa, but having six
children to educate placed considerable pressure on the artist's finances.
Nevertheless, he persisted in producing large paintings in defiance of the
Gimpels' repeated pleas for smaller canvases, though the large number of
gouaches he made after June 1962 may be seen as an attempt to produce
more saleable work.[1] From 1960 he taught part-time at Falmouth School
of Art (until 1961) and at the West of England Academy in Bristol (until
1964), where his friend Paul Feiler was Head of Painting. He made
increasingly frequent visits to New York, where he had become very
friendly with several artists and collectors, and to other parts of America.
From February to April 1963 he was Visiting Professor of Painting at the
Marion Koogler McNay Institute in San Antonio, Texas, where he had an
exhibition, and at the time of his death he was arranging a lecture tour of
Australia and a teaching post at Princeton and was considering a future in
America. More locally, he was elected chairman of the Newlyn Society of
Artists in 1961 and was made a Bard of the Cornish Gorsedd for services
to Cornish art in the same year. During his final summer he accepted an
invitation from Michael Canney to join the committee of the Porthleven

Group of artists, an attempt to boost artistic work in the village, and mused that it was 'odd that after the revolution of the last twelve years I should appear to be drifting towards Porthleven. Believing in the power of fate as I do, perhaps our respective winds are fair'.[2]

Following *The Conflict of Man with Tides and Sands* (1960), Lanyon was commissioned to make another two murals. The first was for a private patron, Stanley J. Seeger, who already had six of the artist's paintings alongside the works of Picasso and others in his collection. Commissioned during Lanyon's visit to New York in January and February 1962, the painting, on the theme of the sea, was for the music room at Seeger's New Jersey estate, Bois d'Arc.[3] It was to occupy an unusual position, a long beam, nine feet off the ground; the work is just over twelve feet long. Lanyon had visited Seeger's home previously, and the painting's situation dictated its form. Referring to drawings of the music room, Lanyon produced three full-sized 'sketches' in gouache and Indian ink – *Porthleven*, *Delaware* and *Bois d'Arc* – which were despatched to Seeger on 8 May 1962; the artist followed at the end of the month. *Porthleven*, which he related back to his 1951 painting, was chosen to be the basis of the mural, which was then painted on canvas in St Ives. The back is inscribed 'July/December 1962', because it was initially completed in July, but Lanyon was told that it was 'too strong' and made changes to the central section when he went to New Jersey towards the end of the year.[4] He visited again in February 1963 on his way to Texas and made smaller changes to the right-hand side. He said that the long painting, called *Porthmeor* in its final state, 'refers to many aspects of the sea, including associated myths. The main appearance of it is of a fast running sea with cross-shore drift and counter drift'.[5] The intention was that the eye should be drawn along the length of the composition, while the movement in the work was related to the structure of the roof timbers above it and to the room's musical function.

Lanyon's third mural commission was for the Faculty of Arts Building at Birmingham University (**92**).[6] The artist visited the site in January 1963, was finally commissioned in June and was to have the work completed by September.[7] He hired the old Penwith Gallery in St Ives, which Hepworth had also used for a large commission a few years earlier. He does not seem to have been given a specific theme and spoke of his final image in terms of weather as a metaphor for human behaviour, which he related to the arts in order to fit the work to its environment. Again, Lanyon produced a full-sized 'sketch' that is formally close to the final work but different in colouring. The mural is framed by two glazed walls through which the landscape is visible and, *in situ*, Lanyon found the rich green and ochre of the sketch inappropriate to its setting.[8] The final work, which recalls the Liverpool mural in its compositional movement, is predominantly blue, with reds along the bottom.

Strong colours had always served in Lanyon's repertoire for both representational and symbolic functions, but in the early 1960s a general

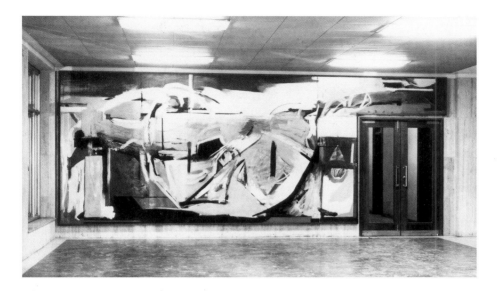

brightening of his palette is clearly discernible. The colours can often be associated with external sources: a burnt orange, for example, can refer to the dried foliage of the moors or the oxides exuded by Penwith's granite rocks, or purple can signify flowering heather. A combination of an olive-green and strong red recurs in several paintings between 1962 and 1964, but, while the green can be seen as a variation on the grassy colour in *St Just* (**59**), for example, the red has no obvious literal function. In a painting such as *Inshore Wind* (**83**), the thinness of those colours – a single layer over a white ground – gives them a vibrancy that is also seen in the characteristically fluid white that is sploshed across them. The effect enhances Lanyon's representation of the weather around the protective form in the bottom left-hand corner, as the white paint mimics the crashing waves against a harbour wall. In such works there is a positive tension between the new and old paint-qualities, as the new, thinner colours provide a background to the thicker, flattened surfaces that had long characterized Lanyon's home-mixed paints.

 The combination of literal and discordant colours is particularly striking in *Wreck* (1963) (**93**), which derived from Lanyon's observation of the actual wreck of a trawler, the *Jeanne Gougy*, which ran aground at Land's End in November 1962.[9] While the blues and translucent greens dragged across the upper part of the composition are clear references to the engulfing sea, the use of red and a range of yellows is less expected and not instantly readable. In fact, the yellow refers to the funnels of the capsized vessel, and the red may combine a similar external reference with the symbolic function that Lanyon had given his colours since *The Yellow Runner* (**31**) of 1946. The overriding presence of water is reflected in the fluidity of the handling of the paint and most especially in the way the white of the circular form has been allowed to run towards the left-hand edge.

92
Untitled, 1963
Oil on board
289 × 609
Faculty of Arts Building, Birmingham University

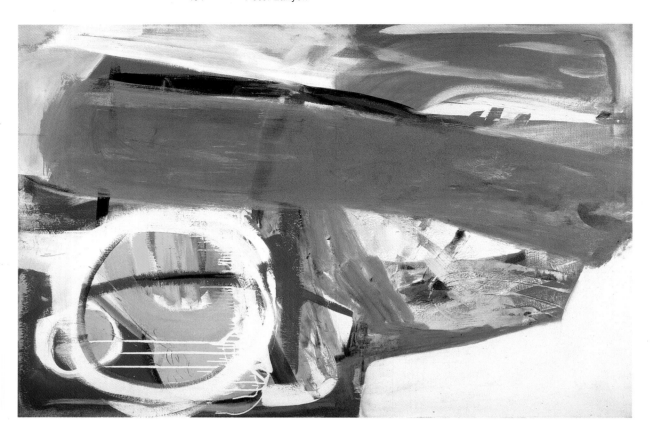

Changes in Lanyon's colour range and handling of paint must be considered in the light of developments in contemporary art. Having appeared in America in the late 1950s, acrylic emulsion paints first became available in Britain in 1963, when they were adopted by many painters, both abstract and figurative. By that time, however, British artists were already familiar with American painting and some imported their own acrylics. Though Lanyon experimented with the new paints, and rejected them as 'dead', the new quality of his work might reflect an awareness of the surfaces being produced by artists using the new technology. While thinner paint might suit the representation of atmospheric effects, it was also, along with the brighter palette, consistent with the development of the less expressive abstract painting that followed in the wake of Abstract Expressionism and the writings of Clement Greenberg. If Lanyon had not encountered the new 'Post-Painterly Abstraction' in London – through such exhibitions as 'New New York Scene' (Marlborough Fine Art, October 1961) or Morris Louis's one-person show at the ICA in May 1960 – he would probably have seen the work of such painters as Frank Stella, Kenneth Noland and Jules Olitski in New York; in any case, comparable works had been shown by British painters in the exhibitions 'Place' (ICA 1959) and 'Situation' (RBA galleries 1960), from which 'St Ives' artists were explicitly

93
Wreck, 1963
Oil on canvas
48 × 72
Tate Gallery, London

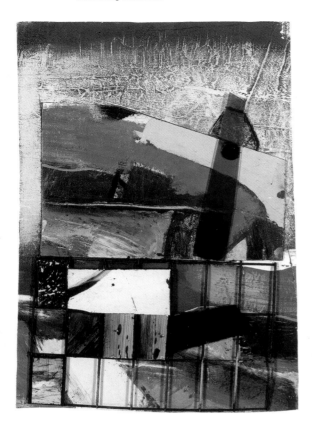

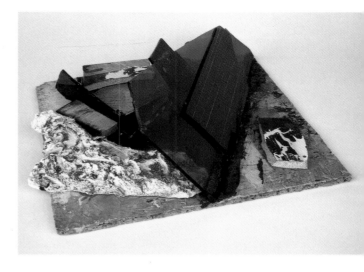

excluded.[10] Lanyon passionately repudiated the flat space of Post-Painterly Abstraction and Greenberg's concept of Modernism, which was anathema to him in its apparent conception of an art that was concerned only with art. Nevertheless, it is possible that the shifting sands of abstract painting might have had an effect on an artist so perceptive of current events. That the work of other British painters of Lanyon's generation – Heron, Scott, Wynter, Davie, for example – underwent radical changes between 1962 and 1965 indicated the need for a fundamental change of practice.

There were other adjustments in Lanyon's work at the beginning of the new decade, as the artist began to produce a number of assemblages. Gimpel Fils appear to have been reluctant to exhibit these, but they were included in the artist's exhibition at Catherine Viviano in May 1964 as 'Collage Constructions' and had been shown alongside earlier constructions at St Ives' Sail Loft Gallery in 1962.[11] Since the preparations for *Porthleven* during 1950, he had constructed three-dimensional objects as a tool for working out the space for paintings, but the later works have an independent status that those preparatory devices did not. These pieces took different forms: some, such as *Blue Glass Airscape* (1960) (**95**), are an assembly of objects on a horizontal base; others, *Built Up Coast* (1960) (**94**) for example, are more like collaged paintings; a few, like *Field*

← **94**
Built Up Coast, 1960
Ceramic tile, glass, metal, mirror and oil on board
26½ × 18⅛
© Manchester City Art Galleries

95 →
Blue Glass Airscape, 1960
Wood, glass, paint and plaster on cork tile
12 × 12 × 5
Private Collection

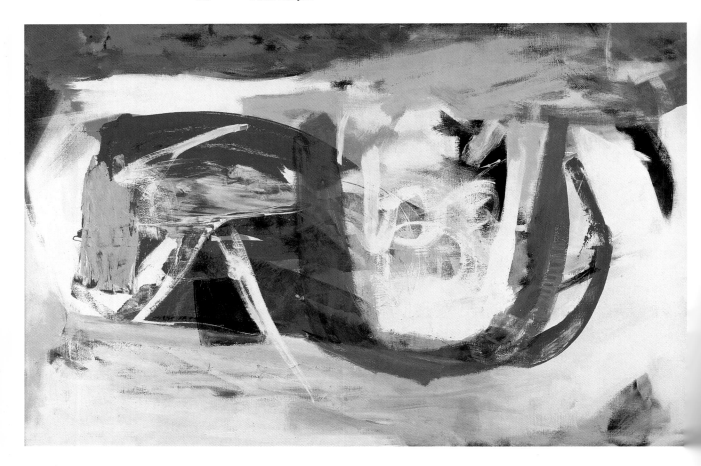

96
Loe Bar, 1962
Oil on canvas
48 × 72
Private Collection

Landing (1963–4) (**98**), can be seen as free-standing sculptures. Their common feature is the predominance of found material and studio detritus in their construction.

These assemblages were, on one level, a continuation of Lanyon's incessant need to make things. A friend recalls that, walking on the beach, he would pick up driftwood, seaweed, shells and pebbles and build a structure, right there, to last until the next high tide.[12] The artist related his interest in beachcombing to his painting process and would gather a variety of things he came across as part of his research into a place. In collecting such objects as stones and fossils, Lanyon saw them as somehow embodying or encapsulating their place of origin, which is immanent within them. 'I bring back a collection of things', he said, 'what I call my museum … I have a sort of environment which belongs to the country I've been in.'[13] In the painting *Loe Bar* (1962) (**96**), the red arc that lies over the gestural definition of the sand bar – which divides the freshwater Loe Pool, near Porthleven, from the sea – derived from one of the 'odd pieces of old wrecks rusted and brilliantly coloured' that were to be found there.[14] This kind of symbolic transmutation was given material form in the collage

constructions, which, in their re-use of rubbish, recalled Lanyon's wartime reconstruction of engines from scrap.

Many of the individual elements of the assemblages derived from Lanyon's own production. In April 1960, he was invited by the Arts Council to make designs to be interpreted in stained glass for an exhibition curated by John Piper and Revd Walter Hussey. Lanyon's proposal for a three-dimensional construction of coloured glass lit from within by a neon tube was received with enthusiasm and the finished piece was sent off at the end of June and acquired by the Arts Council after the exhibition.[15] Off-cuts of different stained and painted glass left over from this project appear in several collage constructions. Other works incorporate pieces of tile from the Liverpool mural, many of which had been painted, and what seem to be fragments of aborted paintings on board frequently provide elements or backgrounds to the assemblages. The found objects are of varying origins and associations, but often seem deliberately to signal their lowly source. *Field Landing*, for example, incorporates the handle of a kitchen implement and what may be the head of a sink plunger; a couple of works include digits from a car number plate, and another is made up of a fragment of painting and a piece of corrugated plastic suspended from the wall on the end of a pair of the artist's braces.

As the title of *Playtime* (1964) (97) makes clear, these works have a witty, playful character, but there are also elements of satire that suggest an equivocation in Lanyon's attitude to the popular material culture to which they refer. In its use of red glass passing over a painted landscape, *Built Up Coast* (1960) has been related to gliding paintings such as *Solo Flight*,[16] but the inclusion of the wire grid seems to refer to the systemization and spoliation of the Cornish coastline by the relentless development that he abhorred. Similarly, *Playtime* can be read as a jovial juxtaposition of random objects or as a satire on the rubbish left in the landscape (signified by the green background, perhaps). The sightless spectacles, reversed mirror and broken hinge thus become more poignant symbols of a fractured, visionless material society blind to the greater truths of nature. Indeed, at that time such work was seen as 'city art', or the obsolescence of its throw-away raw material was characterized as quintessentially urban.[17]

Lanyon retained a copy of the April 1940 edition of *Horizon* in which Clement Greenberg's essay 'Avant-Garde and Kitsch' was published.[18] There, Greenberg prepared the ground for his definition of a Modernism based on the reduction of each of the arts to its particular technical specialism with the proposal that the avant-garde's self-reflexivity had come about in reaction to the growth of an ersatz, urban culture of reproducible commodities: kitsch. He drew a distinction between popular culture, related to an integrated community, and modern kitsch, and one might identify a similar distinction in Lanyon's despair at the surrender of St Ives and Cornwall to the fun-fairs and other forms of

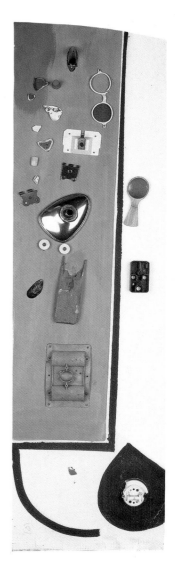

97
Playtime, 1964
Mixed media on board
53¾ × 15¼ × 4
Private Collection

low-brow, touristic leisure. At the same time, he was a great lover of popular culture and combined an interest in local folk traditions with a love of such black American cultural statements as jazz and the Twist. Lanyon rejected Greenberg's belief in art's self-referentiality, and a formal teleology of Modernism, in favour of the individual artist's attachment to a place and a culture. Art, for Lanyon, should be rooted, and this meant a relationship to modern popular culture as much as to tradition. Thus, while he rejected what he saw as the academicism of the Greenbergian abstractions of such British painters as Robyn Denny and Richard Smith, he welcomed Pop Art with enthusiasm:

> I want to set up a chair for Pop Art. I think it's wonderful. It's just what we've wanted for a long time; it's the fairground, which has come back into art … it's wonderful, it's another world … this is very much the artist's fantasy world … it's grand, it's marvellous, I don't think it's even crazy. I think, you know, up boys and at 'em, let's have a go; it's the twist and it's the pony; it's the hully-gully (*sic*) and the Madison and all the rest of it; it's all coming along and really giving everybody a fine kick in the pants.[19]

His welcome was not unqualified, however, as he recognized that Pop's roots were in advertising, and, seeing it as propaganda, was uncertain of its lasting quality: 'I personally can't decide myself whether there are any artistic values in it; I enjoy it hugely'.[20] This ambivalence could be observed in his gouaches, which incorporated, in one case, a rubbing from an old engraved Cornish stone, and, in another, a section of a Texan car number plate; while the titles of most indicate their association with places, others are more whimsical: *Beatle* (1963), for instance, clearly derives its name from the similarity between its dominant black form and the mop-top haircuts of The Beatles who had just had their first hit.[21]

Though Lanyon's view of Pop sheds light on his attitude to contemporary popular culture, his collage constructions are more clearly related to what Alloway described around that time as the 'collage explosion'.[22] In the late 1950s, the subjectivism of Abstract Expressionism had been challenged by the work of such artists as Robert Rauschenberg, which incorporated photographs and a variety of found objects in an assault upon the rarefied aesthetics associated with high modernist abstraction. Such work was consigned under the term 'neo-Dada' and had a parallel in the French neo-Réalisme. It was seen most forcefully in Britain in the work of John Latham, who painted over a conglomeration of varied materials that both challenged the conventions of painting and alluded to deliberate imagery. The prevalence of assemblage was marked by an important exhibition at the Museum of Modern Art, New York, in 1961. In the catalogue of 'The Art of Assemblage', William C. Seitz noted that,

though 'primarily urban', assembled art often incorporated such natural objects as stones, shells and driftwood. If that signalled a continuation with Lanyon's beachcombing, he would no doubt have been heartened by Seitz's association of assemblage with the artist's need to 'draw sustenance from everywhere: from the totality – moral, intellectual, and temporal as well as physical and sensory – of their environment and experience'.[23] In that sense, the collage constructions did not represent a huge departure from Lanyon's previous paintings. The flow and flux of the artist's recycled objects may be seen as an extension of the fusion of images and associations that had been the basis of his picture-making since 1950. Similarly, the assemblages generally remained within painting's two dimensions, albeit stretching them to their limit.

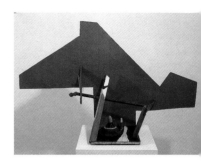

The origins of the various elements incorporated into Lanyon's collages inevitably invest the works with certain meanings, but it is unclear to what degree such associations were intended. *Field Landing* presents two very different faces in reference to the potential dangers of a forced landing in a glider. On one side a mixture of objects and fragments of wood, set against, and supporting, a vivid red steel sheet, have been seen as signifying danger, which is contrasted with the flat green back of the work, the safe *alter ego*.[24] However, unless he was seeking to introduce a sense of the absurdity of such chance situations, this anxious, and literally vital, theme seems to be rather undermined by the artist's use of pieces of household wares.

In 1963–4, Lanyon's painting underwent an even more dramatic change in its colouring as the brighter palette came to dominate works that were associated through their titles to trips abroad. In 1963, Lanyon travelled to Mexico during his two-month stay at the Marion Koogler McNay Art Institute in San Antonio. The year before, he had voiced his interest in 'frontier civilizations', places that avoided the orderliness of Britain, and it is not surprising that he should have been attracted to the untamed landscapes of south-western Texas and the more 'primitive' environment of Mexico. While a few titles relate to Texas, a majority indicate the greater impact of his trip across the border; all are characterized by a range of warm colours: earth reds and ochres, bright reds and fleshy pinks.

One of the finest, *Eagle Pass* (1963) (**99**), records the journey from Texas into Mexico, the title referring to a town named for a pass close to the border. The painting shows a degree of linearity, rare in previous works but which became more frequent, and the colouring is unusually bright and unnaturalistic. It has been suggested that the imagery might have derived from Lanyon's car – the yellow form from the windscreen, the circle in the bottom left-hand corner from a wheel; the car had featured in earlier drawings by Lanyon and had been a necessary part of his experience of the landscape since before the war. While the colours have been seen to derive

98
Field Landing, 1963–4
Painted wood, plastic, perspex and metal
32½ × 54 × 18
Gimpel Fils, London

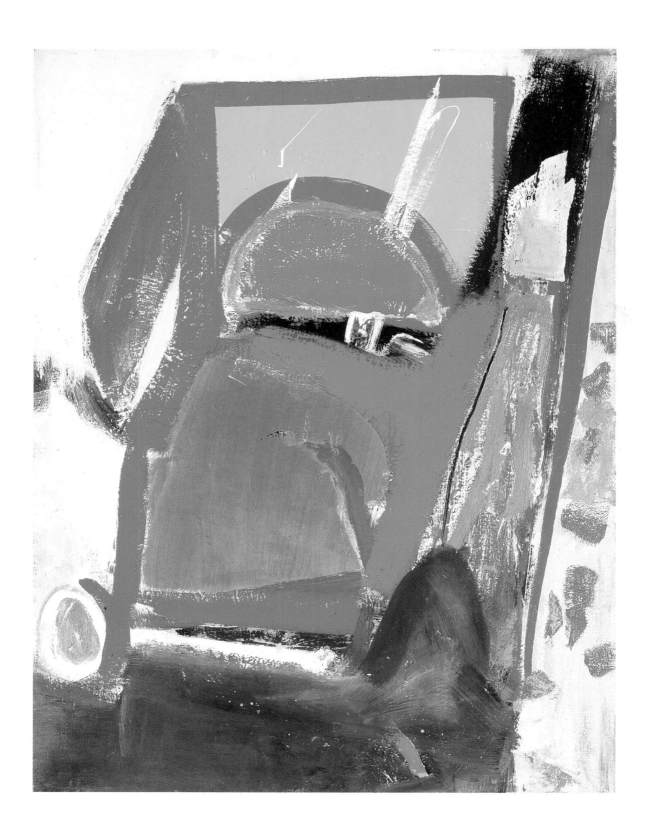

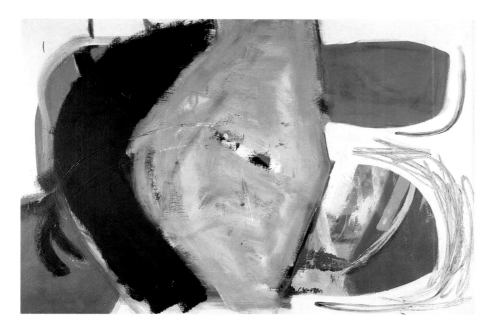

from photographs that the artist took in Mexico of a children's playground and of houses painted a pale green with crimson edging, their source might be a more general memory of the place.[25] In either case, observed colours, and perhaps forms, provided a stimulus for an abstract composition.

Photography came to play a more active role in Lanyon's research and preparation for paintings, and this may be seen as an attempt to compensate for his lack of familiarity with other places in comparison with his immersion in west Cornwall. His photographs of farms in Mexico probably contributed to the painting *Farm* (1963) (**100**), which, with its vivid contrasts of black, bright red and brilliant white, is strikingly unusual in Lanyon's oeuvre even as it displays a consistency with previous works. As in *Eagle Pass*, the novelty of its colouring obscures the retention of a familiar technique. Both works were made with a complex layering of paint applied in a mixture of fast gestures, broad smears and a confusion of drips, splashes and scratches. Underlying the simple forms of *Farm* is the complex composition that one would expect from Lanyon, over which the brighter colours have been painted so that the earlier applications may be just glimpsed, particularly towards the bottom right-hand corner. The apparently greater degree of rigidity in the forms is thus offset by the nuanced surfaces beneath and beside them.

In February 1964, a year after his trip to Texas, Lanyon travelled to Czechoslovakia as a representative of the British Council. There, he gave a couple of lectures at a number of artistic institutions in Prague and Bratislava – one on 'English Landscape' and the other on 'Some Aspects of Modern British Painting' to coincide with the Council's exhibition, 'British Painting 1900–1962'. His research led him to the conclusion that British

← **99**
Eagle Pass, 1963
Oil on canvas
48 × 36
Private Collection
Courtesy Bernard Jacobson Gallery, London

100 →
Farm, 1963
Oil on canvas
42 × 60
Private Collection

painting was worse than he had thought, though he singled out Sickert, Turner, Constable, Bacon and Hitchens as exceptions. He despaired at the lack of originality: 'what a lot of creepers we are', he wrote, 'bits of Matisse, Pollock, Kline, de Kooning, Johns and Mondrian and hardly looking for themselves'.[26] The themes of both lectures allowed him to consider the genealogy of his own painting, which he had reviewed the year before in the preparation of a recorded commentary on slides of his work.[27] The first lecture opened with Giorgione's *La Tempesta*, which introduced the theme of the human relationship to landscape, and culminated with a statement of the artist's view of landscape painting in general:

> Landscape is concerned with spaces beyond human proportions ... with the construction of images whose scale is large and of the macrocosm rather than the microcosm. The real place of a painter today in a landscape tradition is in the creation of works which transform the environment and fill people with images to understand the immense range of human curiosity particularly in the sciences. Landscape then is not any longer tied specifically to 'nature' as the country, but infuses a painting with a sense of the forces beyond human scale.[28]

Lanyon also, tellingly, referred to the importance of the Abstract Expressionists in opening up the possibility of myth. He explained that Constable had abandoned mythological painting for 'nature', and that that abandonment had been secured by Cézanne's emptying of space. Sutherland's reappropriation of Samuel Palmer signalled a yearning for a new mystery, but it was the Americans who 'brought back to painting the mark of the brush and the characteristics of paint itself'. This offered a way through 'the impasse of Nicholson's razor edge precision', as it developed a content that 'remains a part of the actual painted shape but its references exist also outside itself in the reaction of the observer, and it is at this point that the deep-rooted myths and elemental passions of man are able to surface'.[29] Lanyon's first lecture, then, brought together landscape and contemporary painting practice in a single expression of human existence.

The human dimension was also a major theme in his second lecture, in which Bacon was held above all others for the coherence of his content with the paint itself. In a later discussion about his trip, Lanyon recalled being asked by his audience to compare Bacon with the American Ben Shahn, and his response is indicative of the attraction for him of Bacon's work. He distinguished between Shahn's concern with 'the social situation', which produced a 'protest type of painting', and Bacon,

> who was really in a different position, he was in a religious position ... his pictures were neither satirical or critical in

any sense and had no real social relevance at all; they
were events quite on their own.[30]

The focus of Lanyon's interest, then, was a general humanism. In the
lecture, Bacon's works were preceded by paintings by Sickert, Gwen
John, Nicholson and Sutherland, and they were followed by a number of
Lanyon's own circle – Wynter ('one of the heroes of both Prague lectures',
he noted[31]), Scott, Hilton, Davie, Frost, Jack Smith – and younger artists,
David Hockney, R.B. Kitaj, Harold Cohen and Peter Blake. While not
diminishing Bacon's work, he took the opportunity to argue that landscape
should not be seen as provincial but 'a true ambition … (one of) those
things (that) take us into the places where our trial is with forces greater
than ourselves, where skill and training and courage combine to make us
transcend our ordinary lives'.[32]

Lanyon spent a day in Prague but, because many of the artists
there were away, he was taken by his official hosts to Bratislava and from
there to the High Tatra mountains in northern Slovakia. He visited various
contemporary painters and a range of traditional cultural sites, but snow
prevented him from reaching an observatory high in the mountains. In the
spirit of adventure with which he had concluded his talk on contemporary
British painting, Lanyon looked into the possibilities of gliding there.
Though that proved impractical, he found material for several paintings
on Slovakian themes and reported soon after his return to Britain, 'I am
in a good period at present. Czechoslovakia had a good effect'.[33] The
combination of dramatic, mountainous terrain, extreme weather, evidence
of a rich cultural tradition and a brief romance with his Slovakian
interpreter proved highly stimulating. *Lomnica (Marica)* (1964) (**101**)
is named for both a town where he stayed (Lomnica) and his interpreter,
and combines hot, passionate colours and the white and green of a snowy
landscape. 'I fell in love', he told Ivon Hitchens, 'and my affections were
returned in the sweetest manner in the forest at night and in a Christmas
fairyland or floating high on a cable over a blizzarding country'.[34] The use
of bright colours that have no obvious relationship to an external source
was typical of the Czechoslovakian work and, indeed, of all of his paintings
from 1964.

One of the Czech paintings, *Untitled (Observatory)* (1964),
incorporated pieces of white polystyrene glued to the canvas, and this
was a feature of a number of Lanyon's last works.[35] In some of the collage
constructions, the use of partially transparent stained glass and of
protruding elements represented a return to the concern with pictorial
space that he had first resolved with *Box Construction No 1* (1939–40).
His employment of polystyrene offered a new way of creating such a
shallow space and, as such, marks a point where collage constructions
and paintings become almost indivisible. *Pendeen* (1964) (**102**) combines
a fragment of painting, stained glass and a piece of polystyrene that has

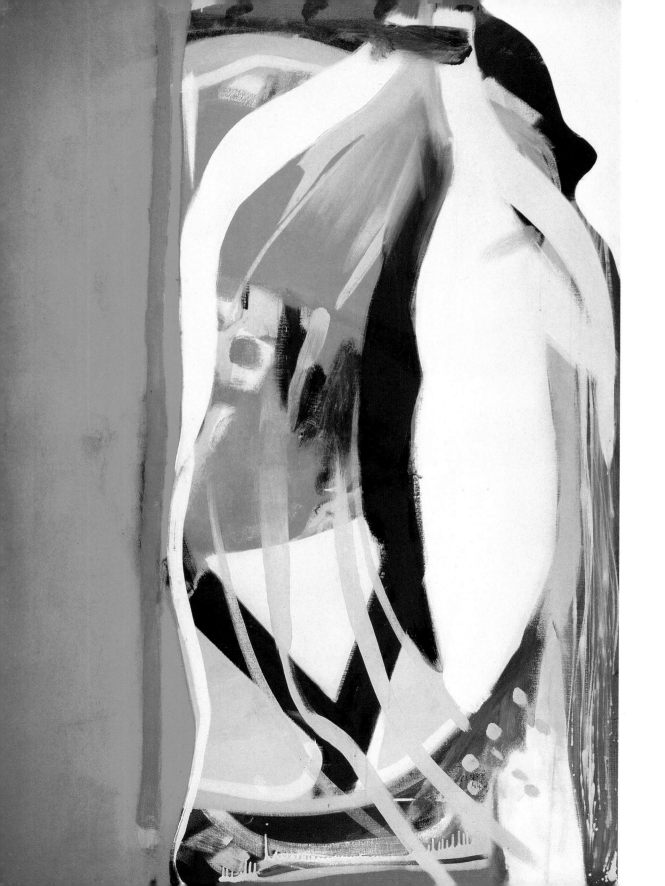

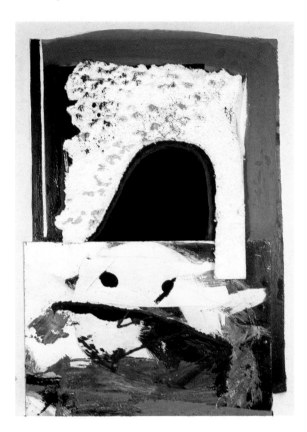

been melted – either with heat or a solvent – to create a textured surface so thin in places that it has been burnt right through. Paint was dragged across the raised peaks to articulate the variations and hint at the excremental. Similar pieces of polystyrene were used in a number of paintings, sometimes melted and at other times with their surfaces intact. Their functions differ: in *Clevedon Night* (1964) (**103**), for example, the slightly arched rectangles signify boats, whilst in *Fistral* (1964) (**105**) they were cut into irregular shapes to represent rocks; in some works the polystyrene serves a compositional function while also introducing a new spatial level into the picture.

 Among the very last works that he made, *Clevedon Night* is one of three paintings and a number of drawings and gouaches that derived from a trip to the town of Clevedon near Bristol. Clevedon is a small, rather dowdy, Victorian resort on the Severn estuary. In May 1964, Lanyon took a group of his students from the West of England Academy of Art there for the day. He made a number of drawings on the spot and took a series of photographs, and a few weeks later he reported to Paul Feiler, 'I seem also to be producing Clevedon paintings. A new Clevedon set – I guess!' (a reference to the Profumo scandal of the previous summer, which had begun at the Astors' home, Clivedon, host in the 1930s to the appeasing

 101
Lomnica (Marica), 1964
Oil on canvas
72 × 48
Private Collection

 102
Pendeen, 1964
Polystyrene, glass and oil on board
32 × 23 ¼
Private Collection

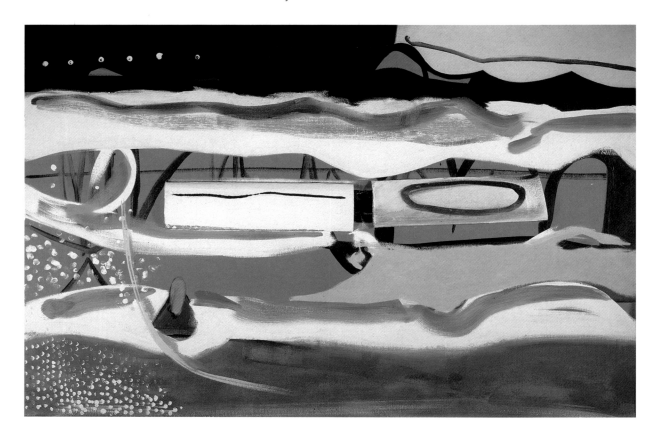

'Clivedon set').[36] The artist described the paintings as 'crazy, quite invisible, victorian and unsaleable', and they have been seen to define the new direction that his work was taking at the time of his death. In fact, the features that distinguish the three Clevedon canvases from the majority of Lanyon's paintings had all been seen in other works: bright, non-naturalistic colours, a thin, single-layered application of paint, more solid forms and a greater linearity in design. However, the works display a vibrancy of form and colour that gives them a certain *jouissance*, most obviously in the white dots that seem to create a phosphorescence like moonlight on the water.

Lanyon's photographs of Clevedon give an indication of the features that interested him, traces of which can be discerned in the paintings (**104**). The seafront is dominated by the elegantly lean form of the pier that stretches into the estuary on a series of thin iron arches, suggestions of which are visible behind the polystyrene blocks in *Clevedon Night*. These blocks are shown to refer to a line of small boats in an adjacent pool, cut off from the sea. The photographs are largely devoid of human activity and emphasize the broad openness of the waterside. They show the pool to have a diving board and a small building on its edge but, otherwise, to be a wide, flat area of water divided from the sea by a thin

103
Clevedon Night, 1964
Oil on canvas
48 × 72
Private Collection

barrage. In some of the photographs this appears as a false horizon and can readily be associated with the artist's interest in sites of interface, being a thin skin between two bodies of water – one tamed and one natural and free. The fiery red line in *Clevedon Bandstand* (**106**) and the encounter of dark and pale blue may refer to this liminal zone. In fact, the components of *Clevedon Bandstand* have been read very literally: the pale blue as the pool, the red as the walls, the white circle signifying the wind, the vertical band of black the pavement, and the green the hedge behind it.[37]

The suggestion of a nude figure, made more sensuous by the addition of grit to give texture to the paint, is said to derive from the pink-painted cast-iron caryatids of the Victorian bandstand. However, Feiler described a trip to Clevedon 'when they sheltered in a pill box along Poet's Walk. The nude they painted on the walls later featured in the Clevedon paintings'.[38] The nude, which also appears diving into the moonlit water in *Clevedon Night*, was, of course, an established figure in Lanyon's visual vocabulary, often deriving from his lover's presence in a place. Whether that was the case in Clevedon is not clear, but the more overt reference, the sensuous handling of the paint, the suggestion of a breast in *Clevedon Bandstand* and the figure's elongated stretch and moonlit bathe in *Clevedon Night* bring a new degree of eroticism to the imagery.

The change evident in the Clevedon paintings has been attributed to the influence of Francis Bacon, who had started using bright colours for his backgrounds in the early 1960s, and of the American Pop artist James Rosenquist, whose work at that time included body fragments enclosed within similarly bounded compartments.[39] While individual features of imagery, style or technique might be so associated with particular artists, one can see in these last works Lanyon's gradual response to more general cultural changes. We know that he was interested in the disturbing sensory effects of the Op Art paintings of Bridget Riley, for example, as well as the work of Pop artists such as Hockney in Britain and Rosenquist in America. Despite the nocturnal setting, the sense of

104
Photo of Clevedon by Lanyon
Photo: Tate Gallery Archive

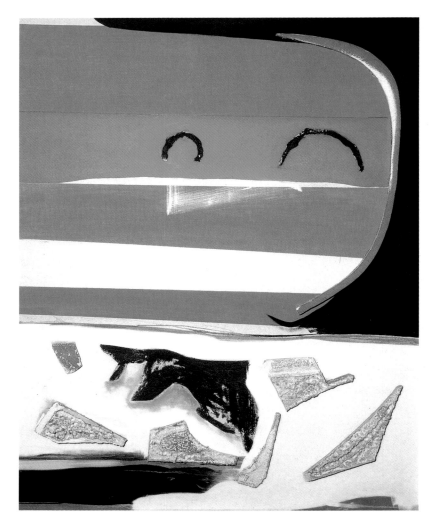

a joyful eroticism, which also appeared in the work of Terry Frost and
Roger Hilton around the same time, is in sharp contrast to the awkward,
anxious work of the 1950s, and this was in keeping with the social changes
of the period. The immediate post-war years were dominated by the
continued austerity of rationing, debates around Reconstruction and ideas
of a new communal Britain based on vibrant regional communities. By the
1960s, a range of political, social and cultural factors had served to secure
a more homogeneous idea of a Britain that was witnessing the beginnings
of a social revolution. Over a decade of economic consensus had secured
full employment nationwide, at the same time eroding regional identities
already under attack from such nationalizing cultural forms as radio and
television. With economic prosperity and increasing Americanization came
a culture dominated by material commodities and the redefinition of the
social fabric to produce, most famously, the newly identified teenager. The

105
Fistral, 1964
Oil and polystyrene on canvas
60 × 48
Belgrave Gallery, London

Profumo Affair to which Lanyon alluded was just one of a series of events
that revealed the extent of the revolution in sexual morality; it does not
seem inappropriate to associate the luxuriant, erotic nudes of Clevedon
with that increasing licence.

So, in 1964 Lanyon's work was undergoing changes that, had
he lived, may or may not have served to keep him at the forefront of artistic
activity in Britain. Apparently, he spent as much of that summer as possible
gliding. In August, he went on a training course with the Devon and
Somerset Gliding Club near Honiton. On the 27th, he came in to land and
for some unknown reason, and in defiance of earlier warnings, he dipped
the wing of the glider in a cross-wind: it tipped over, catapulting him from
the cockpit. His twelfth vertebra was cracked, but in hospital in Taunton
his injuries were not thought to be life-threatening. Friends visited and
spoke to him on the phone and he was soon bored and frustrated at the
enforced inactivity. Suddenly, on 31 August he was killed by an unsuspected
blood-clot resulting from a cut to his leg. Aged forty-six, he left his widow
Sheila and six children along with a body of work, clearly still developing,
which, after some years of gentle neglect, would once again secure his
reputation as one of the most original, rigorous and thoughtful artists of his
time. Despite the circumstances of the accident and the brilliance of his last
paintings, Sheila saw in them a presentiment of his end: 'It was a death he
was expecting', she told Ben Nicholson, 'and by his paintings seemed to be
expecting daily. If you saw the one called *Fistral* in Zurich you will see –
perhaps.'[40]

Modernism can be seen as a cultural response to the conglomeration of
historical processes, social relations, institutional structures and individual
psychologies that is dubbed 'modernity'. At certain times it has celebrated
that formation, and at others it has sought to compensate for its attendant
losses. Just as the mechanized slaughter of the Great War subdued the
Futurists' celebration of the machine, so the Second World War, the
Holocaust and the atom bomb cast fundamental doubts upon the optimism
that had underpinned the work of such artists as Ben Nicholson and Naum
Gabo. In the 1930s, their art had been tied to hopes for a new consciousness
and a new society in tune with modern technologies. That art had been,
necessarily, abstract.

Peter Lanyon's achievement was possible because of his early and
astute perception that the values that underwrote this branch of modernist
painting and sculpture were no longer valid after 1945, and that the aims,
content and forms of that art had, therefore, to change. In keeping with
much contemporaneous thought, he recognized that, for better or worse,
the human element of modernity was not 'the crowd' of Utopian and
socialist fantasy, but the individual, isolated and alone. In his work, he
came to assert that poignant reality and to rediscover those lost points

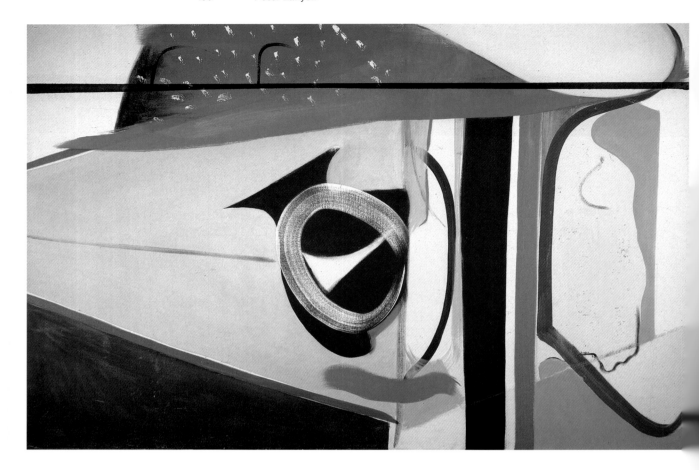

106
Clevedon Bandstand, 1964
Oil on canvas
48 × 72
Private Collection

of communal reference that could offer some compensation. He saw the making of art as an act of self-definition on the part of the artist, but that too was part of a greater campaign to re-establish individual identities. His principal vehicle, but not his only one, was an idea of place – an individual reattachment to 'home' – that was frequently conceptualized as 'landscape'.

In common with others in Britain, Europe and America, Lanyon sought a re-engagement with the natural environment, with place and with mythic and ancestral pasts. In the 1940s, and indeed before the war, British artists had reverted to past national artistic forms and values, in particular to a tradition of landscape, as an escape from modernity. Lanyon's position, however, was not one of conservative reaction, as he sought to radically recast not only how landscape was painted, but also how it was perceived and how it was conceived. He devised new artistic vocabularies with which to articulate a complex understanding of landscape that incorporated the history of a place, its geological make-up, its population, their activities and their actual and mythic pasts. Always at the centre was the individual: born, living, working, procreating, dying

in a place. Later, the term 'place' took on a slightly different meaning in his work, but his ambitions remained constant.

Lanyon combined a subtle and responsive intellect with an immense sensitivity, an intensely passionate nature, a mischievous sense of humour, and technical knowledge and skill to achieve a body of work distinctly his own. Formally, technically, aesthetically, he produced some of the most challenging and the most rewarding art of the post-war period. Whether it achieved his grander aims remains to be seen, but the fact that he maintained such humane ambitions is enough to lay claim to the importance and lasting value of his art.

Notes

Introduction

1. 'Cornish Painter … Peter Lanyon', *The Montrealer*, vol 38, no 3, Mar 1964, p11

2. David Brown (ed), *St Ives: Twenty-Five Years of Painting, Sculpture and Pottery*, London 1985, p197

3. The framing of 'St Ives' between inverted commas is used to distinguish what has come to be seen as a St Ives school of artists, active between 1939 and the 1960s, from the town and to highlight the artificial nature of that construct

4. Charles Harrison, 'The Place of St Ives', *Art Monthly*, no 84, Mar 1985, p9

5. Andrew Causey, *Peter Lanyon*, London 1991

6. For a summary of work on landscape over the last twenty years, see the introduction to the second edition of Denis Cosgrove, *Social Formations and Symbolic Landscape*, London 1984, 2nd ed Madison and London 1998, ppxi–xxx

7. J.P. Hodin, 'The Icarus of Cornwall: Peter Lanyon in memoriam', *Studio International*, vol 170, no 868, Aug 1965, p768

Chapter 1
An overview of themes

1. W.S. Graham, *Collected Poems 1942–1977*, London 1979, pp154–7

2. Letter to Roland Bowden, 22 Mar 1954, Tate Gallery Archive (TGA) 942.40

3. This point is made in John Barrell, *The Idea of the Landscape and the Sense of Place 1730-1840: An Approach to the Poetry of John Clare*, London 1972

4. Many scholars have examined this aspect of landscape of different periods, but the phrase derives from John Barrell, *The Dark Side of the Landscape: The Rural Poor in English Paintings 1730–1840*, Cambridge 1980

5. Letter to Paul Feiler, no date (nd) (June/July 1952)

6. Martin Heidegger, 'An Ontological Consideration of Place', *The Question of Being*, New York 1958, quoted in E. Relph, *Place and Placelessness*, London 1976, p1

7. See Malcolm Yorke, *The Spirit of Place: Nine Neo-Romantic Artists and their Times*, London 1988, and Margaret Garlake, *New Art New World: British Art in Postwar Society*, New Haven and London 1998, pp67–9

8. 'Edge of Landscape', manuscript, nd (early 1950s)

9. Draft letter to the editor of *Cornish Review*, 23 Oct 1949

10. From St Ives Carnival programme, 1961

11. 'Peter Lanyon Talking', *Guardian*, 17 May 1962

12. Untitled manuscript, nd c1948

13. Ibid

14. Opening address at retrospective exhibition, Plymouth City Art Gallery, May 1955, reported in 'Painting "needs peculiar faith" says artist', *Western Evening Herald*, 6 May 1955

15. Transcript of an illustrated lecture recorded for the British Council, Lanyon's script having been edited by Alan Bowness, 1963

16. *Trip round the Lighthouse* (1946), Private Collection, repr. Andrew Lanyon, *Peter Lanyon 1918–1964*, Newlyn 1990, p68, also visible behind *Sculpture* (1946) in the first Crypt Group Exhibition (fig 47)

17. Rosalind Krauss, *The Optical Unconscious*, Cambridge, Mass. and London 1994, p2

18. Roland Barthes, 'Myth Today', *Mythologies* (1957), trans. Annette Lavers, London 1972, p155

19. 'A Sense of Place', *Painter and Sculptor*, vol 5, no 2, autumn 1962, pp3–7

20. Letter to K.O. Götz, published in *Meta 5*, Mar 1951

21. Untitled manuscript, nd (post-1955)

22. 'Some Aspects of Modern British Painting: An Artist's Point of View', lecture for British Council in Czechoslovakia, Jan 1964

23. 'Constructive Art', manuscript, Nov 1948

24. Untitled manuscript, nd (c1948)

25. Letter to Paul Feiler, nd (1952)

26. 'Derbyshire 1957: a conversation between Peter Lanyon, Anthony Fry and Andrew Forge', recorded 25 July 1957, broadcast BBC Third Programme 28 July 1957, TGA TAV297AB

27. 'Horizons', recorded 21 May 1963, broadcast BBC West of England Home Service 22 May 1963, TGA TAV212AB

28. Quoted in Ernst van Alphen, *Francis Bacon and the Loss of Self*, London 1992, p115

29. 'A Sense of Place', 1962

30. Letter to Terry Frost, nd, TGA 7919.3.4

Chapter 2
Beginnings

1. 'An Unfamiliar Land: Interview with Lionel Miskin', 1962, TGA 211AB

2. 'Paintings 1935–40', nd (c1942)

3. *Landscape Near Morvah*, 1937, Private Collection, not reproduced

4. 'Paintings 1935–40', (c1942)

5. Adrian Stokes, *Colour and Form*, London 1937, republished in Lawrence Gowing (ed), *The Collected Writings of Adrian Stokes*, vol 2, London 1978, pp 16–17

6. Referred to in Andrew Causey, *Peter Lanyon: his Paintings*, Henley-on-Thames 1971, p 13

7. *E.g. Ponniou* (1937), Private Collection, repr. Andrew Causey, *Peter Lanyon: Paintings, Drawings and Constructions 1937–64*, Whitworth Art Gallery, Manchester 1978, p 7; *Abstract* (1937), Private Collection, repr. ibid p 7

8. Mary Schofield, interview with the author 14 Jan 1999; Margaret Garlake, *Peter Lanyon*, London 1998, pp 14–15

9. 'An Unfamiliar Land', 1962

10. 'A Young Cornish Artist', cutting from unidentified newspaper in the papers of the late Lilian Lanyon; 'An Unfamiliar Land', 1962

11. Peter Lanyon estate

12. 'An Unfamiliar Land', 1962

13. This is perhaps more likely to have been in 1938, as by January 1939 the Nationalist victory in Spain was assured

14. 'An Unfamiliar Land', 1962

15. Letter to Mary Schofield, nd (mid 1943); 'An Unfamiliar Land', 1962.

16. Ben Nicholson, 'Notes on Abstract Art', *Horizon*, vol 4, no 22, Oct 1941, p 272

17. Letter to Mary Schofield, nd (mid 1943)

18. 'An Unfamiliar Land', 1962

19. Ibid

20. Ben Nicholson, letter to Herbert Read, nd (early 1940), copy TGA 8717.1.3.34

21. British Council lecture, 1963

22. 'Paintings 1935–40', c1942

23. This can be identified by two descriptions in an untitled typescript (?1940), copy in TGA, and letter to Mary Schofield, nd (mid 1943)

24. British Council lecture, 1963

25. Untitled typescript, nd (?1940)

26. 'Paintings 1935–40', c1942 visible on extreme left in a later photograph of Lanyon's studio (fig 41)

27. Untitled typescript (?1940)

28. 'Paintings 1935–40', c1942

29. Untitled typescript (?1940)

30. Ibid

31. Letter to Mary Schofield, nd (mid 1943)

32. Numbers 46, 48 and 52 in Colin Sanderson and Christina Lodder's catalogue raisonné in Steven A. Nash and Jörn Merkert (eds), *Naum Gabo: Sixty Years of Constructivism*, Dallas 1985. There is some dispute over the date of the conception of some of these works. Given his working practice, Gabo may also have been working on new versions of earlier works. On the aestheticization of his work see Benjamin H.D. Buchloh, 'Cold War Constructivism' in Serge Guilbault (ed), *Reconstructing Modernism: Art in New York, Paris and Montreal 1945–64*, Cambridge, Mass. and London 1990, pp 85–112

33. Naum Gabo, 'The Constructive Idea in Art' in J.L. Martin, Ben Nicholson, N. Gabo (eds), *Circle: International Survey of Constructive Art*, London 1937

34. Naum Gabo, 'Constructive Art', *Listener*, 4 Nov 1936, p 846

35. 'Constructive Art: An Exchange of Letters between Naum Gabo and Herbert Read', *Horizon*, vol 10, no 55, July 1944, p 59

36. Graham Sutherland, 'A Welsh Sketchbook', *Horizon*, vol 5, no 28, Apr 1942, pp 224–35

37. George L.K. Morris, 'Art Chronicle: English Abstract Painters', *Partisan Review*, vol 10, no 3, May–June 1943; Lanyon, postcard to Ben Nicholson, nd (?1941), TGA 8717.1.2.2159

38. Nicholson 1941, p 272

39. Herbert Read, 'Vulgarity and Impotence: Speculations on the Present State of the Arts', *Horizon*, vol 5, no 28, Apr 1942, p 267

40. E.H. Ramsden, 'A Critical Survey of the Work of the Younger Exhibitors' in Alex Comfort (ed), *New Road*, London 1943, pl VII

41. Letter to Ben Nicholson, nd (?Apr 1940), TGA 8717.1.2.2154

42. Letter to Ben Nicholson, 27 June 1941, TGA 8717.1.2.2158

43. Letter to Mary Schofield, nd (c Oct 1940)

44. Letter to Ben Nicholson and Barbara Hepworth, nd (1943 or '44), TGA 8717.1.2.2165

45. Ibid

46. Margot Eates, letter to Ben Nicholson, 4 Mar 1942, TGA 8717.1.2.815

47. Letter to Naum and Miriam Gabo, 18 June 1943, Yale Collection of American Literature, Beinecke Rare Book and Manuscript Library, Yale University

48. Letter to Naum and Miriam Gabo, 3 Dec 1944; Arthur Wilson in Andrew Lanyon, *Wartime Abstracts: The Paintings of Peter Lanyon*, Newlyn 1996, p 75

49. David Goodman, letter to the author, Mar 1999

50. Ibid; see also Margaret Garlake, 'Peter Lanyon's letters to Naum Gabo', *Burlington Magazine*, Apr 1995, pp 233–46, and Richard Hoggart, *A Sort of Clowning: Life and Times 1940–59*, Oxford 1990, pp 54–5

51. For a range of Lanyon's wartime work see Andrew Lanyon 1996, p 75

52. Artist's estate, repr. ibid, p 59

53. Letter to Schofield, nd (1943)

54. Letter to Schofield, 16 Jan 1943

55. Letter to Schofield, 26 May 1943

56. Letter to Schofield, 30 Mar 1944

57. Letter to Nicholson, 27 June 1941, TGA 8717.1.2.2158

58. Letter to Nicholson, 22 Sept 1944, TGA 8717.2.2167

59. Letter to Schofield, 2 June 1945

60. Letter to Schofield, 16 May 1945

Chapter 3
Generation and reconstruction

1. Mary Schofield, conversation with the author, 14 Jan 1999

2. Letter to Schofield, 2 Nov 1944

3. Sven Berlin, 'The Eye of the Hurricane' in *Artists from Cornwall*, Royal West of England Academy, Bristol 1992, p 16

4. Visible on the right-hand wall of the first Crypt Group Exhibition (fig 47)

5. Alan Bowness, *Peter Lanyon*, Arts Council, London 1968

6. Barbara Hepworth, letter to Herbert Read, 6 Mar 1947

7. Gabo and Read 1944, p 62

8. Letter to Gabo, Feb 1949

9. Letter to Gabo, Feb 1949

10. Ibid

11. The constitution of the 'Generation Series' is examined in Garlake 1995, pp 236–7, and in Andrew Lanyon, *Portreath: The Paintings of Peter Lanyon*, Newlyn 1993, pp 22–3

12. *Earth* (1946), Private Collection, repr. Garlake 1998, p 26

13. Letter to Gabo, Feb 1949

14. Sir James Frazer, *The Golden Bough*, abridged edition 1922, London 1993, pp 382–3

15. See Adrian Stokes, *Inside Out*, London 1947, and *Smooth and Rough*, London 1951

16. Stokes 1951, p 22

17. Letter to Gabo, Feb 1949

18. Robert Graves, *The White Goddess: A Historical Grammar of Poetic Myth*, London 1948

19. Untitled manuscript, nd (1947)

20. Garlake 1998, p 26

21. From Andrew Lanyon 1990, p 277

22. Manuscript notes, c1962, quoted ibid p 72

23. 'An Unfamiliar Land', 1962

24. *Self-portrait* (1947), Private Collection, repr. Andrew Lanyon 1990, p 74

25. Herbert Read, letter to Naum Gabo, 12 Oct 1945

26. See Germain Bazin, *Braque*, Tate Gallery, London 1946; Jankel Adler, 'Memories of Paul Klee', *Horizon*, vol 6, no 34, Oct 1942, pp 264–7

27. Letter to Gabo, Feb 1949

Chapter 4
Landscapes of experience

3. Letter to William Scott, nd (Jan/Feb 1951), William Scott Foundation, A/10/0099

2. 'An Unfamiliar Land', 1962

3. Letter to Eugene Rosenberg, 9 Dec 1960, Mrs E. Rosenberg

4. Ibid

5. Letter to Terry Frost, 26 June 1949, TGA 7919

6. The split with Nicholson and Hepworth is discussed in Chapter 5; see his letter to Gabo, Feb 1949, on their encouragement and affection

7. Patrick Heron, 'Adrian Ryan and Peter Lanyon', *New Statesman and Nation*, 15 Oct 1949

8. M.H. Middleton, 'Two Young Painters of Talent', *Spectator*, 21 Oct 1949

9. David Lewis, 'Peter Lanyon', *Cornish Review*, no 4, spring 1950, p 73

10. David Lewis, 'St Ives: A Personal Memoir 1947–55' in David Brown (ed), *St Ives: Twenty Five Years of Painting, Sculpture and Pottery*, London 1985, p 17

11. For suggestions see Andrew Lanyon 1993, p 26

12. Letter to Gabo, Feb 1949

13. Letter to Rosenberg, 9 Dec 1960

14. Letter to Gabo, Feb 1949

15. Manuscript, nd (c1959)

16. Peter Lanyon, 'The Face of Penwith', *Cornish Review*, no 4, spring 1950

17. Letter to Gabo, 9 May 1948

18. Letter to Gabo, Feb 1949

19. Letter to Roland Bowden, 20 July 1952, TGA 942.13

20. Manuscript notes on slides, nd (c1962); letter to K.O. Götz, published in *Meta 5*, Mar 1951

21. Patrick Heron, 'Adrian Ryan and Peter Lanyon', *New Statesman and Nation*, vol 38, no 971, 15 Oct 1949, p 422

22. Letter to Peter Gimpel, Aug 1951

23. Lewis 1950, p 73

24. Douglas Cooper, 'Exhibition: London-Paris', publication unidentified, Peter Lanyon's press-cuttings album

25. British Council lecture, 1963

26. Letter to Rosenberg, 7 Dec 1960

27. British Council lecture, 1963

28. Peter Lanyon, 'Time Space and the Creative Arts', manuscript dated 31 Dec 1948

29. Ibid

30. Draft letter to the editor, *Facet* magazine, 1949

31. Manuscript, nd (c1951–2)

32. Lanyon's interest in Relativity is recorded in J.P. Hodin, 'The Icarus of Cornwall: Peter Lanyon in memoriam', *Studio International*, vol 170, no 868, Aug 1965, p 769

33. Letter to Gabo, 9 May 1948

34. 'Time Space and the Creative Arts', 1948

35. Letter to Gabo, Feb 1949

36. Letter to Frost, 26 June 1949, TGA 7919

37. Peter Lanyon talking to Lionel Miskin about painting and his visit to Czechoslovakia, spring 1964, TGA TAV215 AB

38. Letter to Frost, 26 June 1949

39. Hadyn Griffiths, 'Bath Academy of Art, Corsham Court, Wilts. 1946–c1955', M.A. Report, University of London, Courtauld Institute of Art, 1979. Griffiths argues that ceramics teacher James Tower introduced Lanyon to Bergson's concept of the 'élan vital' as well as Hans Driesch's theory of 'entelechy'

40. Hodin 1965, p 769

41. For the influence of Bergson on Leach see Rachel Gotlieb, '"Vitality" in British Art Pottery and Studio Pottery', *Apollo*, vol 127, no 313, Mar 1988, pp 163–7

42. On this aspect of Bergson, see Martin Jay, *Downcast Eyes: the Denigration of Vision in Twentieth Century French Thought*, Berkeley and Los Angeles 1993, pp 191–5

43. See David Mellor, 'Existentialism and Post-War British Art' in Frances Morris (ed), *Paris Post War: Art and Existentialism 1945–55*, London 1993, pp 56–7, and Chris Stephens, *The Sculpture of Hubert Dalwood*, London 1999

44. Henri Bergson, *The Creative Mind: An Introduction to Metaphysics*, trans. Mabelle L. Andison, New York 1946, 1992, p 12; Adrian Stokes, *Colour and Form* (1937) in Lawrence Gowing (ed), *The Critical Writings of Adrian Stokes*, London 1978, p 45

45. Peter Lanyon, letter to John Wells, 31 Mar 1949 in Andrew Lanyon, 1990, p 93

46. Letter to William Scott, nd (1950), William Scott Foundation

47. Adrian Stokes, *Inside Out*, London 1947, p 45, republished in Gowing (ed) London 1978, p 166

48. Letter to Patrick Heron, nd (May 1950), copy TGA

49. British Council lecture, 1963; manuscript notes, c1962

50. George Eglin, 'Preston Gets Unusual Art Show', *Lancashire Evening Post*, 22 May 1952

51. John Berger, 'Brobdingnag', *New Statesman and Nation*, 30 June 1951

52. Manuscript notes, nd (c1962), TGA

53. See Causey 1978, p 20, no 32. Causey provides a detailed study of a number of the drawings and constructions made in the preparation of *Porthleven*

54. Manuscript notes, nd (c1962)

55. Ibid

56. Quoted in Causey 1978, p 20, no 34

57. Manuscript notes found behind a review pasted in Lanyon's press-cuttings album

58. Ibid

59. British Council lecture, 1963

Chapter 5
Lanyon and St Ives

1. Letter to Nicholson, nd (late 1943/early 1944), TGA 8717.1.2.2165

2. Letter to Schofield, 14 May 1944

3. Letter to John Wells, nd (1948), TGA 8718.1

4. Letter to Sven Berlin, 21 Nov 1948, Collection Eric Quayle

5. Letter to Stanley Wright, nd (?Mar 1949)

6. Sven Berlin, *The Dark Monarch*, London 1962

7. Letter to Berlin, 21 Nov 1948

8. Letter to Wright, ?Mar 1949

9. Ibid

10. *St Ives Times*, 18 Feb 1949, quoted in Brown (ed) 1985, p 105

11. Penwith Society of Arts in Cornwall minutes, 26 May 1949 and 15 Nov 1949, copies: TGA TAM 76/1–8

12. Letter to the secretary, Penwith Society of Arts, 1 Sept 1959

13. Brown (ed) 1985, p 112

14. ?Draft letter to Nicholson, 3 Apr 1950

15. Letter to Peter Gimpel, nd (c1954/5)

16. Draft letter to *St Ives Times*, nd (May 1950)

17. 'Foreword', *Paintings from Penwith by Peter Lanyon*, The Bookshop of G.R. Downing, St Ives 1951.

18. Manuscript, nd (?c1951/2)

19. Letter to Peter Gimpel, 23 Mar 1957

20. Letter to Peter Gimpel, 1 Nov 1960

21. Michael Canney in Andrew Lanyon 1990, pp 160–1

22. Autobiographical note sent to Gimpel Fils, 1 May 1957

23. St Peter's Loft advertising leaflet, 1955

24. Jeremy Le Grice, interview with the author, 9 Jan 1999

25. Letter to Rosalie Mander, July 1957

26. Lanyon, letter to Charles and Kay Gimpel, 17 Mar 1958

27. Letter to Gabo, 9 May 1948

28. Letter to Terry Frost, 8 Nov (1953), TGA 7919.3.4; letter to Frost, 30 Apr 1953, TGA 7919.3.4; letter to Charles Gimpel, nd (Oct 1956)

29. Lisa Tickner, 'Men's Work? Masculinity and Modernism' in Norman Bryson, Michael Ann Holly and Keith Moxey (eds), *Visual Culture: Images and Interpretation*, Hanover and London 1994, p 63

30. Patrick Heron, letter to Nicholson, 7 Sept 1964, TGA 8717.1.2.1638

31. Heron said that Greenberg did not wish to see Lanyon as he had snubbed him whilst visiting New York (conversation with the author, 11 Aug 1995), while Linden Holman (née Travers) recalls Lanyon specifically asking her to arrange for Heron to meet Rothko at her house (conversation with the author, 7 Mar 1996)

32. Patrick Heron, letter to Nicholson, 24 May 1962, TGA 8717.1.2.1633

33. Draft letter to *The Cornishman*, 1961, quoted in Causey 1978

34. Ronald Perry, 'Cornwall Circa 1950' in Philip Payton (ed), *Cornwall Since the War*, Redruth 1993, pp 29–30

35. University College of the South West, *Devon and Cornwall: A Preliminary Survey*, Exeter 1947

36. Perry 1993, p 38

37. Cornwall County Council, County Development Plan, 1952

38. Sylvia Crowe, *Tomorrow's Landscape*, London 1956, pp 131 and 150

39. See *Royal Commission on the Distribution of Industrial Population, Town and Country Planning as Portrayed in the Reports of the Barlow Commission and the Scott and Uthwatt Committees, Being No 1 of the Staples Reconstruction Digest*, London 1942

40. On the association of the CPRE with Leavis's *Scrutiny* see Ken Worpole, 'Village School or Blackboard Jungle' in Raphael Samuel (ed), *'Patriotism: the Making and Unmaking of British Cultural Identity Vol. 3 National Fictions*, London 1989, p 129; for the debt of the Scott and Uthwatt Reports to inter-war constructions of the countryside see Alex Potts, '"Constable Country" Between the Wars', Samuel (ed) 1989, pp 166–7; see also Vaughan Cornish, *National Parks and the Heritage of Scenery*, London 1930 and *The Scenery of England*, London 1932 and H.V. Morton, *In Search of England*, London 1927

41. Ministry of Town and Country Planning, *Report of the National Parks Committee*, HMSO, London July 1947 (Hobhouse Report)

42. CPRE Cornwall Branch, *Cornwall: a survey of its coasts, moors and valleys, with suggestions for the preservation of amenities*, London 1930

43. J. Dower, *National Parks of England and Wales*, Ministry of Town and Country Planning, 1945 and Hobhouse Report 1947

44. Norman Browning, *National Parks and Access to the Countryside*, London 1950

45. The term 'Cornish Riviera' first appeared in S.P.B. Mais, *The Cornish Riviera*, Great Western Railway Co, 1928

46. Potts 1989, p163

47. Perry 1993, p27

48. W.G. Hoskins, *The Making of the English Landscape*, London 1955; Jaquetta Hawkes, *A Land*, London 1951

49. Letter to Schofield, 22 Mar 1940

50. Untitled manuscript, nd

51. Ibid

Chapter 6
A Penwith pilgrimage

1. Untitled and undated text, Andrew Lanyon 1990, p292

2. Letter to Roland Bowden, 20 Apr 1952, TGA 942.1

3. Though dated 1952, this work is discussed in a letter to Patrick Heron postmarked 31 Dec 1951

4. Letter to Heron, postmarked 31 Dec 1951

5. Letter to Bowden, 1 Aug 1952, TGA 942.14

6. See Chapter 9

7. Maurice Merleau-Ponty, *Phenomenology of Perception* (1945), trans. Colin Smith, Evanston 1962, p206

8. Ibid p102

9. Gary Brent Maddsion, *The Phenomenology of Merleau-Ponty: a Search for the Limits of Consciousness*, Athens, Ohio 1981, p73

10. British Council lecture, 1963

11. 'An Unfamiliar Land', 1962

12. Quoted by Norman Levine in 'The First of the Cornish Painters', BBC radio programme, broadcast 18 Jan 1965, National Sound Archive 29506

13. John Berger, 'A Return to Realism?' (letter), *New Statesman and Nation*, 14 Mar 1953

14. Letter to *St Ives Times*, 6 July 1956, p 4

15. 'The Face of Penwith', 1950, p43

16. John Berger, 'Landscapes and Close-ups', *New Statesman and Nation*, vol 47, no 1204, 3 Apr 1954, p436

17. Letter to John Dalton, nd (c1952/3)

18. 'An Unfamiliar Land', 1962

19. Ibid

20. Berger 1954

21. Letter to Bowden, nd (?Dec 1952), TGA 942.25

22. Letter to Paul Feiler, nd (June/July 1952)

23. Roland Bowden, 'Peter Lanyon and the Third Abstraction' (1952), not published until *Modern Painters*, vol 6, no 3, autumn 1993, p 93

24. Letter to Bowden, 20 Apr 1952, TGA 942.1

25. British Council lecture, 1963

26. Causey 1978, p 23

27. F.E. Halliday, *A History of Cornwall*, London 1959, 2nd ed 1975

28. D.B. Barton, *A History of Tin Mining and Smelting in Cornwall*, 1965, 2nd ed Exeter 1969, p 246

29. 'An Unfamiliar Land', 1962

30. Letter to Bowden, 20 Apr 1952, TGA 942.1

31. 'An Unfamiliar Land', 1962

32. Letter to Mary Schofield, 26 May 1943

33. David Leverenz, 'The Last Real Man in America: From Natty Bumppo to Batman', Peter F. Murphy (ed), *Fictions of Masculinity: Crossing Cultures, Crossing Sexuality*, New York and London 1995, pp21–53

34. Letter to Bowden, 20 Apr 1952, TGA 942.1

35. Letter to John Dalton, nd (?late 1952), quoted in Andrew Lanyon 1990, p116

36. Letter to Bowden, 20 Apr 1952

37. Ibid

38. Letter to Heron, postmarked 10 Jan 1952

39. Letter to Bowden, 16 Dec 1952, TGA 942.22; letter to Rosalie Mander, 17 Mar 1952

40. Letter to Peter Gimpel, 20 Apr 1952

41. Letter to Bowden, nd (May/June 1952), TGA 942.7

42. Letter to Bowden, 1 June 1952; letter to Heron, 7 June 1952

43. Letters to Peter Gimpel, July and Aug 1952, quoted in Andrew Lanyon 1990, p130; letter to Bowden, 20 July 1952, TGA 942.13

44. Graham Sutherland, *Crucifixion*, 1949, St Matthew's Church, Northampton; Francis Bacon, *Fragment of a Crucifixion*, Stedlijk van Abbemuseum, Eindhoven; Peter Lanyon, 'Some Aspects of Modern British Painting: An Artist's Point of View', lecture for British Council in Czechoslovakia, Jan 1964

45. Letter to Bowden, 16 Dec 1952, TGA 942.22

46. Francis Bacon quoted in Gilles Deleuze, 'Francis Bacon: The Logic of Sensation' in *Francis Bacon*, Museo Correr, Venice 1993

47. Letter to Rosalie Mander, 17 Mar 1952

48. The story of Osiris's murder, dismemberment and restitution through the labours of Isis and the intervention of Anubis are narrated in Frazer 1922, 1993, pp362–8

49. Though some of these are dated 1951, Causey has demonstrated them to date from 1949, Causey 1978, p25–6

50. Letter to Bowden, 20 Apr 1952, TGA 942.1

51. The form of the leg in the Lanyon gouache is especially reminiscent of the style of *The Charnel House*

52. Letter to Ivon Hitchens, nd
(late 1952/early '53)

53. Letter to Bowden, 20 July 1952,
TGA 942.13

54. Letter to Bowden, 16 Dec (1952),
TGA 942.22

55. Ibid

56. Letter to Hitchens, nd (Dec 1952)

57. British Council lecture, 1963

58. Berger 1954

59. Ibid

60. Julia Kristeva, *Powers of Horror*
(1980), trans. Leon S. Roudiez, New
York, 1982, p 109

61. David Sylvester, 'In Camera',
Encounter, vol VIII, no 4, Apr 1957, p 23

62. British Council lecture, 1963

63. *Green Mile* (1952), Bishop Otter
College, Chichester, repr. Andrew Lanyon
1990, p 122

64. Letter to Bowden, nd (14 July 1953),
TGA 942.30

65. Letter to Bowden, 23 July 1953,
TGA 942.31

66. Letter to Bowden, nd (1953),
TGA 942.15

Chapter 7
Filth, sex and death

1. Postcard to Bowden, 2 Mar 1953,
TGA 942.26

2. Letter to Bowden, 7 May 1952,
TGA 942.3

3. Letter to Bowden, nd (1953),
TGA 942.15; letter to Frost, 30 Apr 1953,
TGA 7919.3.4

4. For information on the artistic
heritage of Anticoli Corrado, I am grateful
to Fabio Benzi of the Museo Comunale
d'Arte Moderna, Anticoli Corrado, and to
Derek Hill, director of the British School in
Rome 1953–5, 1957–9; see also Fabio Benzi
(ed), *Italian Art from Symbolism to Scuola
Romana: The Artists of Anticoli Corrado*,
Accademia Italiana, London 1996

5. Causey 1978, p 32

6. Letter to E.C. Cummings, director of
Plymouth City Art Gallery, 20 Dec 1960,
quoted in Andrew Lanyon 1990, p 140

7. Lawrence Alloway, 'London',
Art News, vol 56, no 8, Dec 1957

8. Letter to Cummings, 20 Dec 1960

9. Letter to Rosalie Mander,
15 May (1953)

10. Letter to Frost, 30 Apr 1953,
TGA 7919.3.4

11. British Council lecture, 1963

12. Letter to Rosalie Mander, 1952

13. Letter to Peter Gimpel, nd
(cFeb 1952)

14. Sent to Gimpel Fils, 1 May 1957

15. Letter to Frost, 30 Apr 1953,
TGA 7919.3.4

16. Lanyon on his father: 'An Unfamiliar
Land', 1962; Michael Canney interviewed
by the author, 13 Aug 1995

17. Kristeva 1982

18. Ibid, p 53

19. Letter to Frost, nd (c1953),
TGA 7919.3.4

20. 'An Unfamiliar Land', 1962

21. David Lewis, 'St. Ives: A personal
memoir 1947–55' in Brown (ed) 1985, p 17

22. Letter to Bowden, 20 July 1952,
TGA 942.13

23. Patrick Heron, letter to the author,
11 Sept 1995; Lanyon, letter to Frost, nd
(c1953), TGA 7919.3.4

24. Griffiths 1979, p 74, n 89

25. Patrick Heron, 'Peter Lanyon',
Art News and Review, 6 Mar 1954, p 7

26. 'An Unfamiliar Land', 1962

27. Robert Melville, 'Francis Bacon',
Horizon, vol XX, no 120–121, Dec 1949–
Jan 1950, pp 419–23

28. Ibid

29. British Council lecture, 1963

30. Manuscript notes, c1962

31. British Council lecture, 1963;
manuscript note, quoted Andrew Lanyon
1990, p 210

32. Letter to Bowden, 1 Aug 1952,
TGA 942.14; letter to Bowden, 20 July
1952, TGA 942.13

33. Letter to Bowden, nd (late 1952),
942.17

34. Letter to Bowden, 31 May 1952,
TGA 942.5

35. 'An Unfamiliar Land', 1962; this
is consistent with Merleau-Ponty's 'body
image', Merleau-Ponty 1962, p 100 ff

36. Ibid

37. British Council lecture, 1963

38. *Judy* (1953), Private Collection,
not reproduced

39. Manuscript note, repr.
Andrew Lanyon 1990, p 158

40. Quoted ibid, p 158

41. Letter to John Dalton, Jan 1957;
Tamarisk (1956), Bernard Jacobson
Gallery, repr. Andrew Lanyon 1990, p 155

42. Letter to Bowden, 22 Mar (1954),
TGA 942.40

43. Deleuze 1993, p 105

44. *Orpheus* (1961), Premio Marzotto
Institution, Valdagno, repr. Andrew
Lanyon 1990, p 209; *Salome* (1961),
Private Collection, repr. ibid p 211

45. Manuscript notes, quoted ibid, p 211

46. Letter to John Dalton, nd (1954)

47. Julia Kristeva, 'Motherhood
According to Giovanni Bellini', *Desire
in Language*, Oxford 1980, p 263; C.G.
Jung, *The Archetypes and the Collective
Unconscious, The Collected Works of
C.G. Jung*, vol 9, pt 1, p 82

48. Ovid, *Metamorphoses*, trans.
Mary M. Innes, Harmondsworth 1955, p 72

49. Letter to Bowden, nd (Sept 1952),
TGA 942.20

50. 'An Unfamiliar Land', 1962

51. Letter to Bowden, 20 Apr 1952,
TGA 942.1

52. 'A Sense of Place', 1962

53. Letter to Frost, nd, TGA 7919.3.4

54. Letter to Bowden, 20 July 1952

55. See Mikhail Bakhtin, 'The grotesque
image of the body and its sources' in
Rabelais and his World, trans. Helene
Iswolsky, Bloomington 1984

Chapter 8
Lanyon's doubt

1. *Mullion Bay* (1954), National Gallery of Victoria, Melbourne, repr. Garlake 1998, p 45

2. Quoted in Alan Bowness, *Peter Lanyon*, Arts Council exh. cat., London 1968

3. Patrick Heron (The British Influence on New York), part 2, *Guardian*, 11 Oct 1974

4. Lanyon stated his intention to visit the Biennale in a letter to Patrick Heron, nd (mid May 1950); Pollock, *Number One* (1948), Metropolitan Museum of Art, New York; de Kooning, *Light in August* (c1946), Tehran Museum of Contemporary Art, *Dark Pond* (1948), Private Collection, *Mailbox* (1948), Edmund P. Pillsbury Family Collection, all shown in a display of Ashile Gorky, Pollock and de Kooning in the American pavilion

5. *Woman VI* (1953), Carnegie Institute, Pittsburgh; *Woman as Landscape* (1955), Private Collection; *Woman I* (1950–2), Museum of Modern Art, New York

6. 'Three British Painters (Peter Lanyon, William Gear and James Hull)', Passedoit Gallery, New York, Jan 1953 (the exhibition was organized through Gimpel Fils); 'Three British Painters', *Artnews*, vol 51, no 9, Jan 1953, p 49

7. Heron, 11 Oct 1974

8. See, for example, Patrick Heron, letter to Clement Greenberg, 23 May 1955, Archives of American Art N70-7R

9. See Stephen Polcari, *Abstract Expressionism and Modern Experience*, Cambridge 1991, p 192

10. Robert Motherwell postcard to Lanyon 9 Dec 1958; Chris Stephens, *Mark Rothko in Cornwall*, Tate St Ives 1996

11. 'Landscape Coast Journey and Painting', c1959, typescript, TGA TAV216AB

12. Denys Sutton, *Metavisual Tachiste Abstract: Painting in England Today*, Redfern Gallery, London 1957

13. Lawrence Alloway, *Abstract Impressionism*, Arts Council touring exh. cat., 1958

14. Sheila Lanyon, letter to Tate Gallery conservation department

15. Letter to Paul Feiler, nd (?18 Oct 1961)

16. Following a well-used convention, the upper case initial is employed for Greenberg's specific theory of Modernism, as opposed to a broader modernism for an art that engages in some way with modernity

17. Harold Rosenberg, 'The American Action Painters', *Artnews*, Dec 1952, p 22 ff; reprinted in Rosenberg, *The Tradition of the New*, New York 1959

18. 'A Sense of Place', 1962, p 4

19. Letter to Rosalie Mander, 28 July 1949

20. Letter to Mander, nd (1953)

21. Undated text, Andrew Lanyon 1990, p 290; 'On Dread', typescript dated 12 July 1956

22. Letter to Peter Gimpel, 16 May 1956 (Gimpel Fils, London)

23. In 'Derbyshire 1957: A Conversation on Landscape between Peter Lanyon, Anthony Fry and Andrew Forge', recorded 25 July 1957, broadcast BBC Third Programme, 28 July 1957, TGA TAV297B

24. Letter to Bowden, 1 Aug 1952, TGA 942.14

25. Transcript of recording made by Michael Canney as a contribution to 'The First of the Cornish Painters' (courtesy of Madeleine Canney)

26. Letter to Gabo, Feb 1949

27. Letter to Bowden, 4 Dec 1955, TGA 942.20; letter to Bowden, 16 Nov (1957), TGA 942.55 (wrongly dated '1959 or 1960' in 'Letters from Lanyon to Roland Bowden', *Modern Painters*, vol 5, no 1, spring 1992)

28. Letter to Bowden, 16 Aug 1952, TGA 942.15

29. Letter to Feiler, 20 May 1958

30. Maurice Merleau-Ponty, 'Le Doute de Cézanne', *Fontaine*, no 47, Dec 1945 and in *Sens et Non-Sens*, Paris 1948 (trans. Hubert L. Dreyfus and Patricia Allen Dreyfus, Evanston, Il. 1964); Sarah Wilson in *Morris* 1993, p 31

31. Merleau-Ponty 1948, trans. 1964, p 12

Chapter 9
The threatened body and the new sublime

1. Letter to Bowden, 22 Mar 1954, TGA 942.40

2. *Wheal Owles* (1958), Private Collection, repr. Andrew Lanyon 1990, p 173

3. British Council lecture, 1963

4. Letters to Peter Gimpel, 1959, quoted in Andrew Lanyon 1990, p 190

5. British Council lecture, 1963

6. Manuscript notes, c1962

7. 'Derbyshire 1957'

8. British Council lecture, 1963

9. Recording TGA TAV210AB, published as 'Offshore in Progress', *Artscribe*, no 34, 1982, pp 58–61

10. British Council lecture, 1963

11. See Mo Enright, *Peter Lanyon: The Mural Studies*, Gimpel Fils exh. cat., London 1996

12. Manuscript notes, 1960

13. 'Warren Mackenzie discussing Peter Lanyon at the Leach Pottery with David Lewis', 21 July 1984, TGA TAV365A

14. 'Time Space and the Creative Arts', 1948

15. 'A Sense of Place', 1962

16. Letter to Bowden, 23 July 1953, TGA 942.31; Kristeva 1982, p 69

17. Letter to Bowden, nd (1954), TGA 942.38

18. Ibid

19. Martin Heidegger, *Being and Time* (1927/1962) Section 40, quoted in Martin Heidegger, *Basic Writings: from Being and Time (1927) to The Task of Thinking (1964)*, David Farrell Krell (ed), London 1993, p 90

20. Barnet Newman, 'The Sublime is Now', *Tiger's Eye*, no 6, 15 Dec 1948, pp 52–3; Mark Rothko, 'The Romantics were Prompted', *Possibilities*, no 1, winter 1947/8, p 84

21. Robert Rosenblum, 'The Abstract Sublime', *Artnews*, Feb 1961, p 39 ff; Robert Rosenblum, *Modern Painting and the Northern Romantic Tradition*, New York 1975, p 204

22. Untitled manuscript, nd (?1952–7)

23. Ibid

24. Antoine de Saint-Exupéry, *Southern Mail* (1929), trans. Stuart Gilbert, New York 1933; *Night Flight* (1931), trans. Stuart Gilbert, New York 1932; *Wind, Sand and Stars*, trans. Lewis Galantière, New York 1939

25. *Wind, Sand and Stars* 1939, p 6

26. 'Night Flight' in *Southern Mail & Night Flight*, trans. Curtis Cate (with acknowledgements to Stuart Gilbert's translation), London 1971, p 132

27. Quoted in Stuart Gilbert, 'Introduction' to Antoine de Saint-Exupéry, *The Wisdom of the Sands*, trans. Stuart Gilbert, New York 1952

28. Letter to Mary Schofield, 30 Mar 1944

29. British Council lecture, 1963; notes on 'The First Gliding Painting', nd, in Andrew Lanyon 1990, p 195

30. Peter Lanyon, Paul Feiler and Michael Canney, 'The Subject in Painting', 'Horizons', radio programme recorded 21 May 1963, broadcast BBC West of England Home Service 22 May 1963, recording and transcript TGA TAV212AB

31. 'The First Gliding Painting'

32. Lawrence Alloway, 'Light Waves', *Weekly Post*, 29 Oct 1960

33. British Council lecture, 1963

34. Merleau-Ponty, 1962, p 206

Chapter 10
Widening horizons

1. Peter Gimpel, letters to Lanyon 25 June 1963, 3 July 1963; Martin Holman, 'Biography' in *Peter Lanyon: Air, Land and Sea*, South Bank Centre exh. cat., 1992, p 65

2. Letter to Michael Canney, 9 June 1964

3. Information on this commission from Causey 1978, pp 42–3

4. Letter to Paul Feiler, 19 Nov 1962

5. *Porthmeor* (1962–3), Manchester Metropolitan University, repr. Andrew Lanyon 1990, p 302; statement, manuscript notes, nd, ibid p 307

6. Untitled (1963), repr. Garlake 1998, p 59

7. Letter to Gimpel Fils, 6 June 1963

8. For information and reproduction of full-sized sketch see Enright 1996

9. *Tate Gallery Catalogue of Acquisitions 1982–84*, London 1986, pp 224–5

10. Roger Coleman, 'Introduction', *Situation*, London 1960

11. Letter to Gimpel Fils, 1 May 1964

12. James Brown, conversation with the author, 17 Aug 1999

13. 'Derbyshire 1957'

14. British Council lecture, 1963

15. *Colour Construction* (1960), Arts Council Collection, repr. Garlake 1998, p 58

16. Causey 1978, p 42

17. Lawrence Alloway in *Architectural Design*, vol 31, no 3, Mar 1961, p 122

18. Clement Greenberg, 'Avant-Garde and Kitsch', *Horizon*, vol 1, no 4, Apr 1940, artist's estate

19. Peter Lanyon, Paul Feiler and Michael Canney, 'The Subject in Painting', broadcast 22 May 1963

20. Ibid

21. *Beatle* (1963), sold Phillips, London, 9 June 1998

22. Lawrence Alloway, 'The Collage Explosion', *Listener*, vol 67, no 1723, 5 Apr 1962, pp 603–5

23. William C. Seitz, *The Art of Assemblage*, New York 1961, p 72

24. Garlake 1998, pp 65–6

25. This reading from Causey 1978, p 45

26. Letter to Ivon Hitchens, 28 Jan 1964 in Lanyon 1990, p 257

27. British Council lecture, 1963

28. 'English Landscape', lecture typescript dated 26 Jan 1964

29. Ibid

30. 'Peter Lanyon Talking to Lionel Miskin about Painting and his Visit to Czechoslovakia', recorded spring 1964, TGA TAV215AB

31. Ibid

32. 'Some Aspects of Modern British Painting: An Artist's Point of View', lecture transcript dated 27 Jan 1964

33. Letter to Catherine Viviano, quoted in Andrew Lanyon 1990, p 262

34. Letter to Ivon Hitchens, 25 Feb 1964, in Lanyon 1990, p 260

35. *Untitled (Observatory)*, 1964, Private Collection, repr. Garlake 1998, p 62

36. Letter to Paul Feiler, 5 June 1964

37. Causey 1978, p 54

38. Quoted in Andrew Lanyon 1990, p 271

39. Causey 1978, pp 50–4

40. Sheila Lanyon, letter to Ben Nicholson, 25 Sept 1964, TGA 8717.1.2.2170

Index